KRISTIN CAPP

AMERICANA

Essay by Andy Grundberg
Text by Kristin Capp

EDITION STEMMLE
Zurich New York

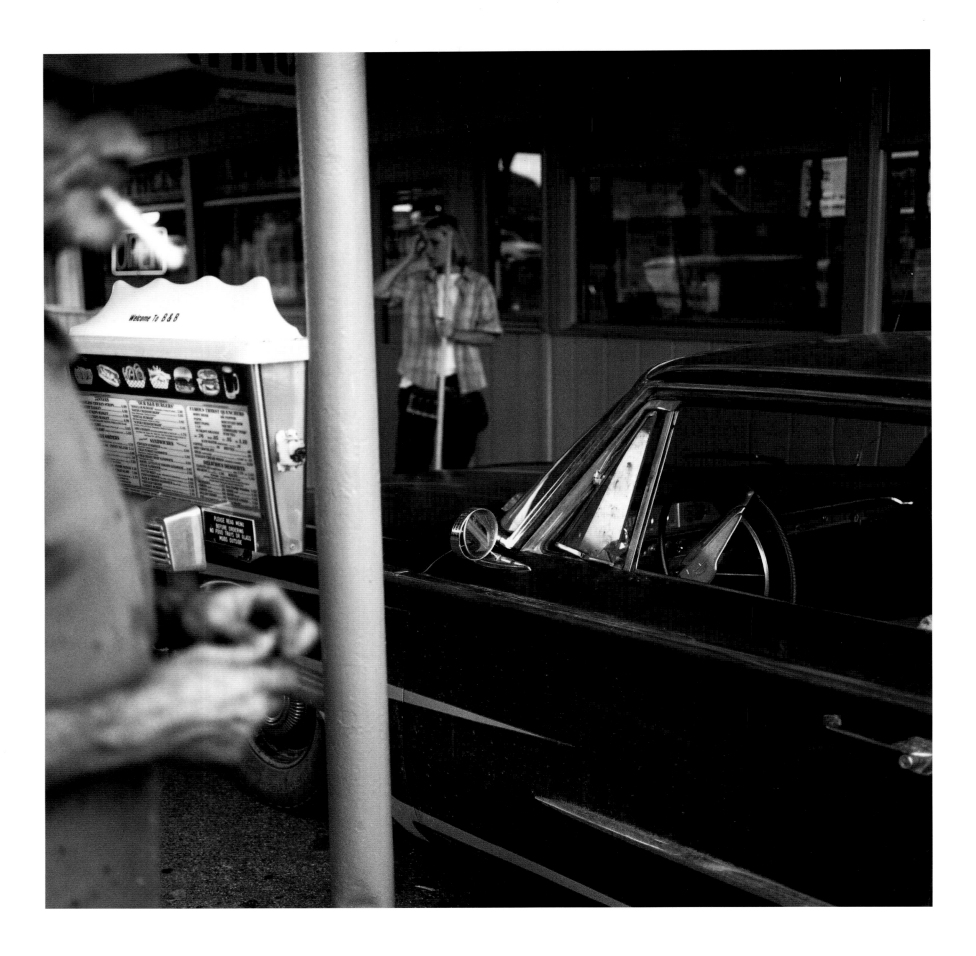

B&B Drive-In, Soap Lake, Washington, 1994

CONTENTS

LOCAL CHARACTER

by Andy Grundberg

Americana. One thinks first of homemade fruit pies, ice-cream cones from the side of a truck, sparklers on the Fourth of July, novelty salt-and-pepper shakers, Aunt Jemima cookie jars (African-Americana, a whole subject in itself), drive-in movies, fifties convertibles and sixties muscle cars, Willie Nelson and Pete Seeger singing Woody Guthrie songs, Mark Twain's Tom Sawyer and Huck Finn and Willa Cather's Antonia. According to the large dictionary beside my desk, "Americana" is strictly defined as "books, papers, maps, etc., relating to America, esp. to its history and geography." A ridiculously arcane and useless definition, I would contend. Americana may indeed be rooted in material culture, but for most of us it consists not so much of "books, papers, maps, etc." as of more ordinary memorabilia—that is, commonplace objects imbued with a nostalgic sense of historical and geographic memory. And surely our notion of Americana is informed by much more than reading material and knick-knacks. That, at least, is the argument one could make after looking at Kristin Capp's pictures, which, in an eccentric but beguiling manner, encompass American architecture, spaces, and faces as well as artifacts.

The pictures in *Americana* are a consequence of five years of attentive looking by Capp, who took the photographs on sojourns in and travels to the Pacific Northwest, Southwest, South, and Northeast. If they can be said to have a geographic center it would be in Soap Lake, Washington, where Capp lived while working on a project to photograph the Hutterite communities in the state. Soap Lake, as we see it in these pictures, may embody the whole idea of Americana all by itself, being sufficiently remote and rural as to seem unsullied and blessed with an inordinate number of potential rodeo queens. So it is a surprise to recognize others of the pictures as having been made, say, in the center of New York City, that paragon of media displacement and sophisticated international Diaspora. Suffice it to say that the pictures encompass a broad territory that spans the continent and, more important, ranges from traditional family values to postjudgmental urbanity.

It is one thing to assay America, or Americans, and quite another to call your subject "Americana." This small shift in language is emblematic of a much larger distinction in attitude and worldview that separates Capp's pictorial essay of life in these United States from its antecedents. For example, Walker Evans's *American Photographs* and Robert Frank's *The Americans*—closely related works of the 1930s and 1950s, respectively—sought to trace the American character through its most vernacular manifestations. Evans and Frank focused on material aspects of American culture that might well be called Americana, such as film posters, jukeboxes, and automobiles, but neither photographer saw these as in any way redemptive. The point was not the particularity of these things necessarily, but their ubiquity. They were, especially in Frank's dyspeptic case, examples of a homogeneity that seemed to engender a widespread malaise of the spirit.

American Photographs and *The Americans* served as models for photographers intent on tackling the big subject of The American Character for half a century. An obvious example, since it wore its affiliation on its sleeve, is Joel Sternfeld's 1987 book *American Prospects*. Sternfeld traded Frank's refined European sense of alienation for a sense of humor, which gave his elegant pictures a more indigenous irony. Sternfeld showed us a fireman shopping for a pumpkin in a field in front of a burning house, as well as a basketball backboard perched on endless desert near the Grand Canyon. Along with these puzzlements, however, he also included pictures of new tract housing, backyard pools and hot tubs, and anonymous glass-walled skyscrapers in depopulated urban centers. The resulting message was much like Frank's: any battle against the forces of conventionality and conformity fast overtaking American life could be waged only on the margins, in the untainted authenticity of hardscrabble, rural lives and in the consolation of vestiges of unspoiled natural beauty.

Two scant years before *American Prospects*, Richard Avedon's *In the American West* (1985) made this fundamentally romantic assertion the centerpiece of its own problematic internal debate. Avedon, working in a portrait mode that eliminated all context beyond the sitter and what he or she was wearing, managed to exceed even Frank's cynicism to the extent that he stripped away his subjects' capacity to engage us as empathetic characters. Much as cowboys, prisoners, drifters, and diner waitresses might be seen as heroic outsiders, Avedon also made them

appear as the sad last dregs of the legendary American frontier spirit—tarnished, compromised, even venal. This was not a popular book west of the Mississippi, needless to say, though it successfully posited an America without any redeeming features.

This increasingly skeptical sequence of books about America, from Evans to Frank to Avedon and Sternfeld, is united in at least three respects. One, all of the photographers lived in New York City at the time they made their pictures, so we could say that they were essentially tourists when they entered the American heartland. Second, all the photographers were men. And third, all carried the assumption that they were photographing something quintessentially American in character in a national sense, as opposed to regional or local. (This is true even of Avedon, I would argue, since his *American West* exists without reference to geographic specificity.)

Americana breaks this mold even though Capp, during the time she made these pictures, was indeed living part of the year in lower Manhattan. She is unaffected by any hint of New York provincialism, though, because for most of her life she has been a resident of Washington state. She has lived in the remote and moist reaches of the Olympic Peninsula and in the eastern, arid high plains near Spokane. Her previous book, *Hutterite. A World of Grace* (1998) chronicled a community of Anabaptist "plain people" who live and farm in the area of Soap Lake. In part because of these determining roots, Capp has been able to photograph an America that looks and feels astoundingly different from that of her most obvious antecedents.

For Capp, the texture and values of American life are to be found in rural communities, and especially in the small towns that sustain them, and in the inconsequential visual incidents of life one might, with a sharp eye and open mind, discover there. Her best pictures sneak up on you: A vacuum cleaner lies unattended on a carpet, its twisted hose making it look like a science-fiction creature, poised to strike. A pie sits perfectly composed on a milk-glass pedestal in a Texas diner. Similarly odd but perfectly normal sights crop up in more urban contexts. The skin on a man's back puckers up and over the back of a bench as he watches the boardwalk's passing parade. A collection of

blankets cascades from the shoulder of a man walking the Bowery. None of these small, sharp bits of data from everyday life amounts to great symbolic significance; here there are no oily, smirking politicians outlined next to American flags, as in *The Americans*. But in aggregate the pieces of data Capp assembles outline, like so many iron filings in the sway of a horseshoe magnet, an understanding of people, time and place that is clearly defined and irresistible.

Capp seems content to accept ambiguity as a given condition of meaning, and to embrace ellipsis as a stylistic strategy. In form her images are foursquare, seemingly straightforward and unpretentious, without the multiple centers of interest and syncopated echoes of shape typical of a more self-conscious, self-referential approach. This allows her to seem to disappear even while she actively directs our eye to what she has seen. Not every picture is necessarily simple, however. Case in point: An arm grabs a horse's tail, making a plume of hair seem to issue like water from below the hand; other than this, we see only the back end of the horse and the turned torso of a cowboy or cowgirl. Her pictures of people can be just as indirect and elusive, as when we see a baby, its back to us, lying in a window like a display mannequin, and we are left to wonder why.

The provisional, contingent quality of pictures like these will not be unfamiliar to many who keep up with contemporary photography; one thinks, for example, of Keith Carter's equally four-square images taken in Texas, which dote on small-scale incongruities as strange and unlikely as anything David Lynch, the director of *Blue Velvet,* might imagine. What distinguishes Capp's pictures is their devotion to the particularity of the local as a way of describing a national character. For Capp, Americana—and, one wants to say, American life—is defined by that which resists homogenization and not, as we have become accustomed to thinking, by the homogenizing process itself. Her camera does not interpose itself between franchise fast-food restaurants and identical interstate-highway rest stops; these dreary signs of national uniformity are simply not present in Capp's worldview. Like the Hutterites she has depicted with such graceful circumspection, Capp does not admit the worst aspects of modern life into her purview. This is true even when she is inside a transient

hotel on the Bowery; instead of squalor she finds solace in a neat row of matchbooks serving to prop up someone's treasured photographs.

Nonetheless, it is tempting to think that Capp's *Americana* pictures represent the very outside world from which the Hutterites have kept their distance—the contemporary "other" against which they define themselves. Where the Hutterites are insular and suspicious of modern life, these pictures seem expansive, curious, and full of contemporary references. But just as Capp has shown the Hutterites to be more engaged with the modern world than we might have expected, owning long-haul trucks and farming on a commercial scale, she shows us here that American contemporary culture is neither as soulless nor as seamless as we might assume. Forsaking the modern, presumably macho ambition to represent America as a whole, she has wisely and modestly chosen to stick to specifics in terms of both subject-matter and place. This is where she parts company with Evans, Frank, and their successors. In *American Photographs* and *The Americans*, particular people and things often function metaphorically as signs of something larger, such as economic disparity or racial prejudice. In *Americana*, they function metaphorically as signs of something quite small, namely the persistence of the local, the individual, the idiosyncratic, in America's national character. The result is refreshing and more than a little postmodern.

PLATES

Echo

Back in time
for supper
when the lights

Robert Creeley

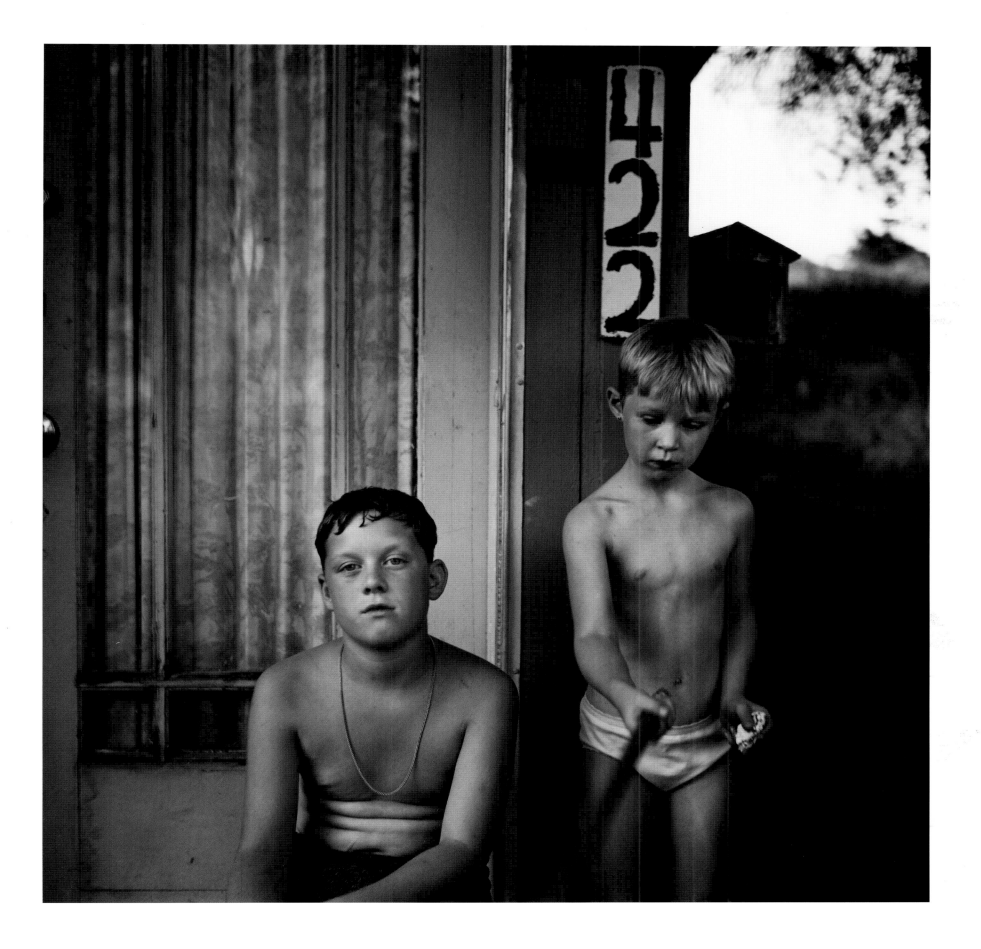

Front Stoop, Soap Lake, Washington, 1994

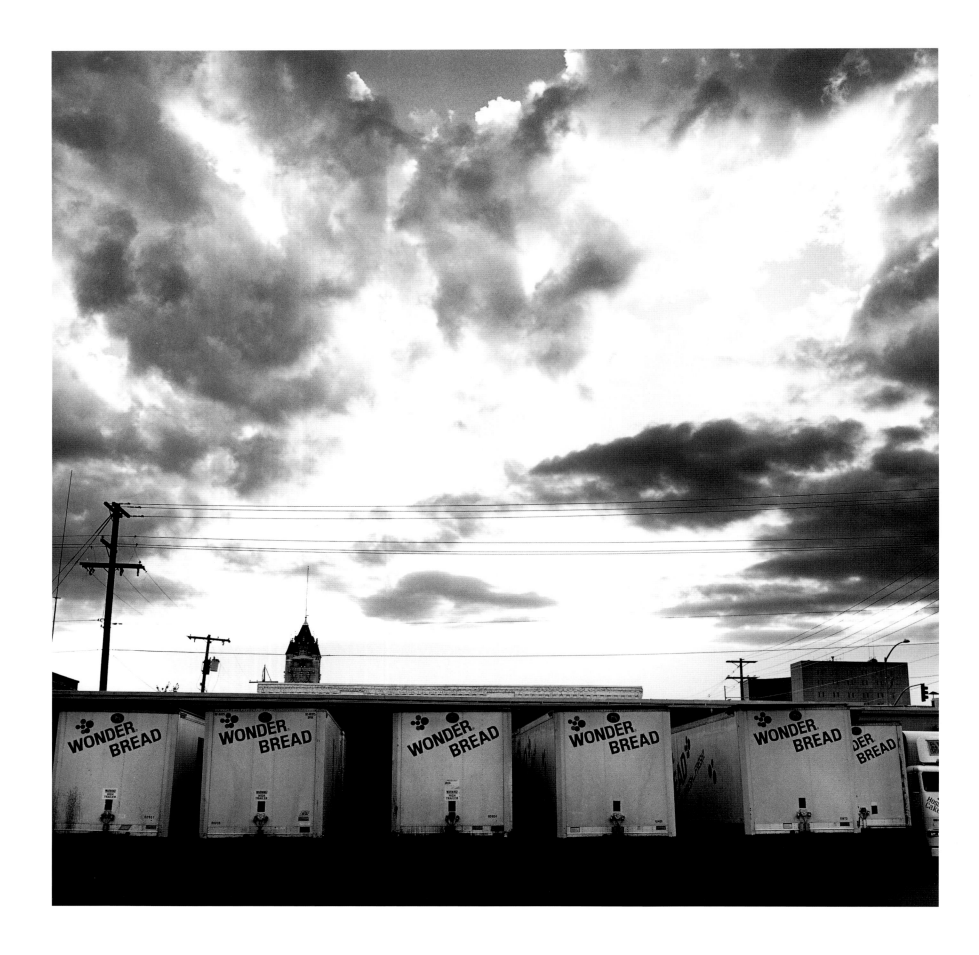

Wonder Bread Factory, Spokane, Washington, 1994

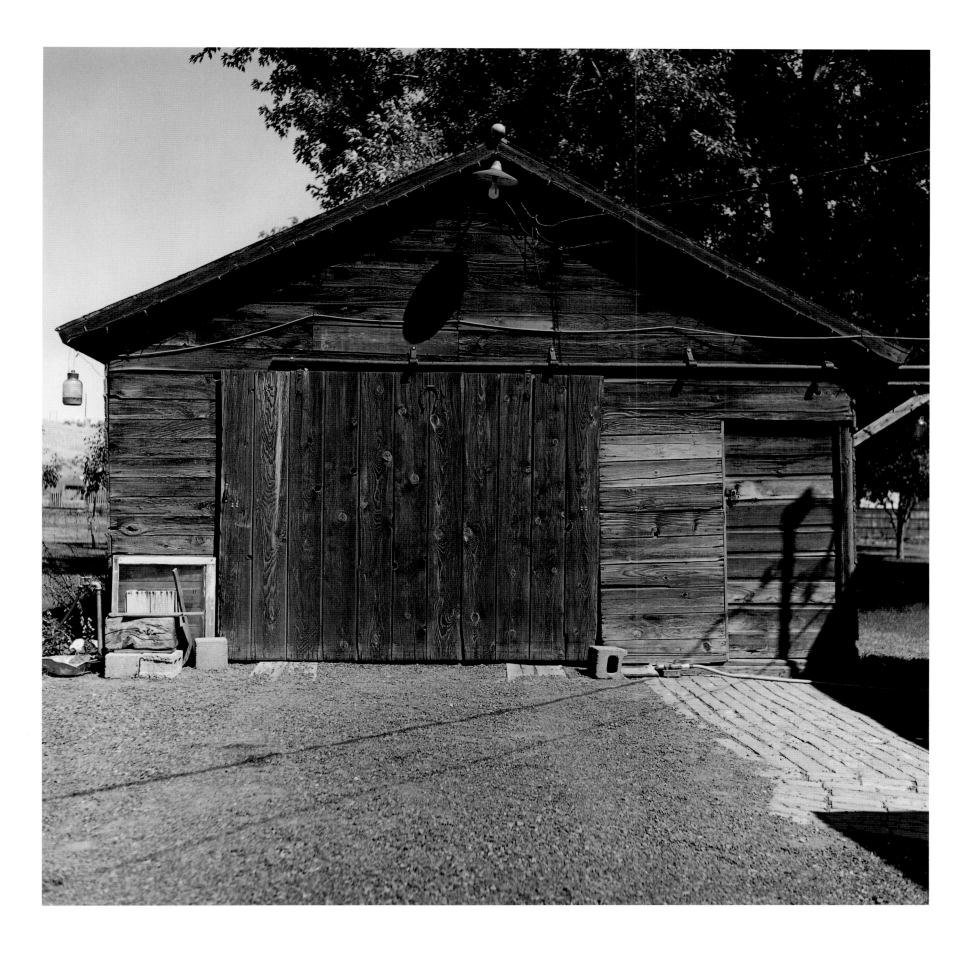

Garage, Wilson Creek, Washington, 1995

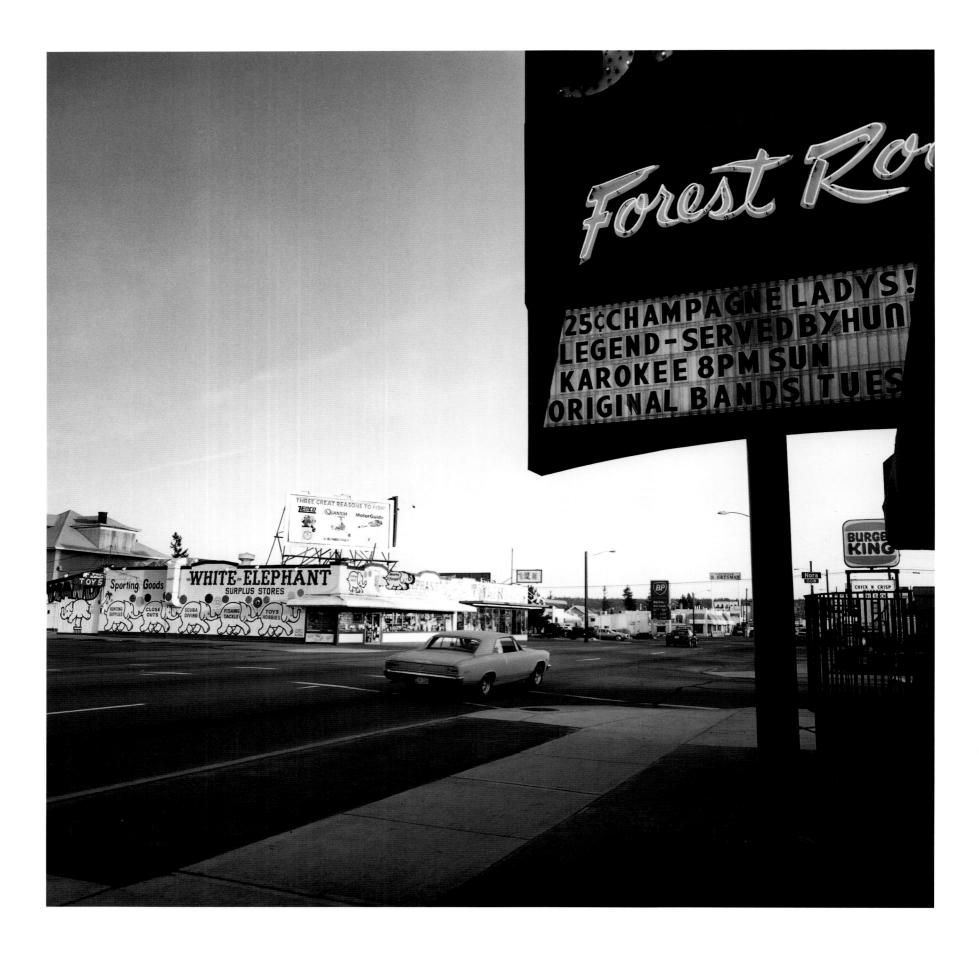

Division Street, Spokane, Washington, 1998

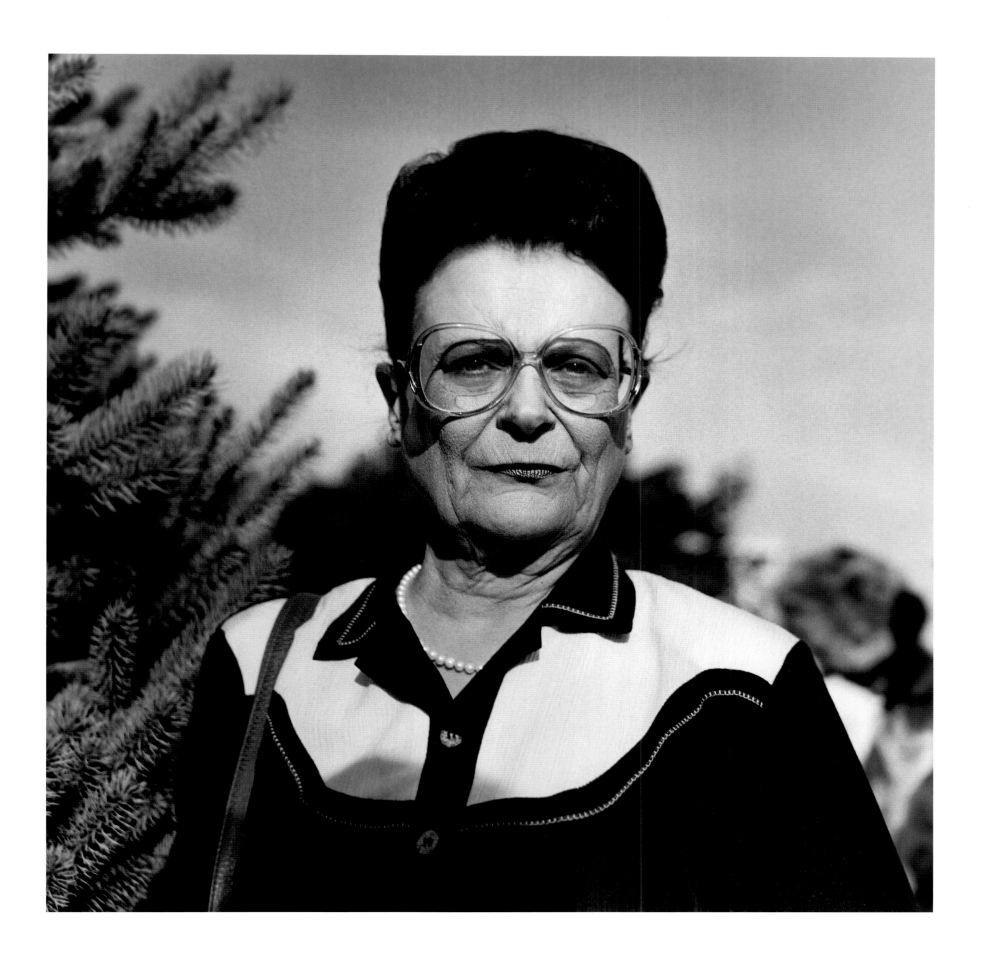

Woman, Ephrata, Washington, 1996

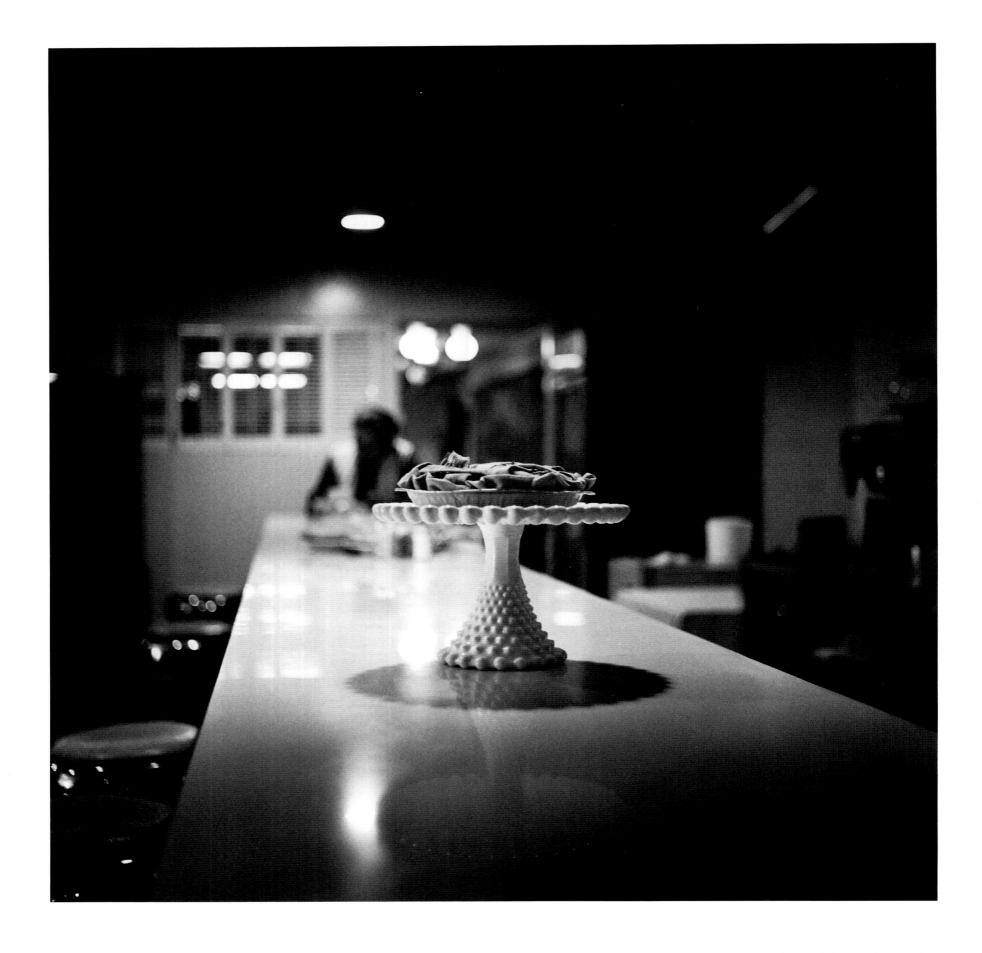

Diner, Palacios, Texas, 1996

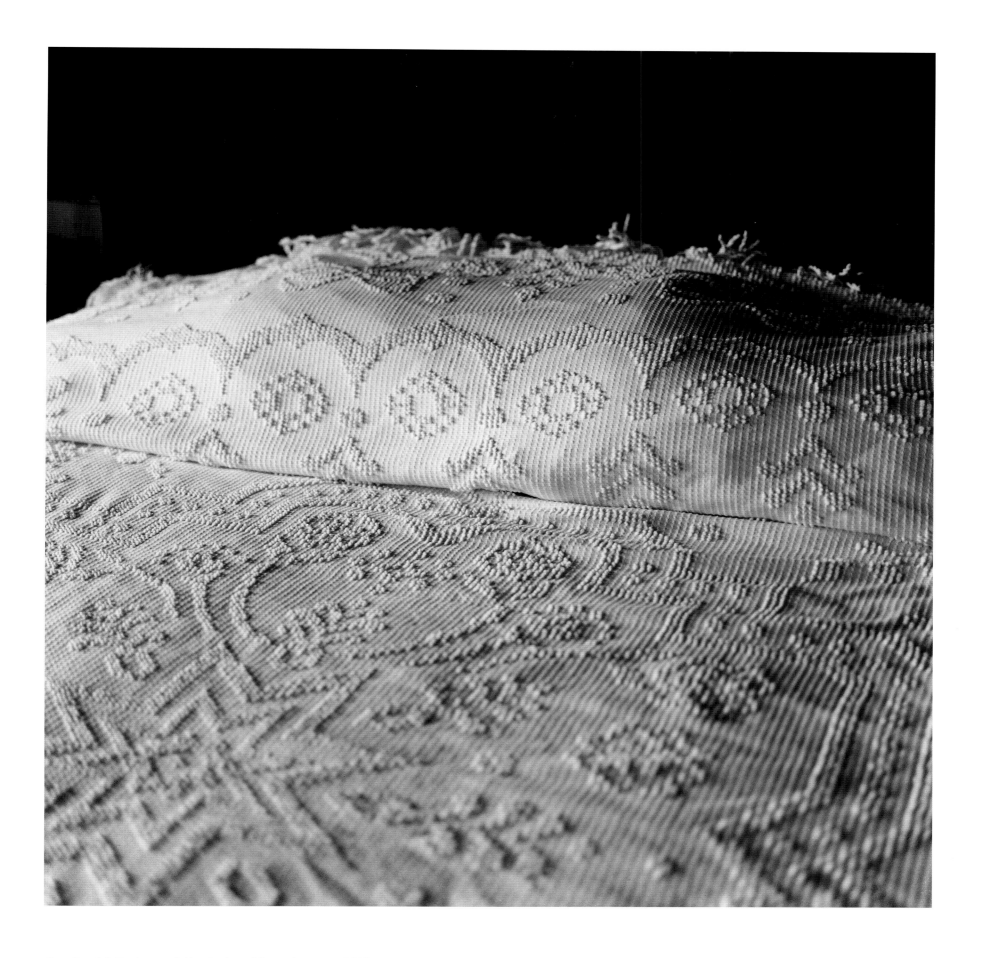

Candlewick Bedspread, Nantucket, Massachusetts, 1999

Flatiron Building, New York, 1998

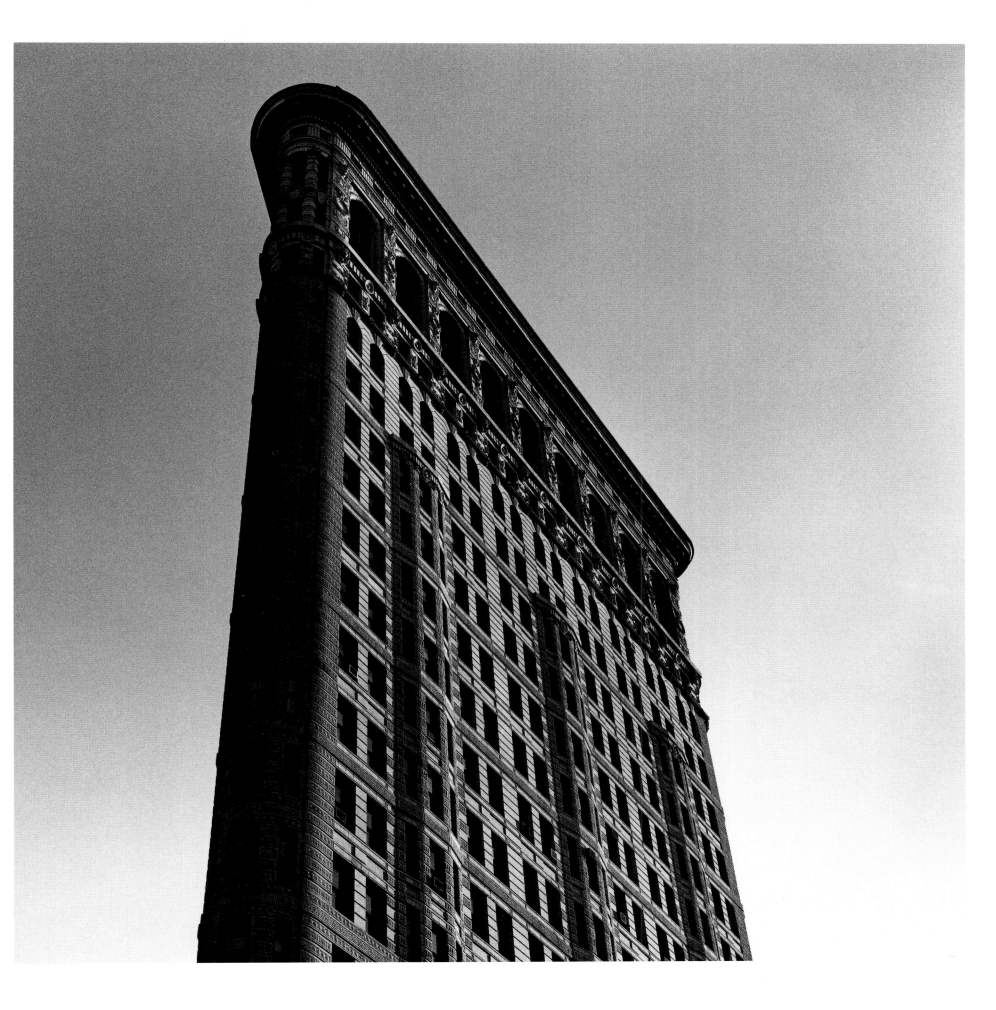

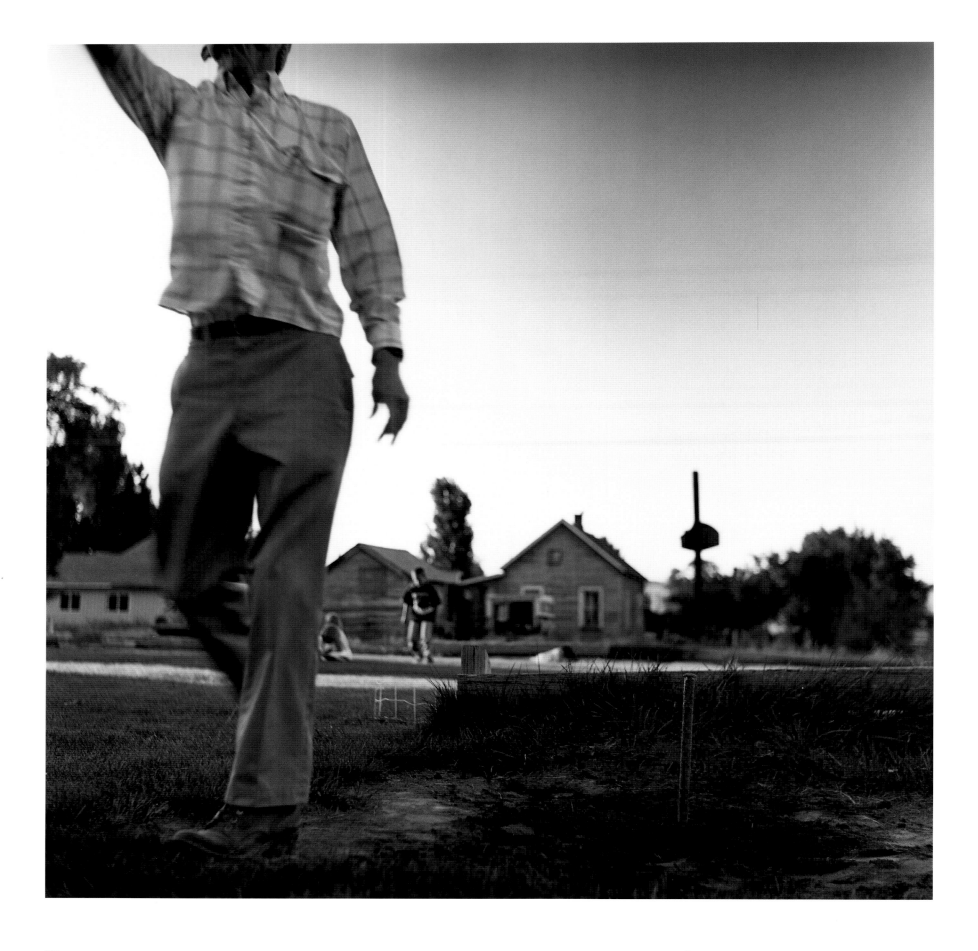

Horseshoe Toss, Wilson Creek, Washington, 1994

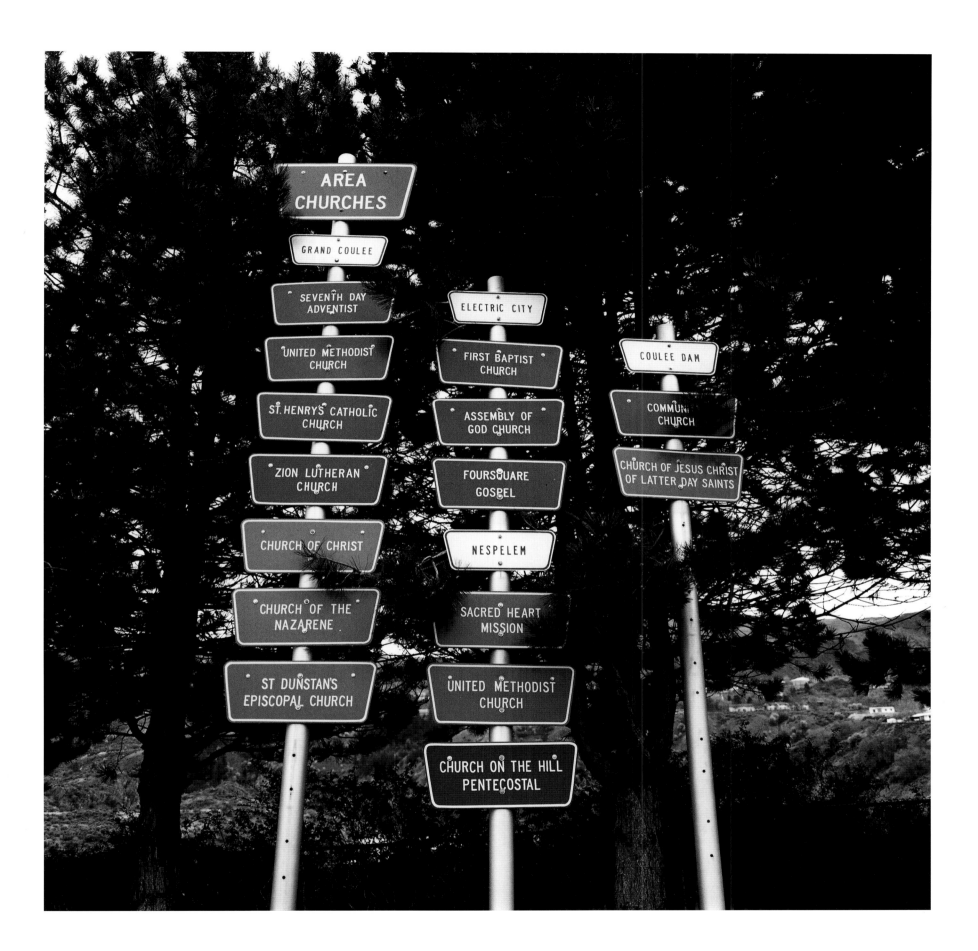

Scenic overlook, Grand Coulee, Washington, 1998

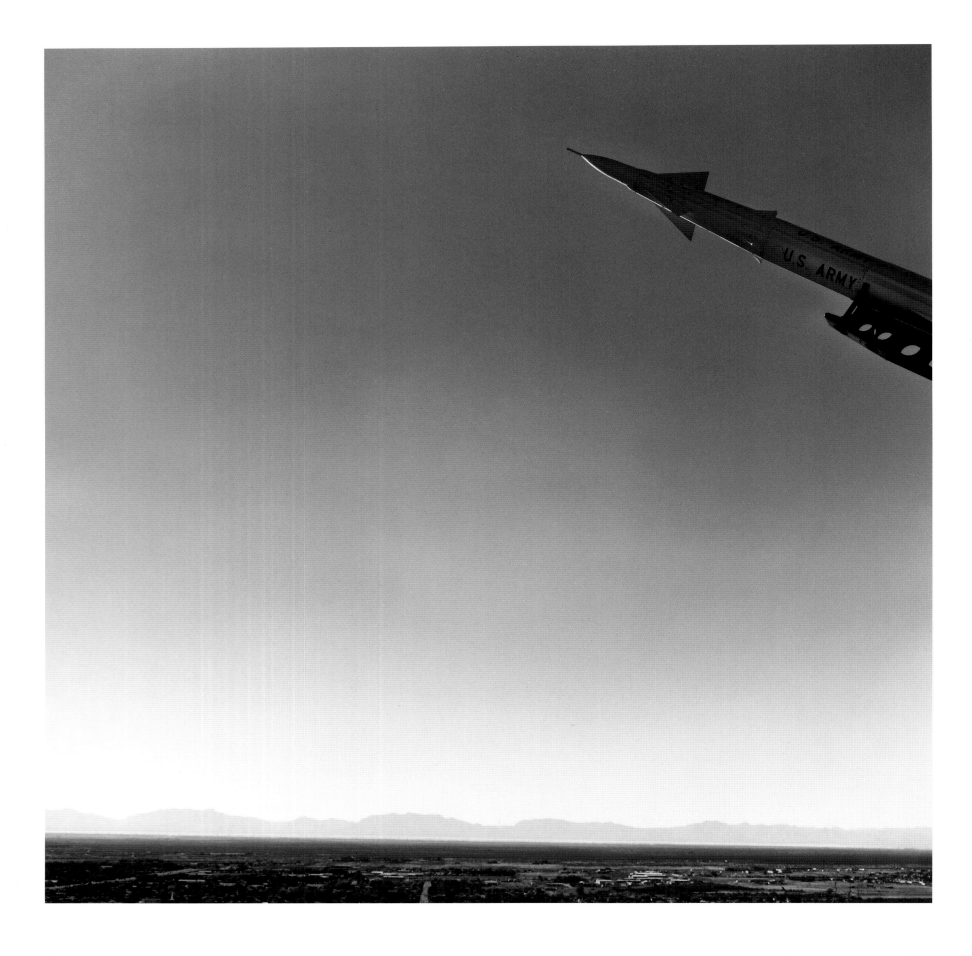

Desert, White Sands, New Mexico, 1996

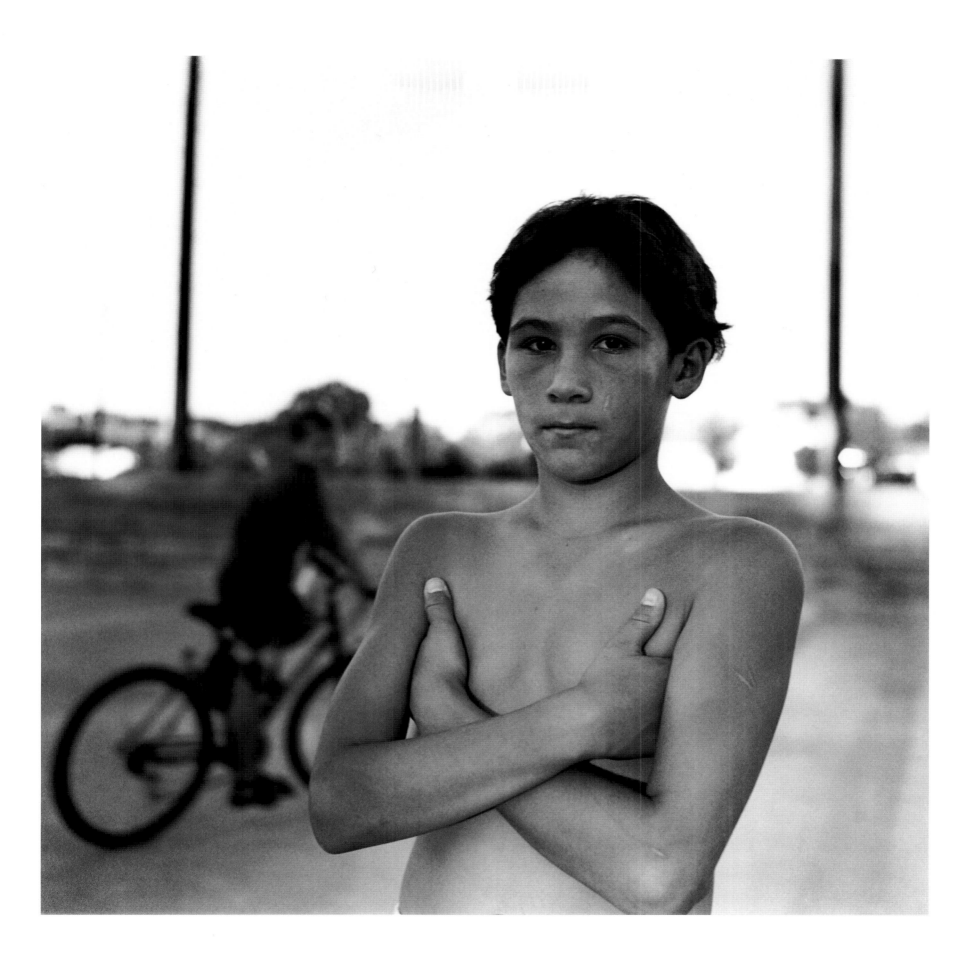

Boy, Soap Lake, Washington, 1994

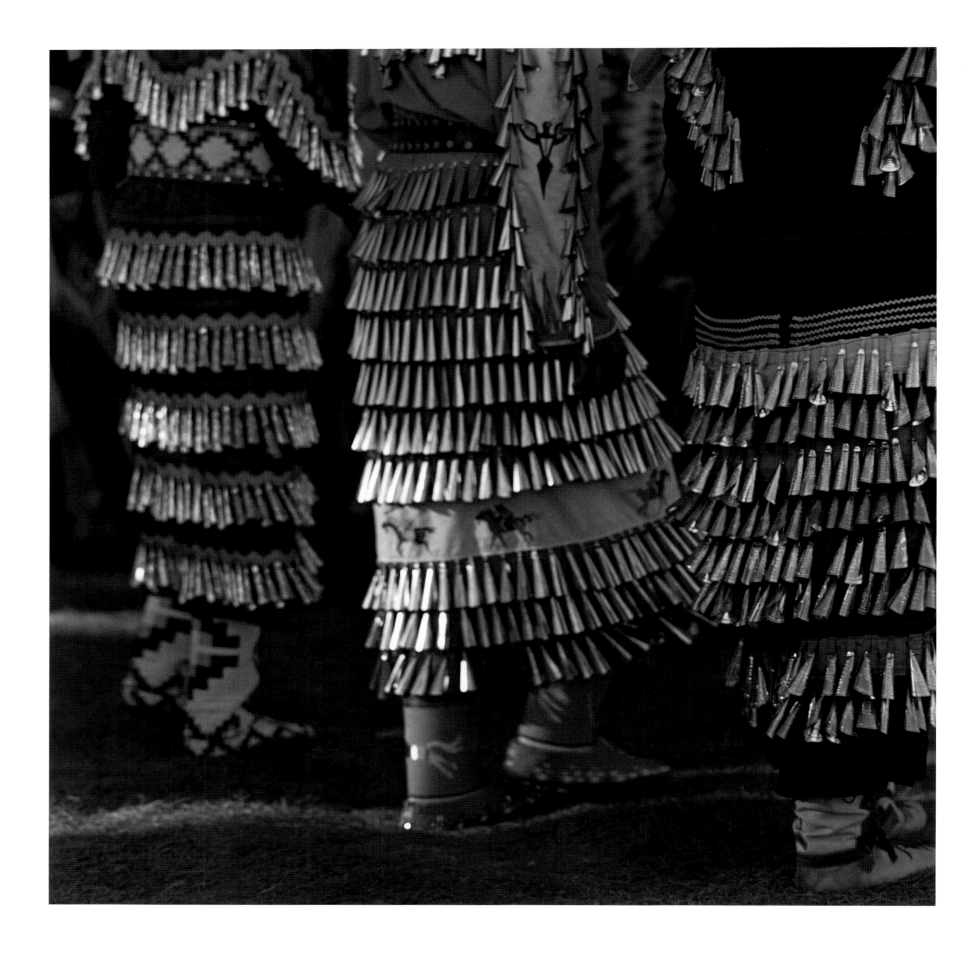

Pow-Wow Dancers, Kamiah, Idaho, 1996

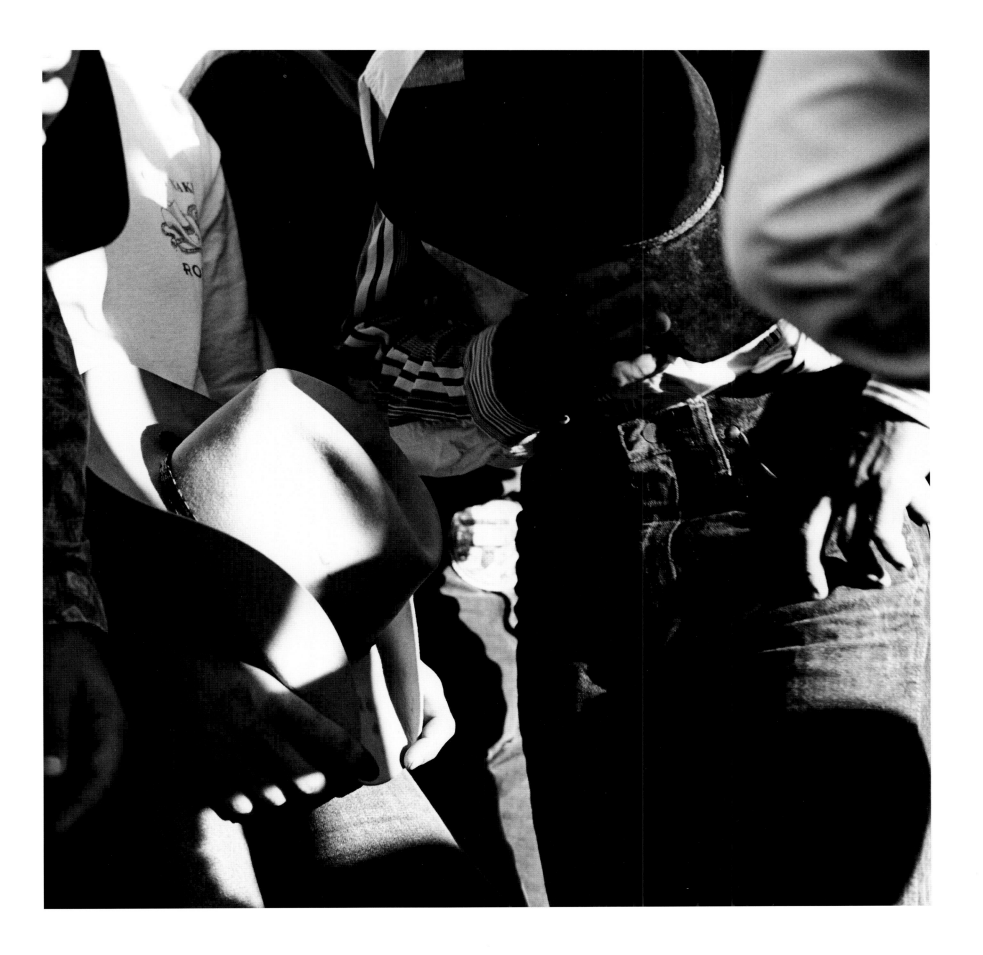

Cowboys, Moses Lake, Washington, 1995

Car Repair, Soap Lake, Washington, 1994

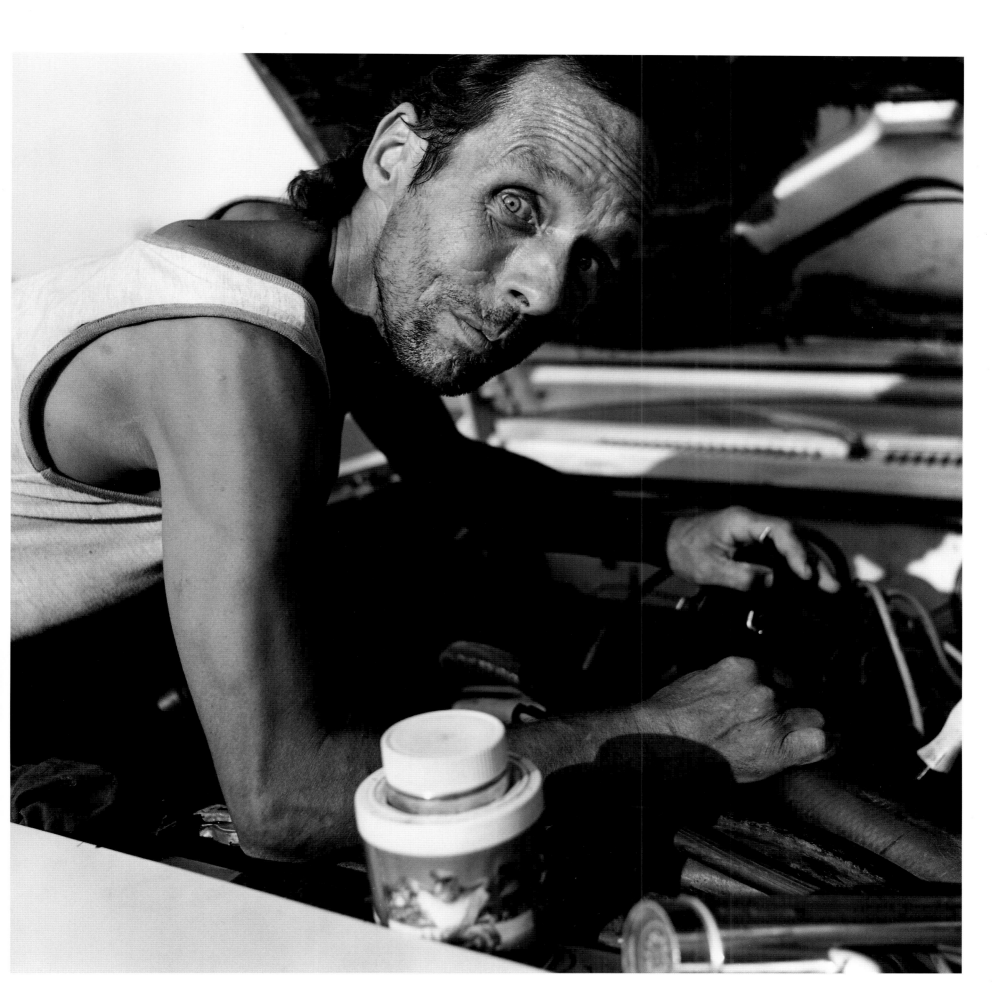

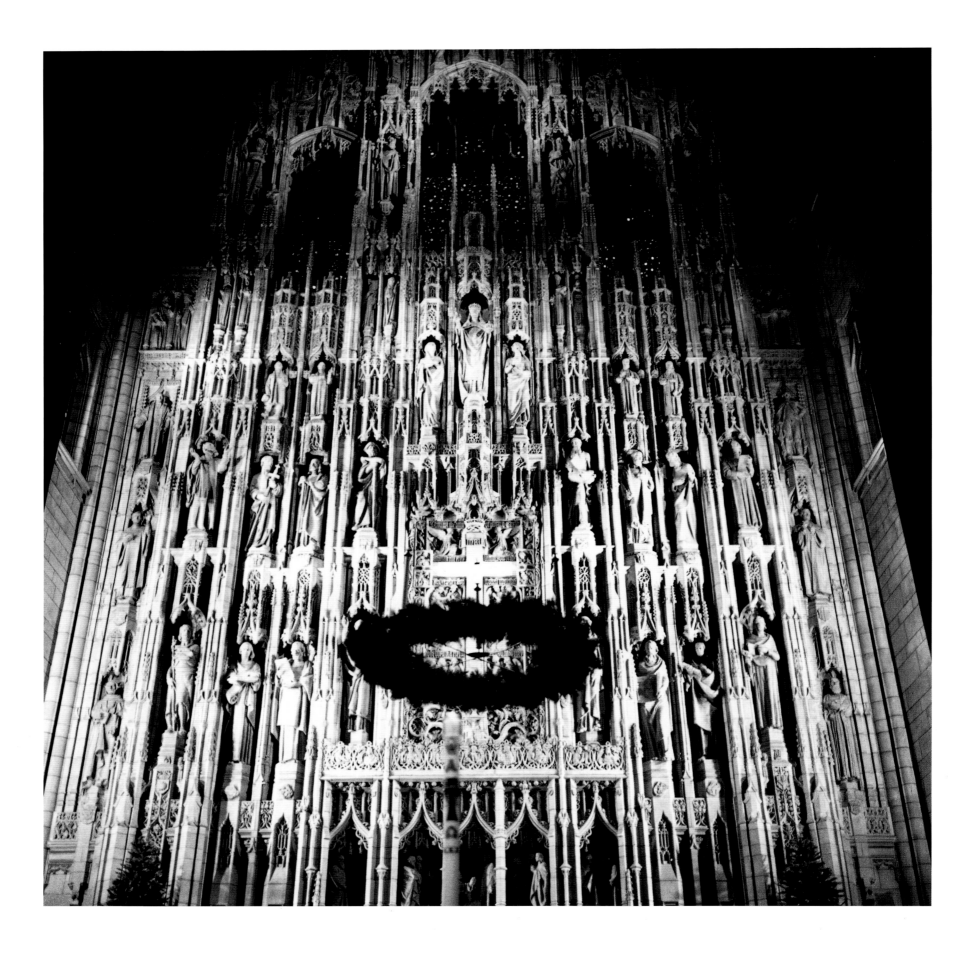

St. Thomas's Cathedral, New York, 1998

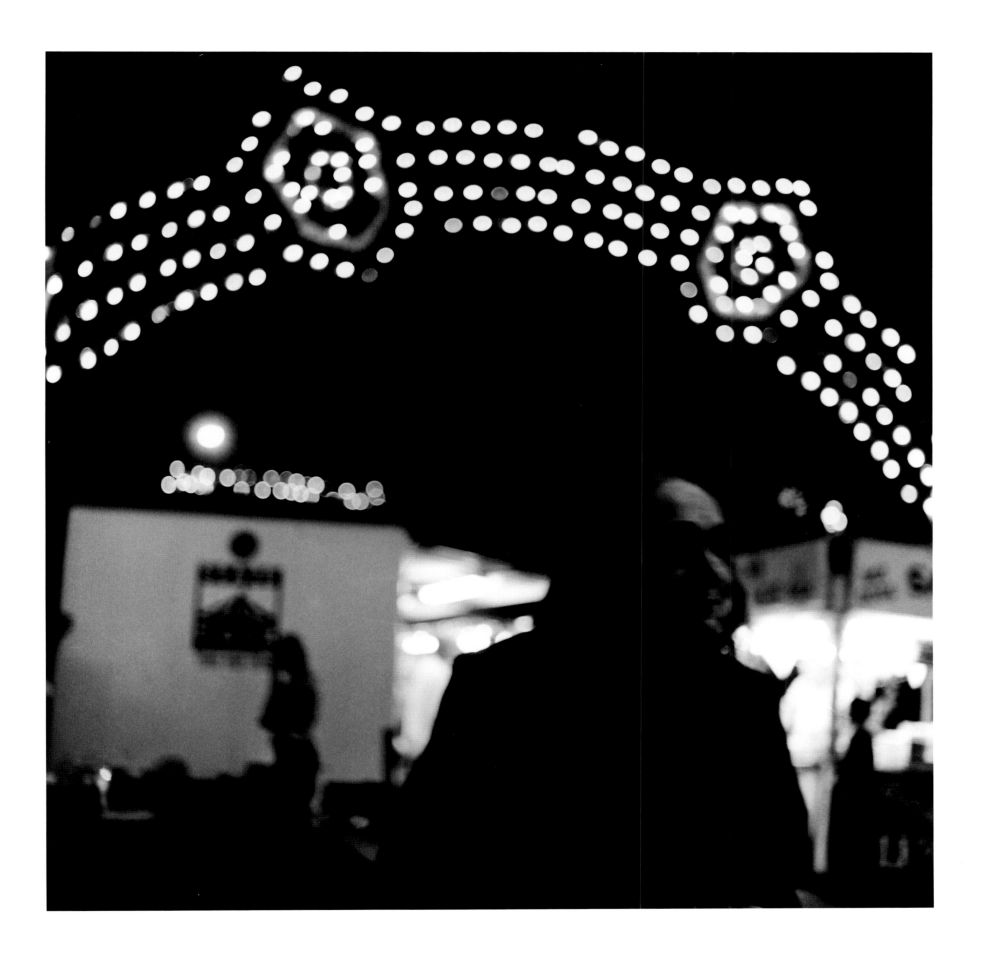

Sullivan Street Fair, New York, 1996

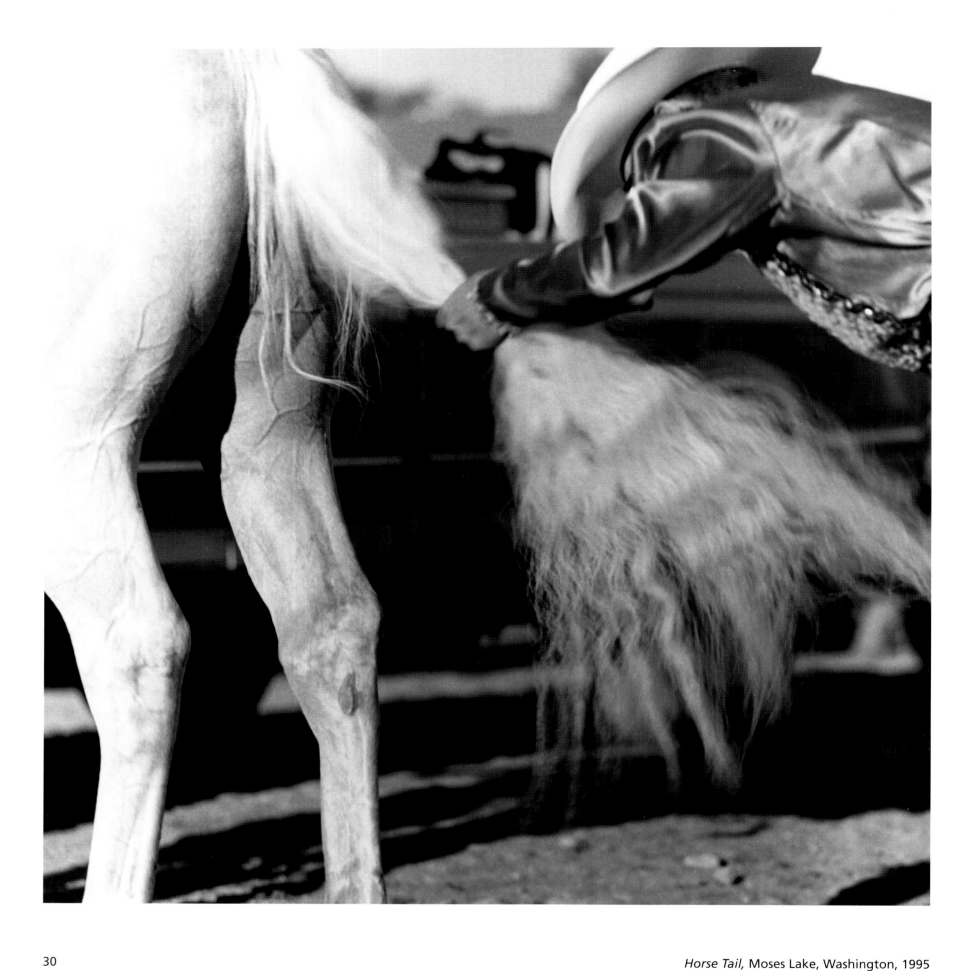

Horse Tail, Moses Lake, Washington, 1995

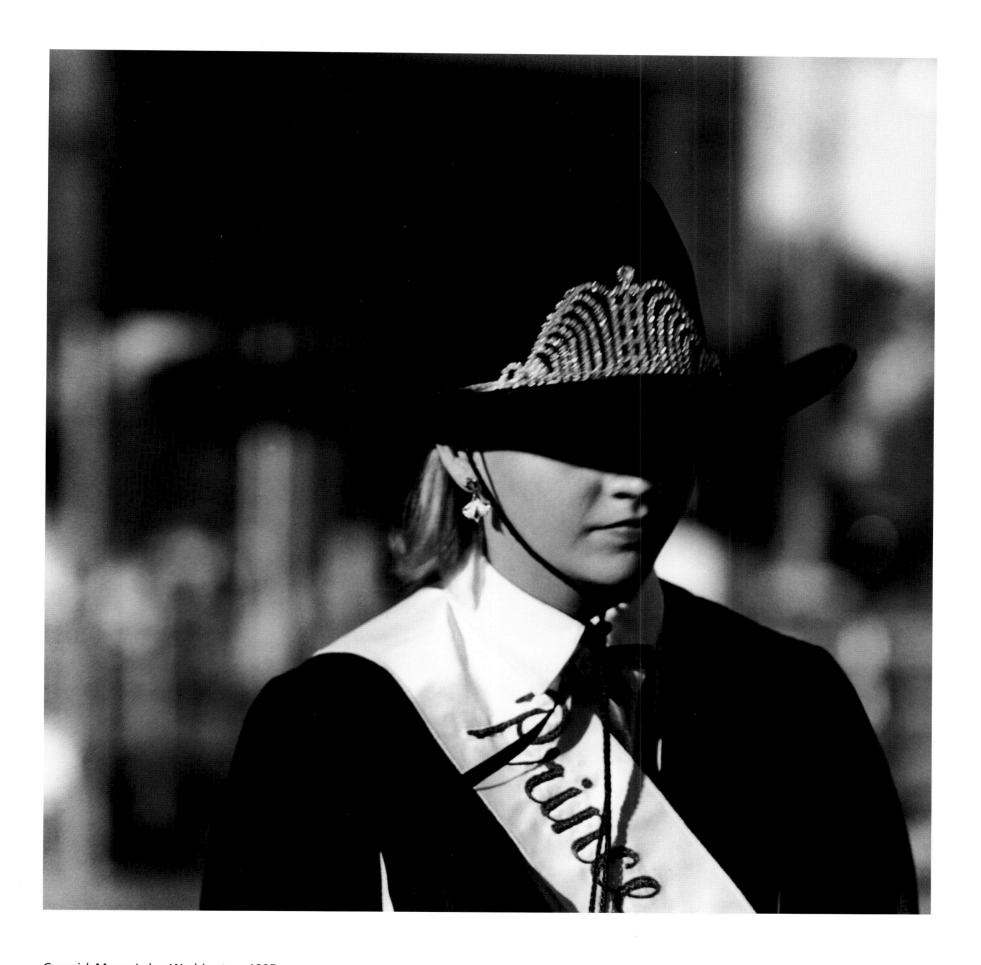

Cowgirl, Moses Lake, Washington, 1995

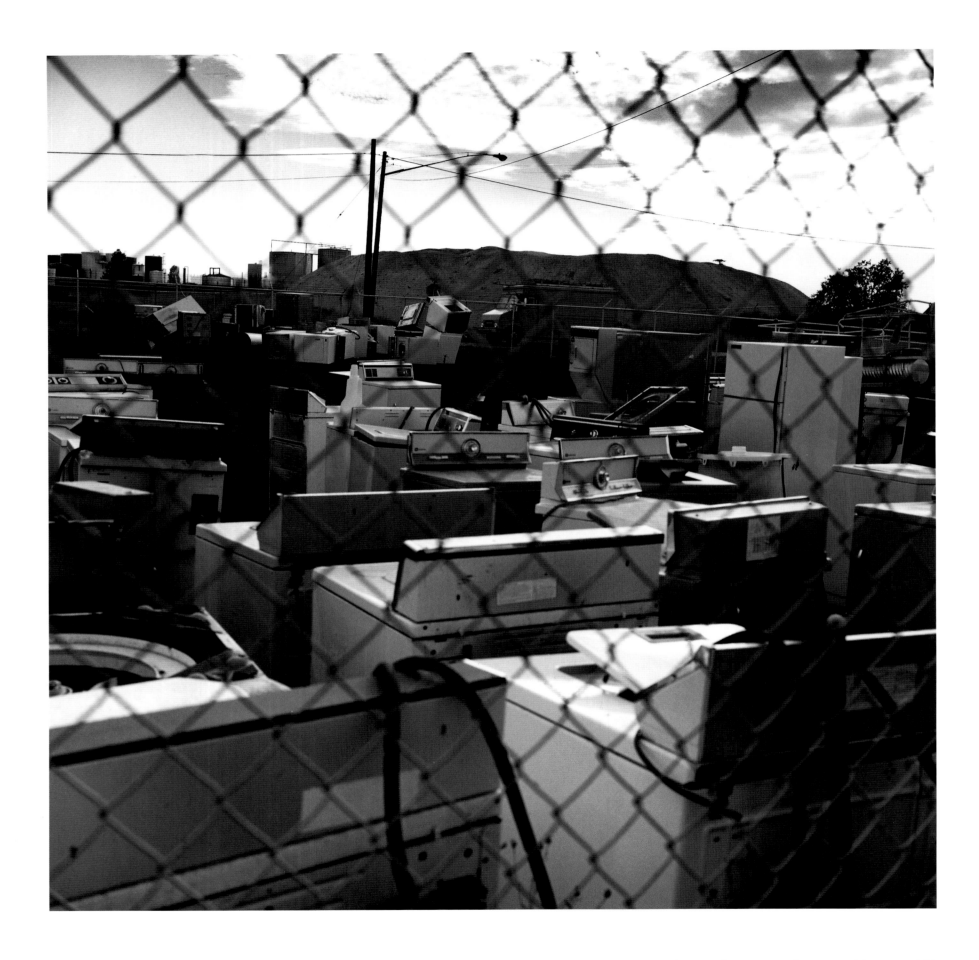

Washers and Dryers, Spokane, Washington, 1998

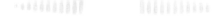

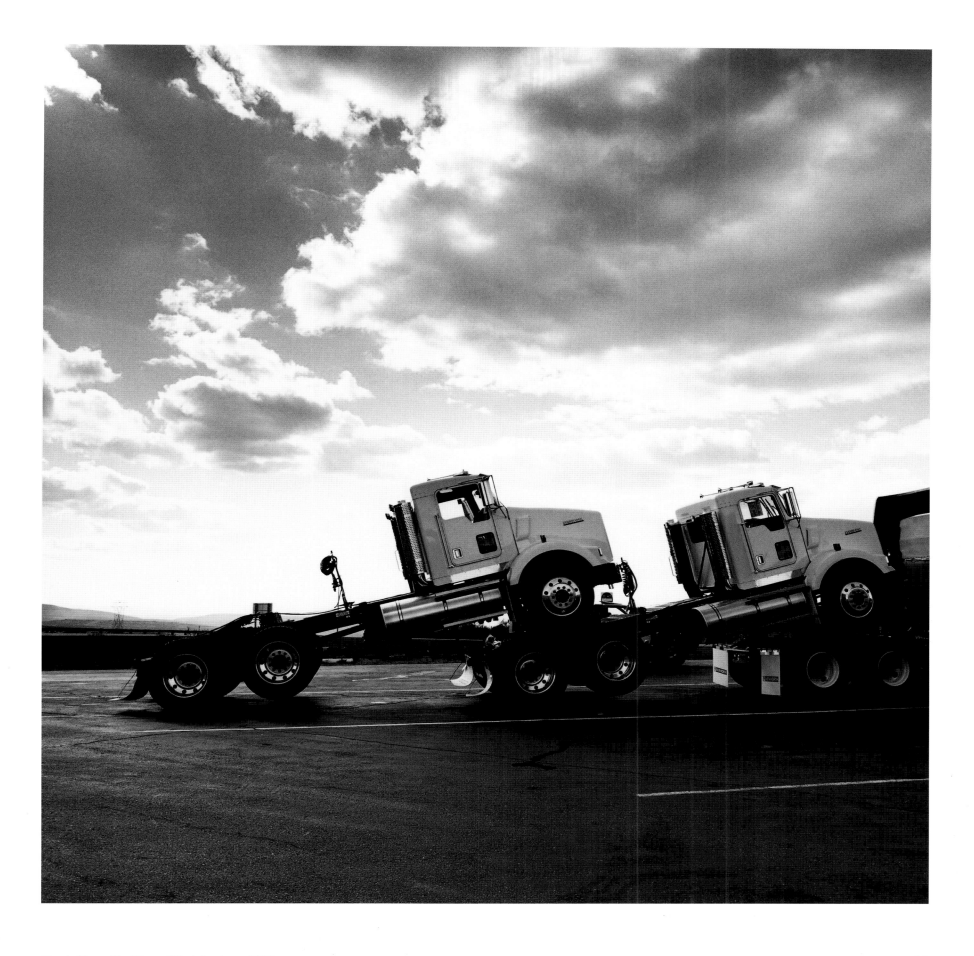

Truck Stop, Cle Elum, Washington, 1998

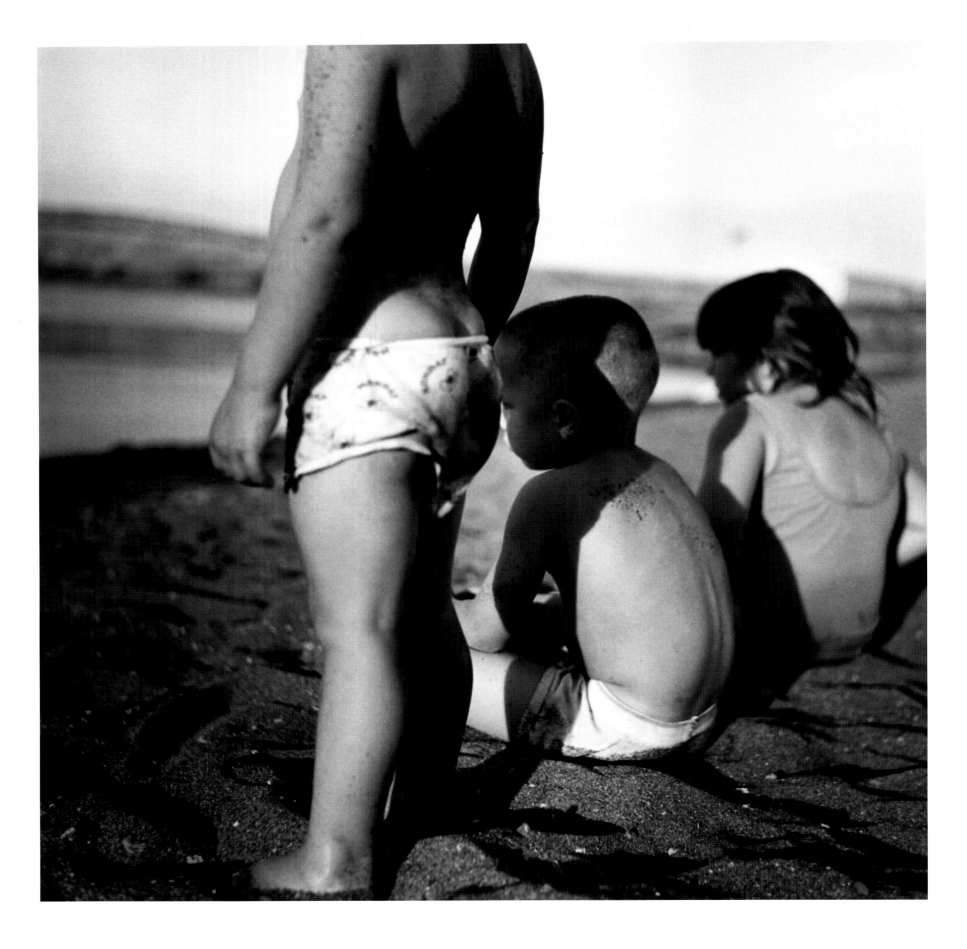

Three Kids on Beach, Soap Lake, Washington, 1995

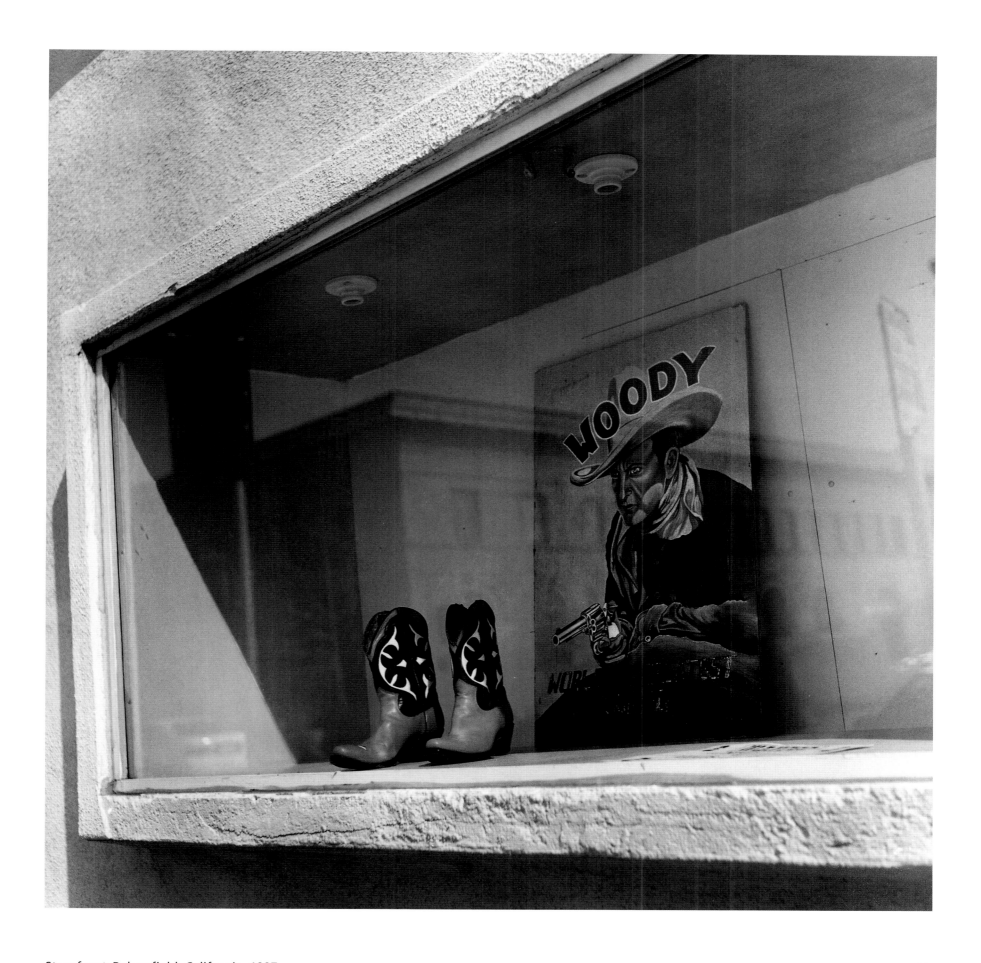

Storefront, Bakersfield, California, 1997

Profile, Moses Lake, Washington, 1995

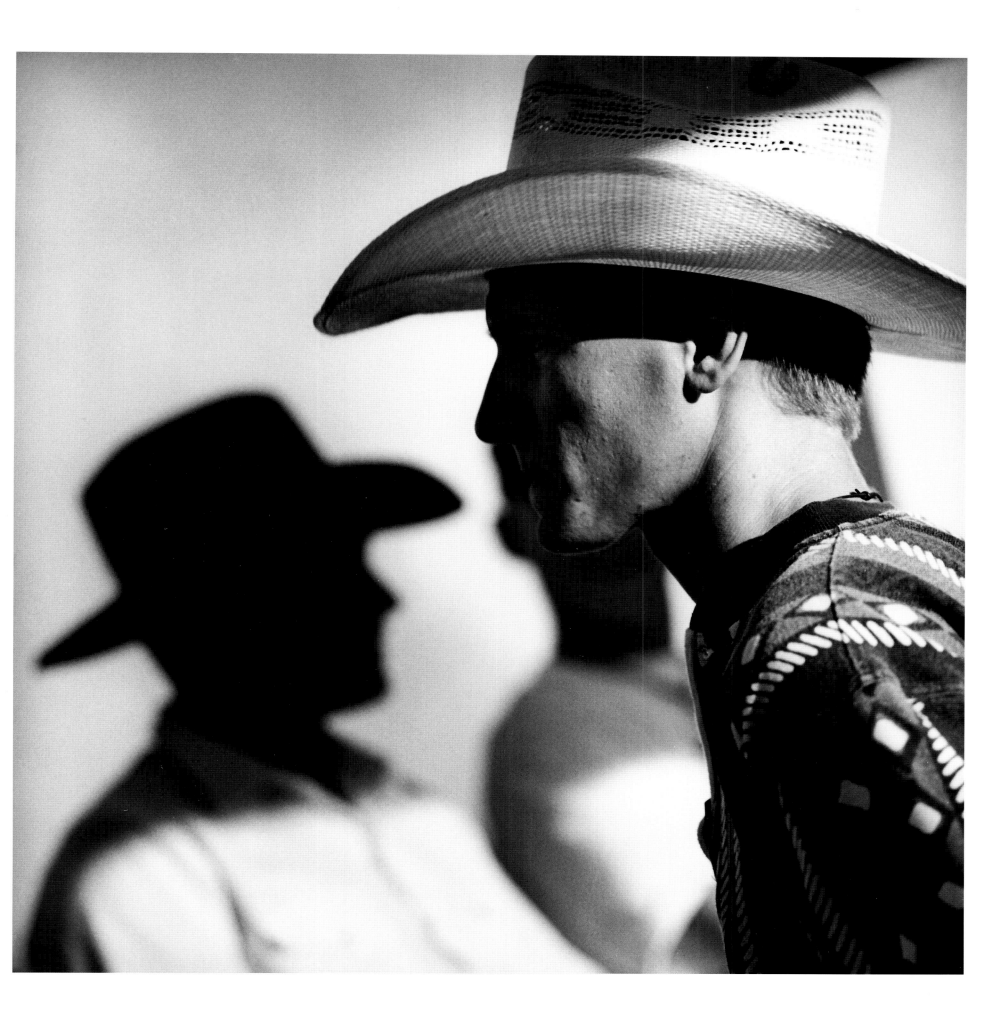

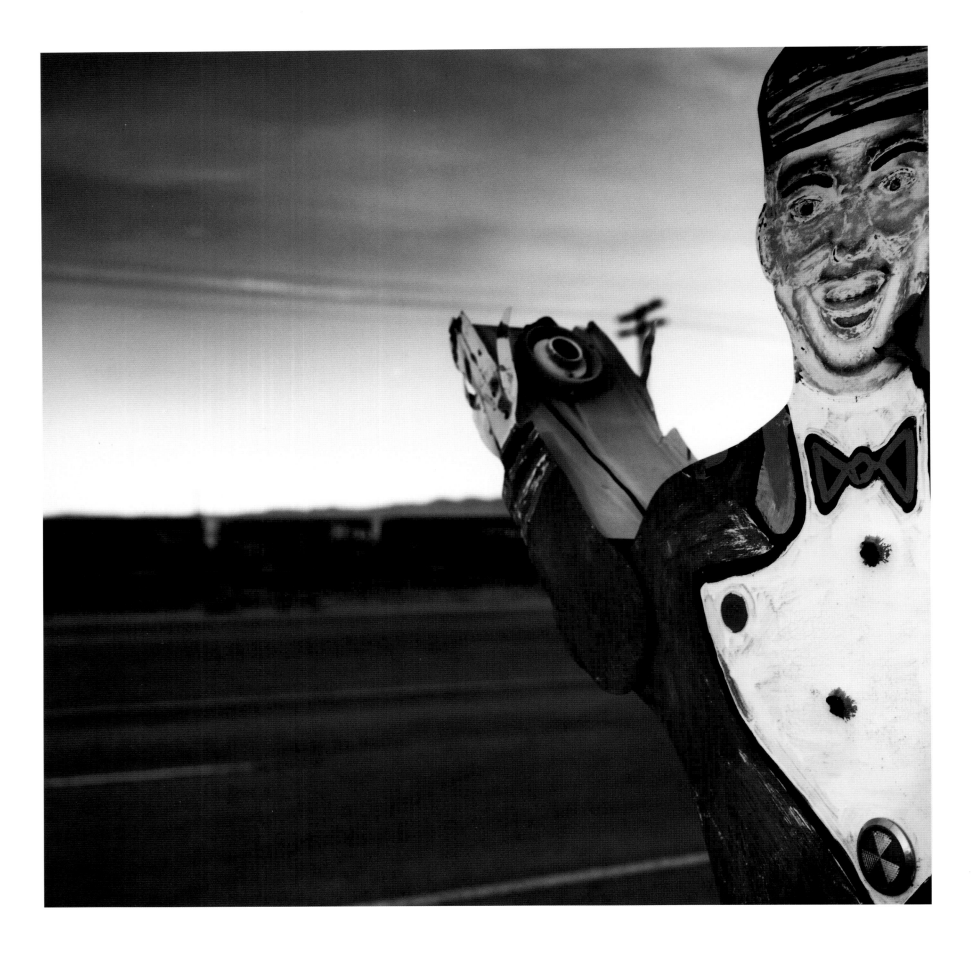

Old Gas Sign, Lordsburg, New Mexico, 1996

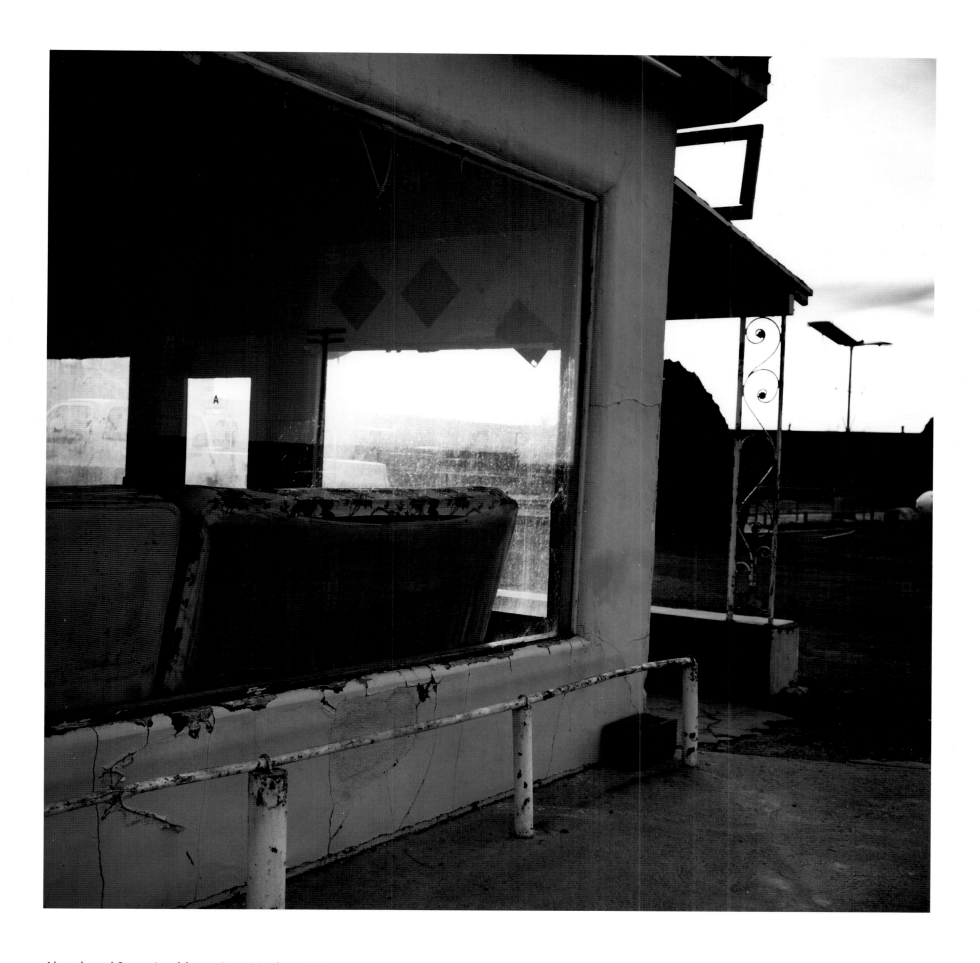

Abandoned Store, Lordsburg, New Mexico, 1996

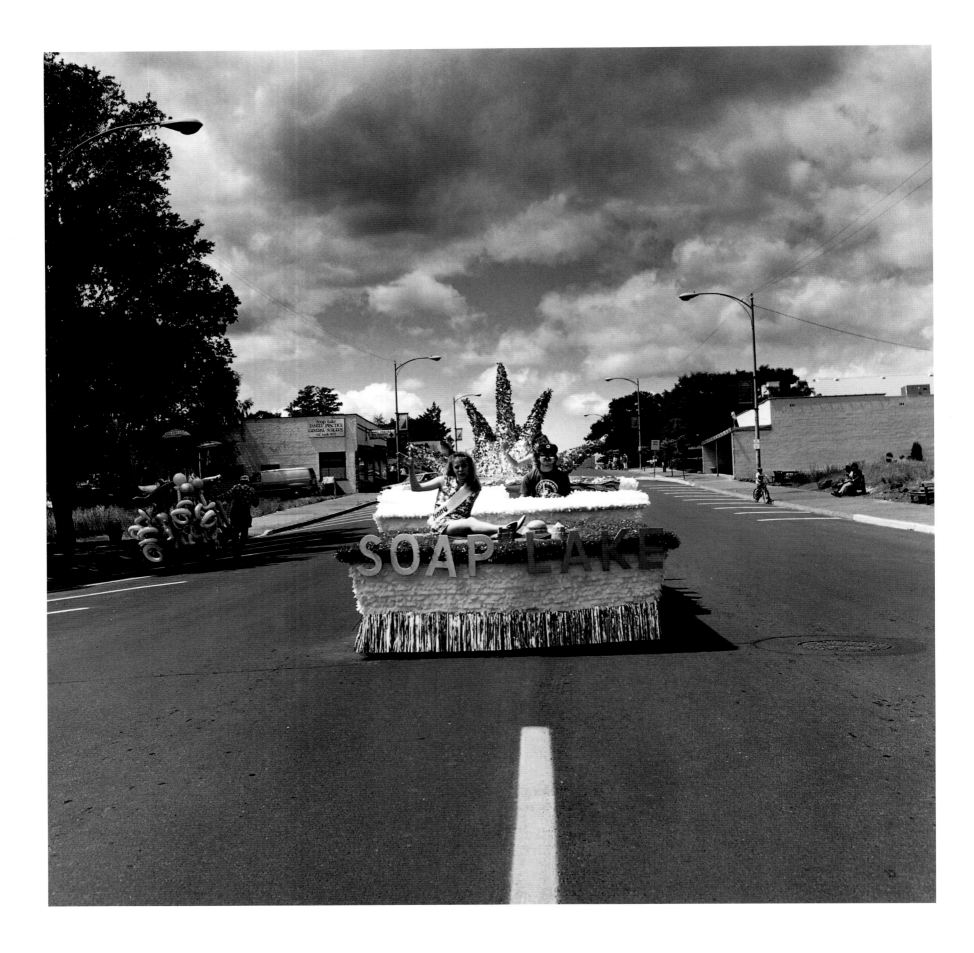

Parade, Soap Lake, Washington, 1994

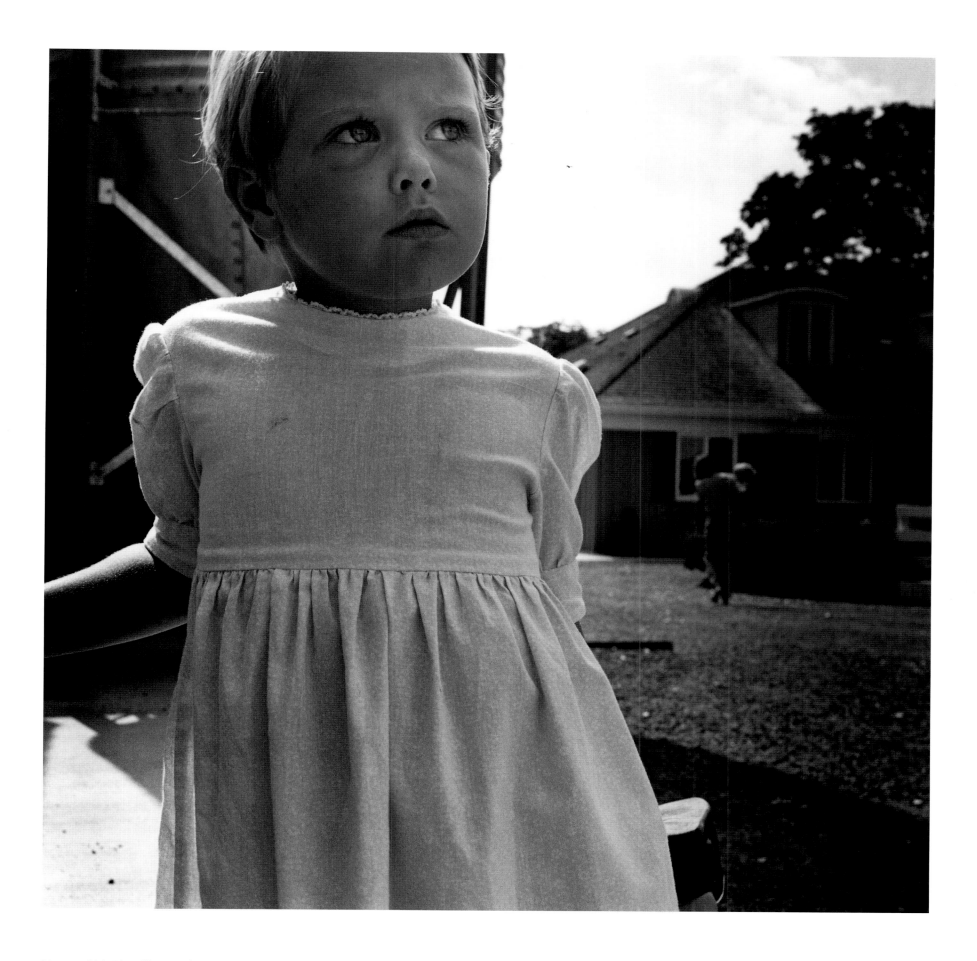

Young Girl, Ritzville, Washington, 1994

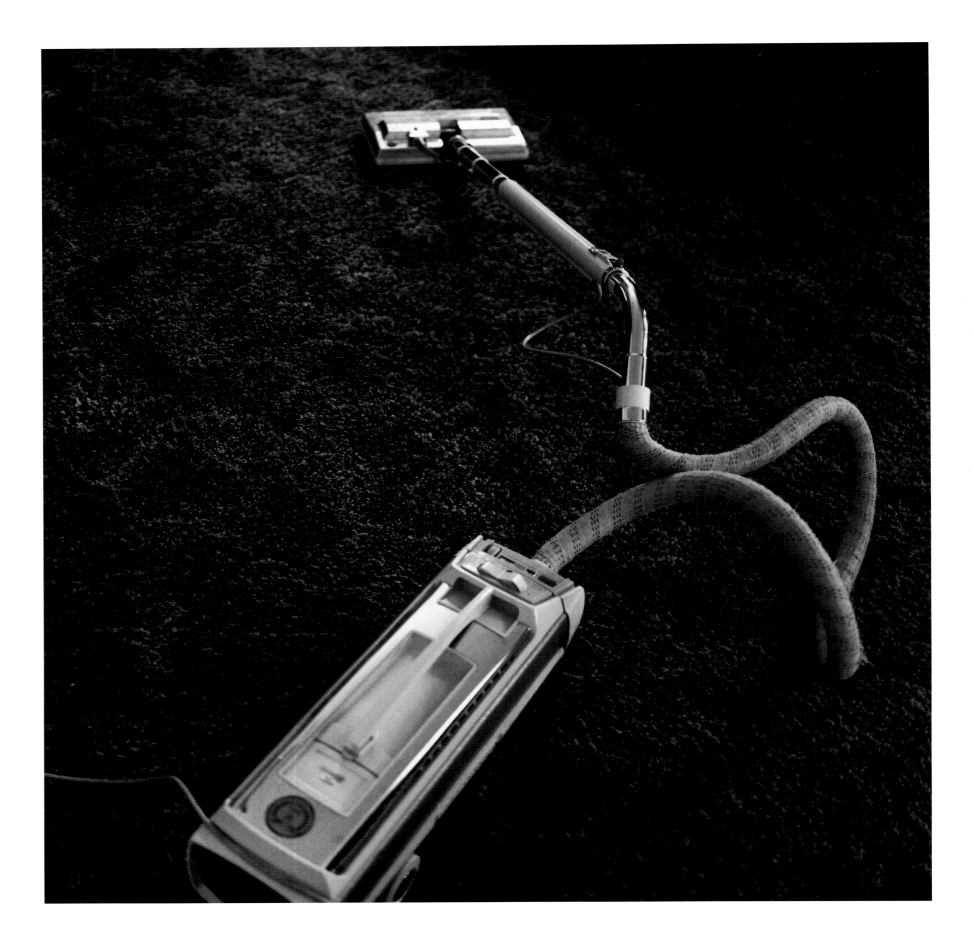

Vacuum, Odessa, Washington, 1997

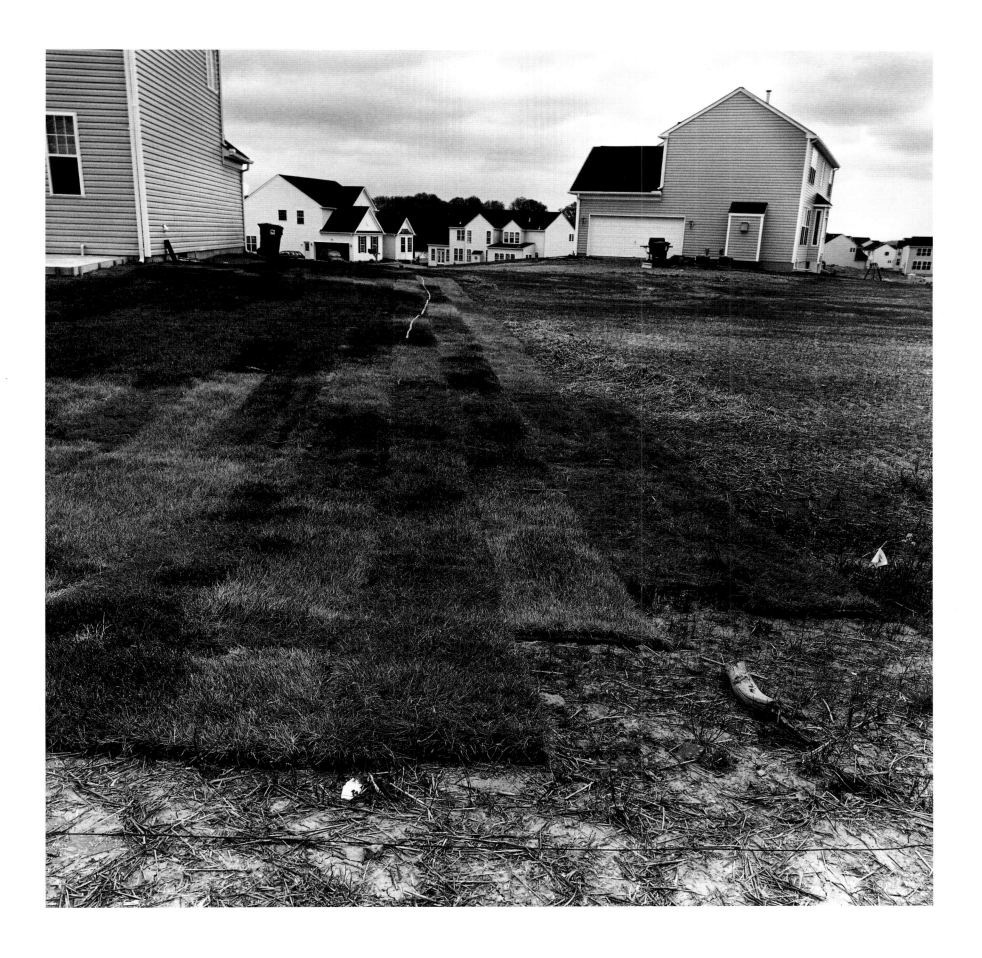

New Homes, Newark, Delaware, 1999

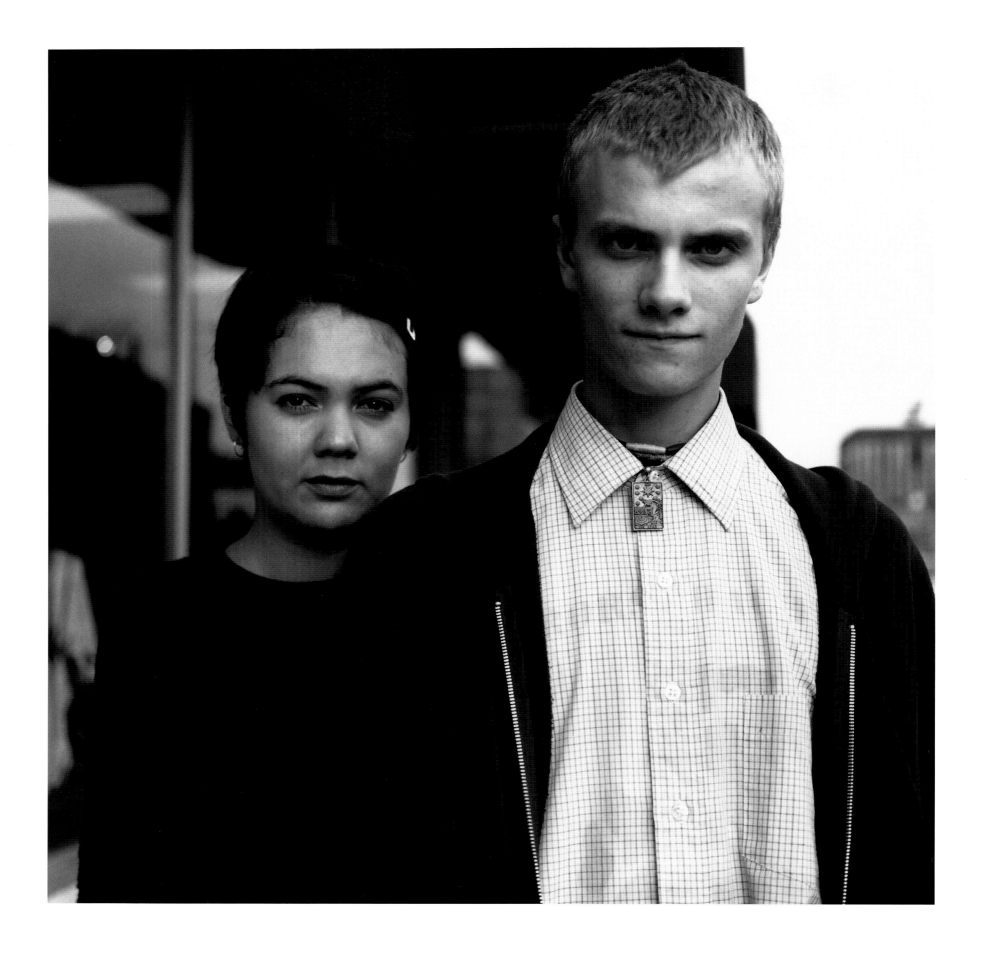

Couple, Spokane, Washington, 1996

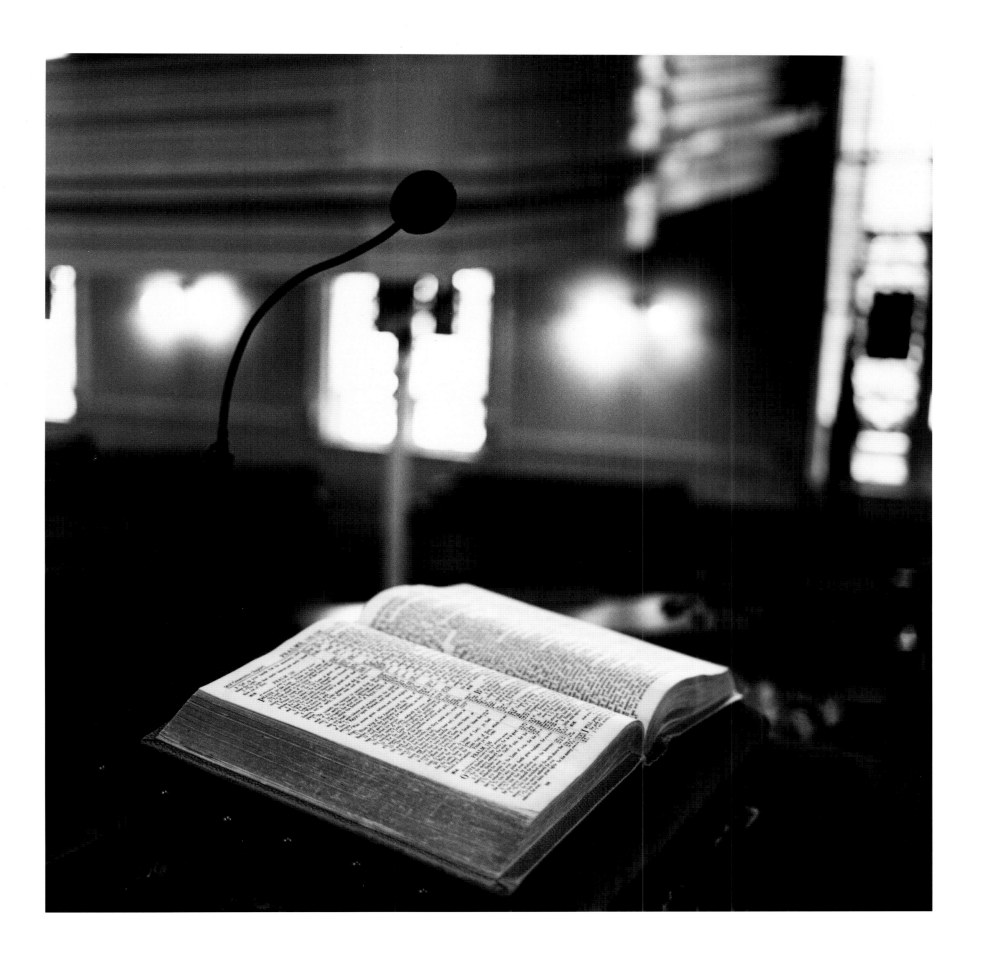

Pulpit, Savannah, Georgia, 1998

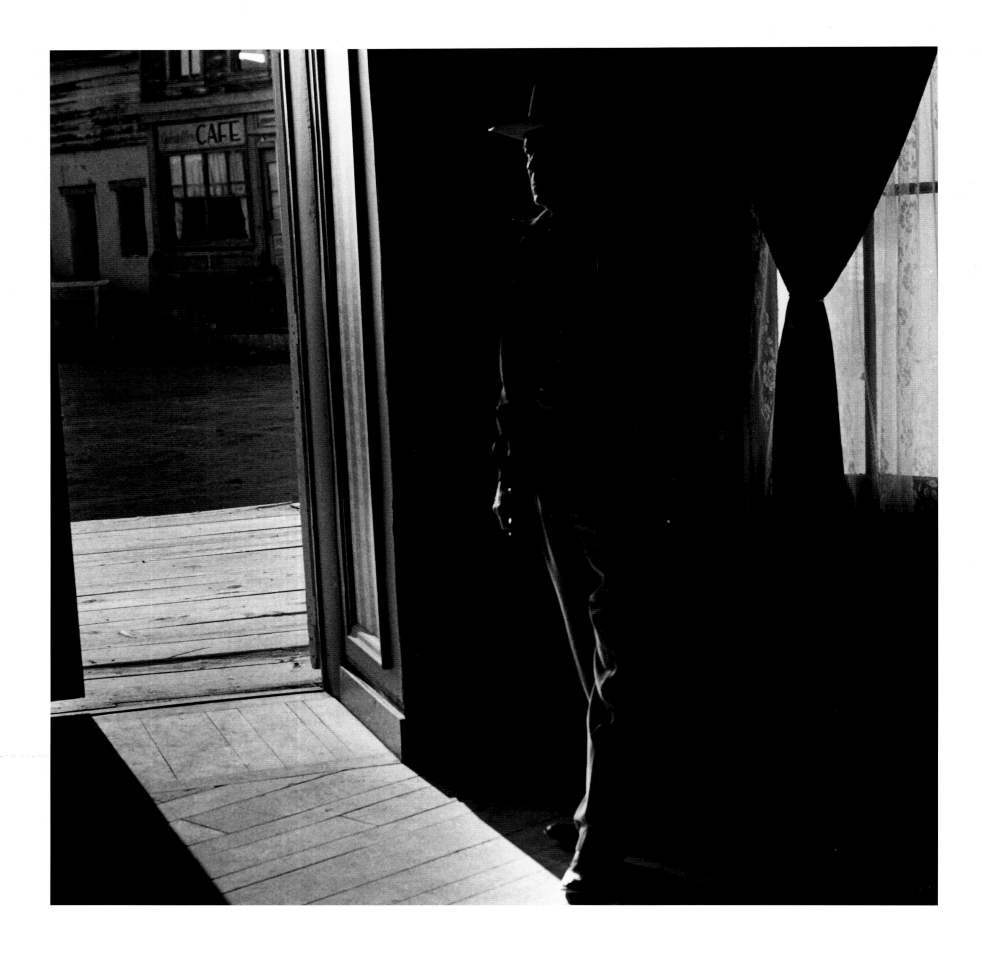

Ghost Town, Albuqurque, New Mexico, 1996

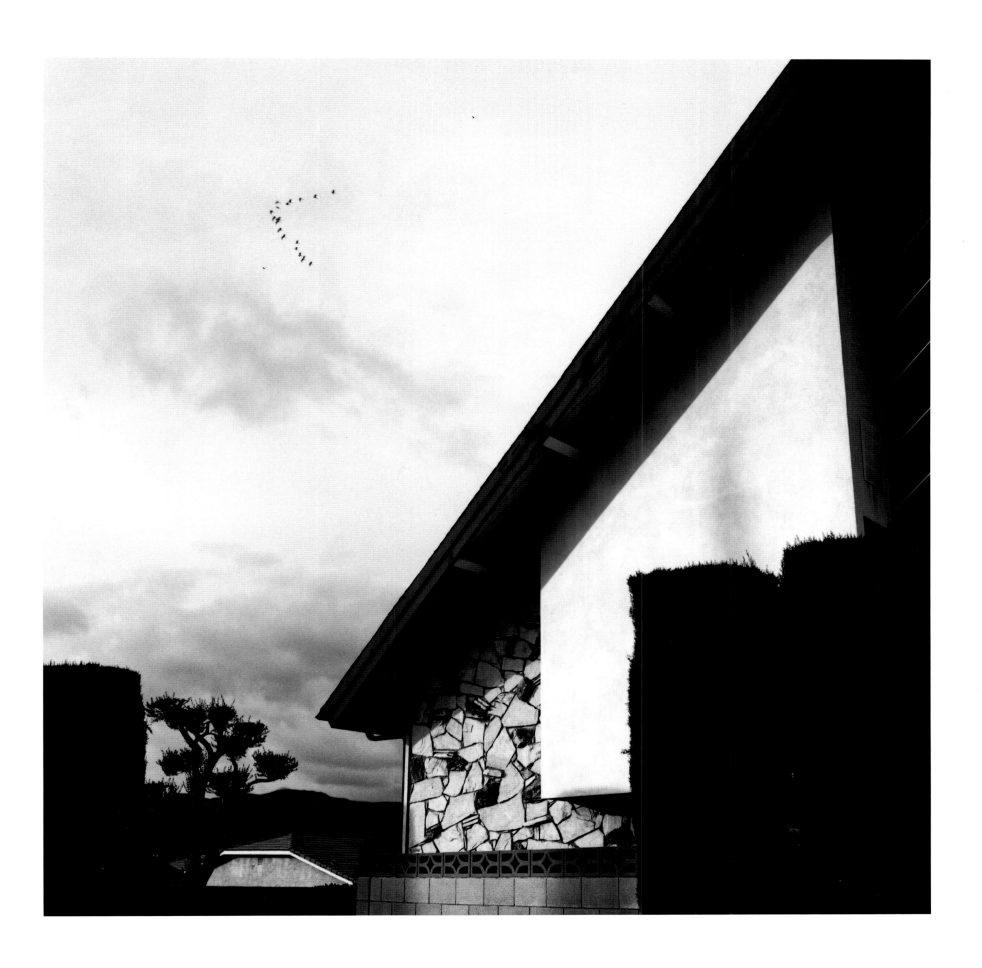

Church, Palm Desert, California, 1996

Stick-Horse Race, Coeur D'Alene, Idaho, 1995

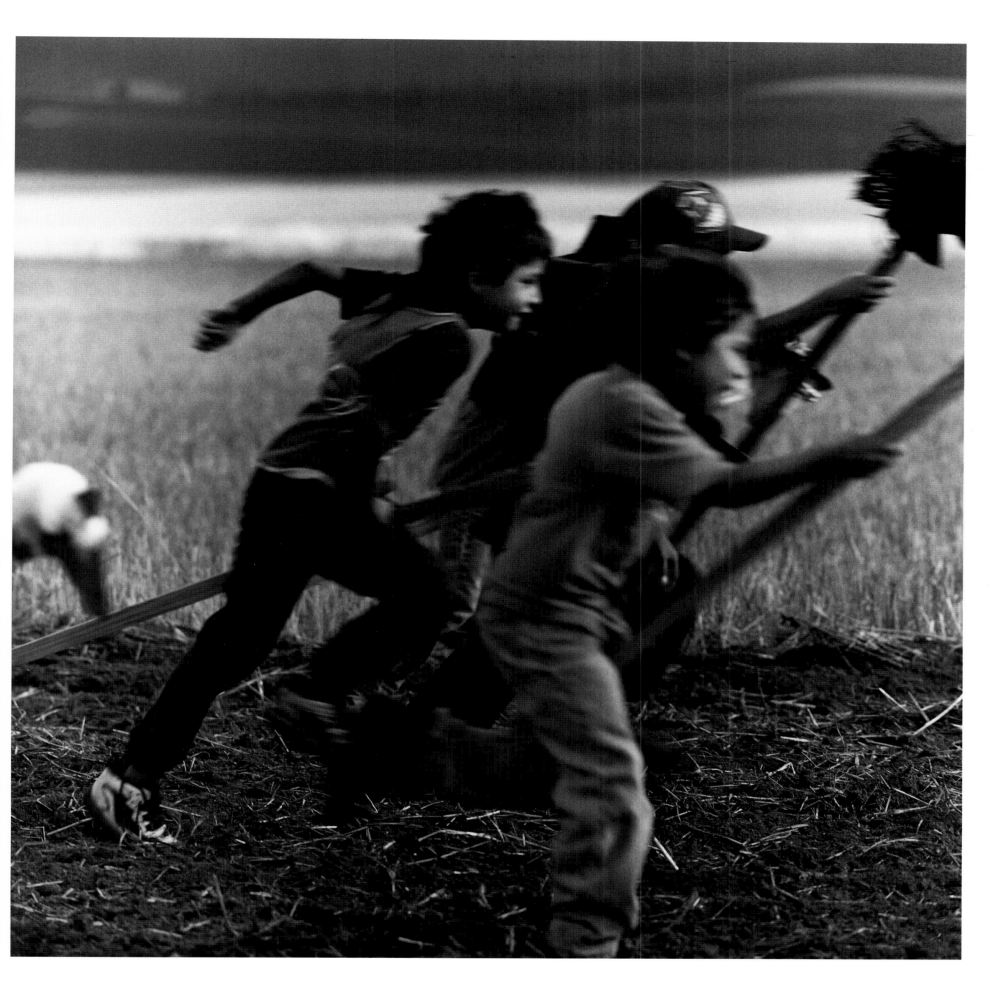

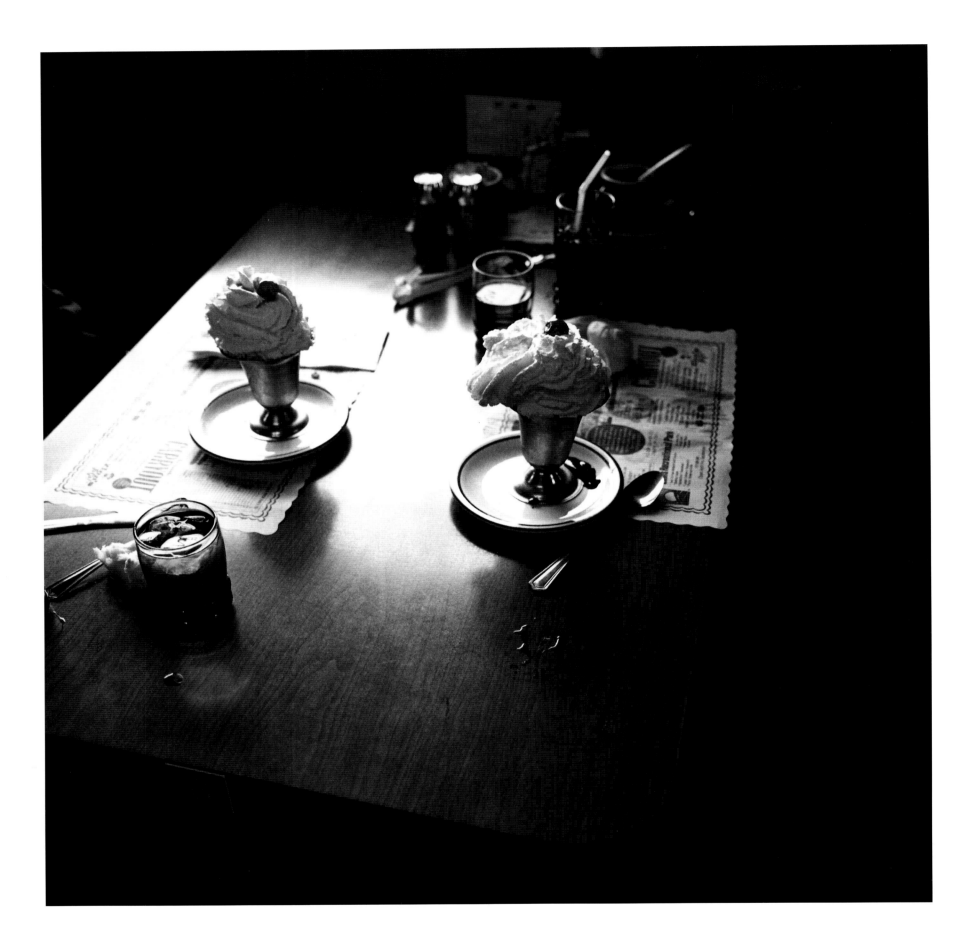

Diner, Lancaster, Pennsylvania, 1998

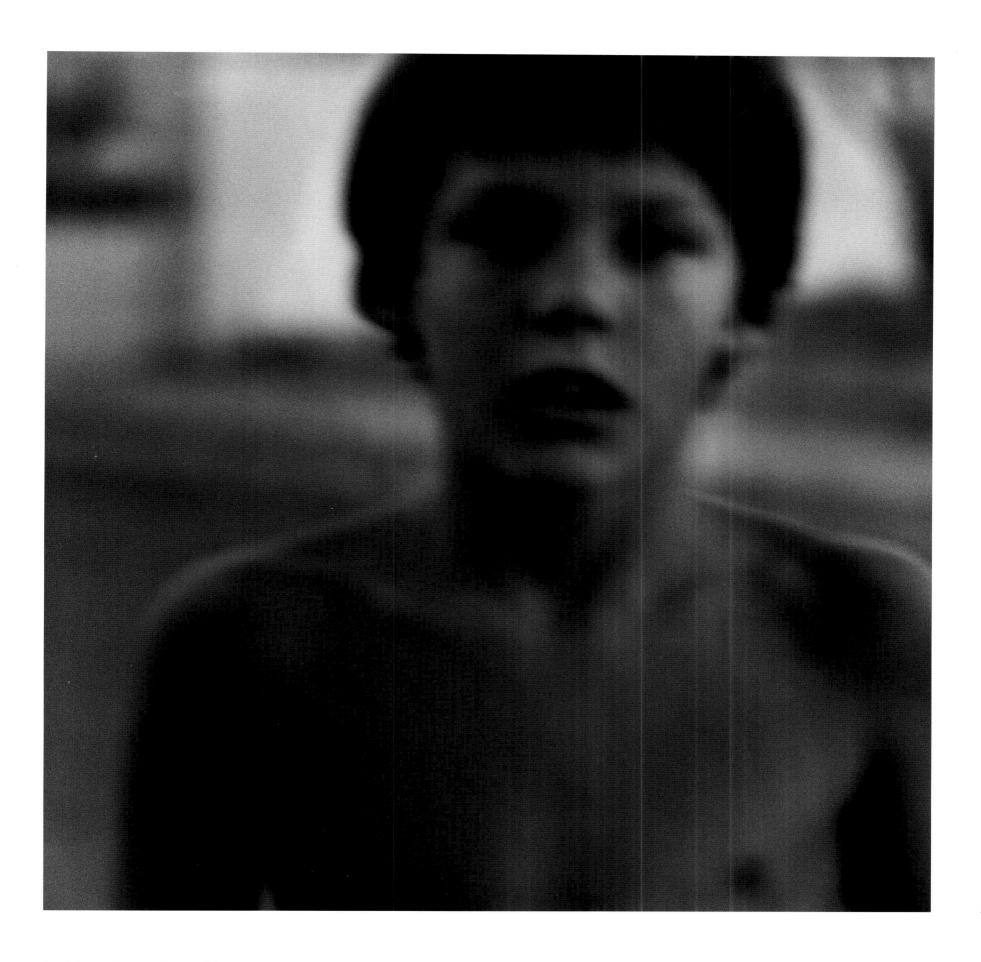

Boy's Torso, Soap Lake, Washington, 1994

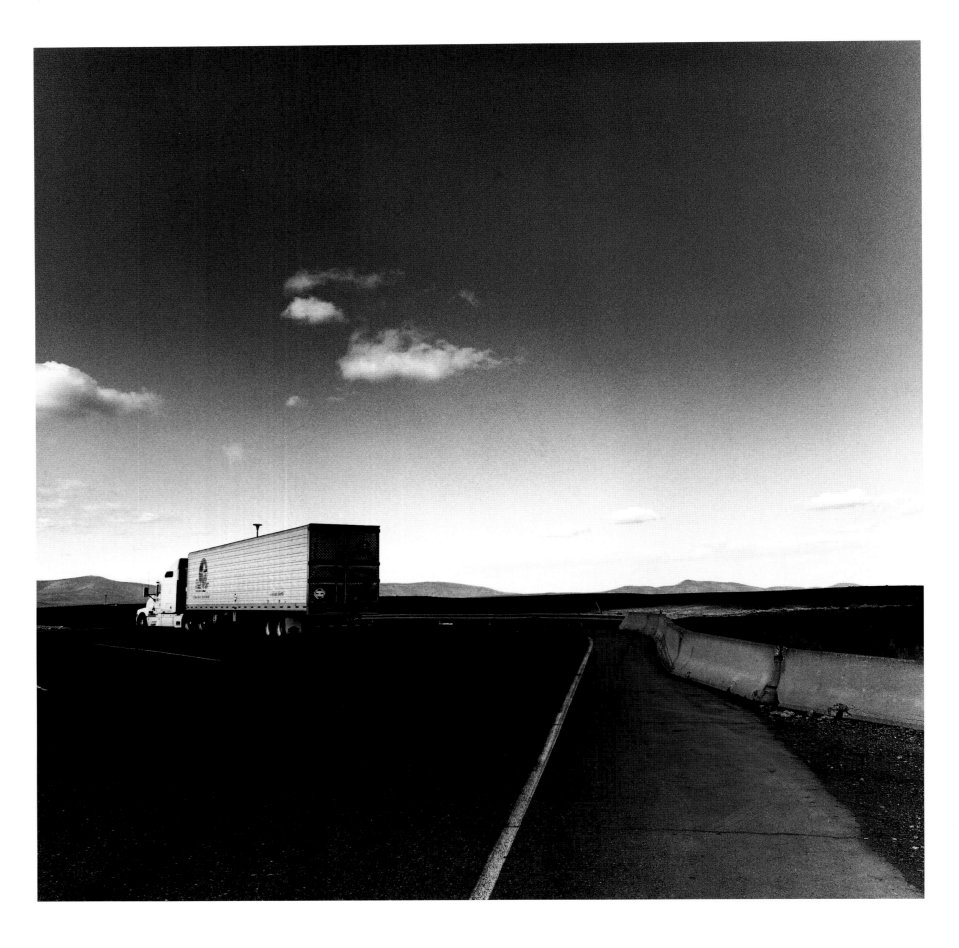

Truck Rest Area, Vantage, Washington, 1998

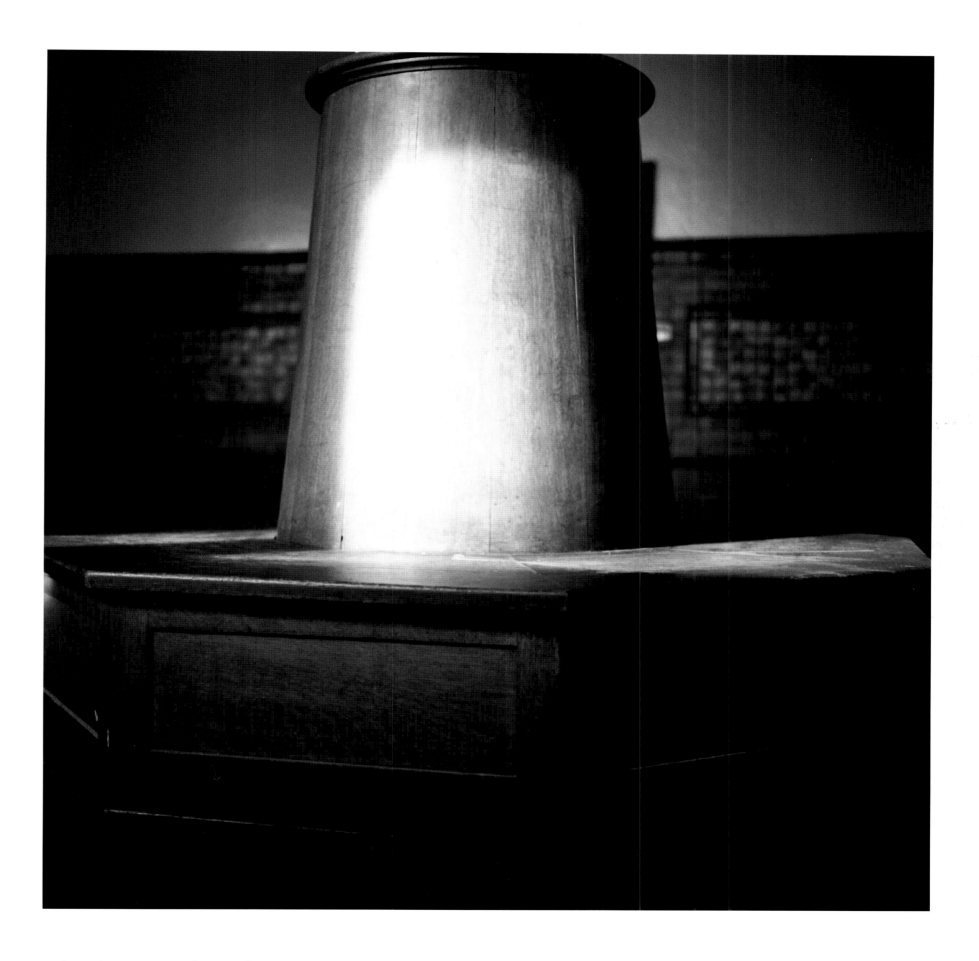

Train Station, San Bernardino, California, 1996

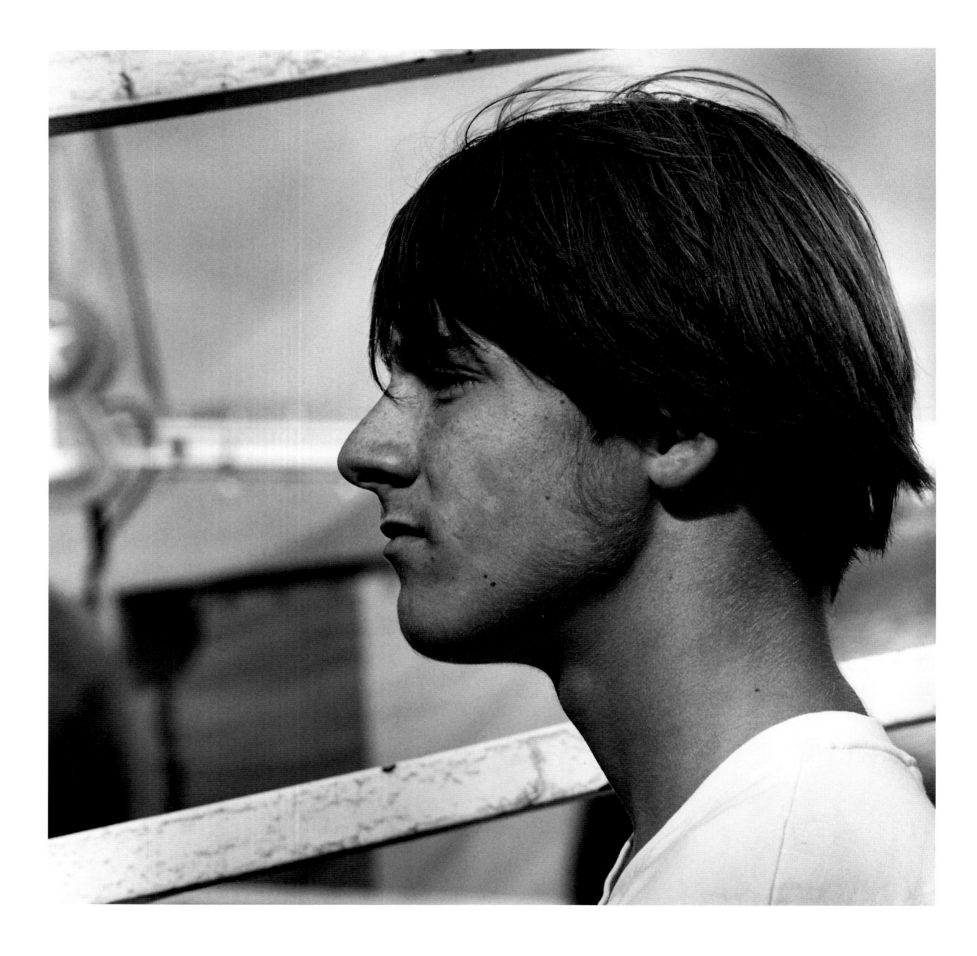

Profile of Boy, Waterville, Washington, 1995

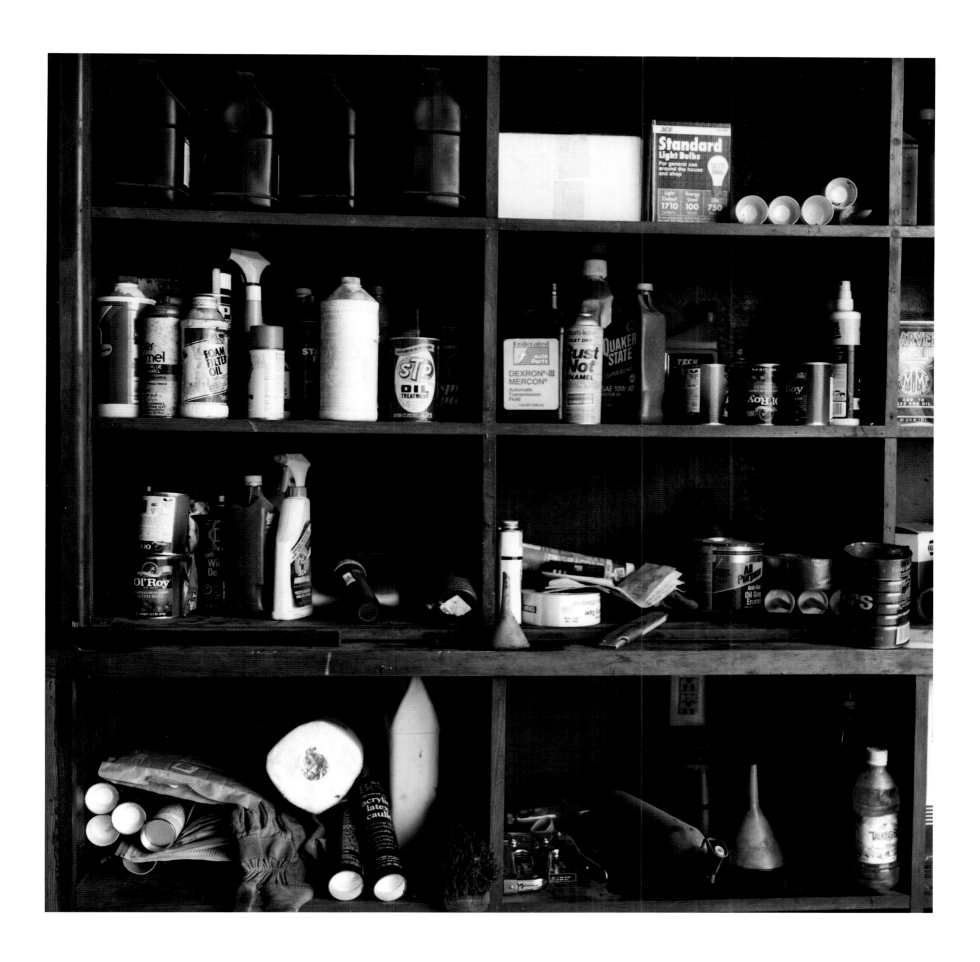

Workshop, Wilbur, Washington, 1998

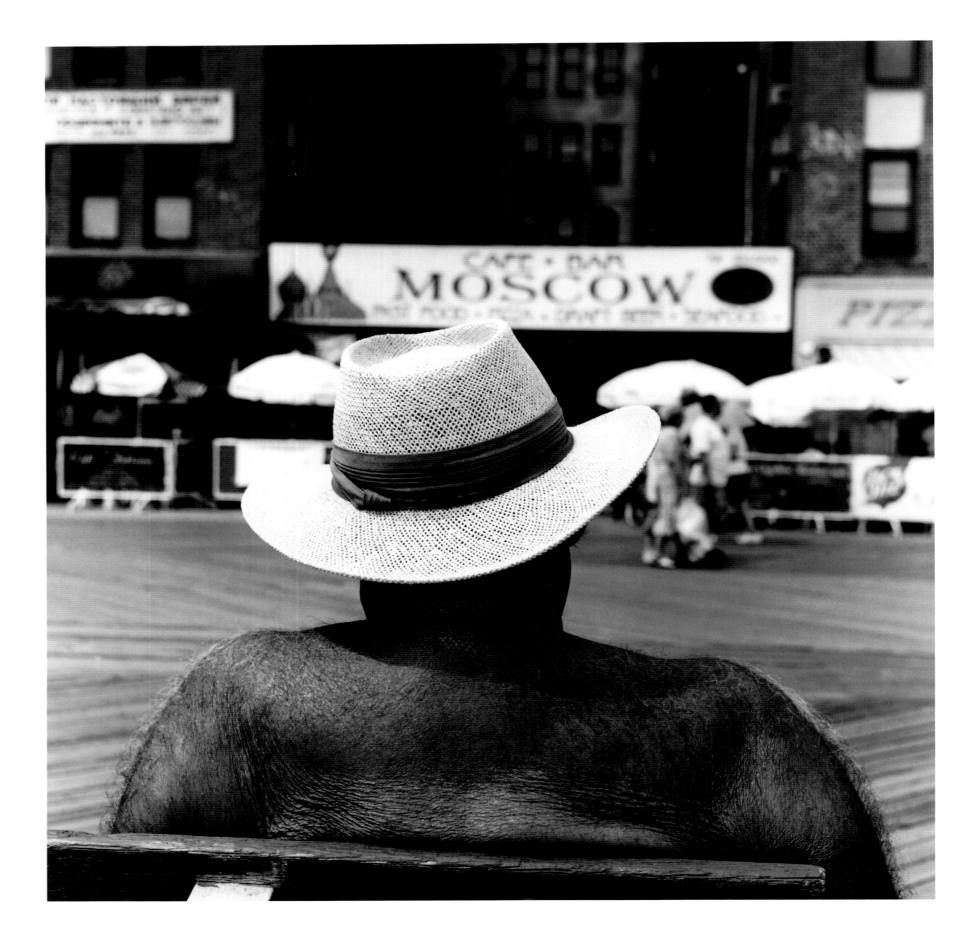

Boardwalk, Brighton Beach, New York, 1998

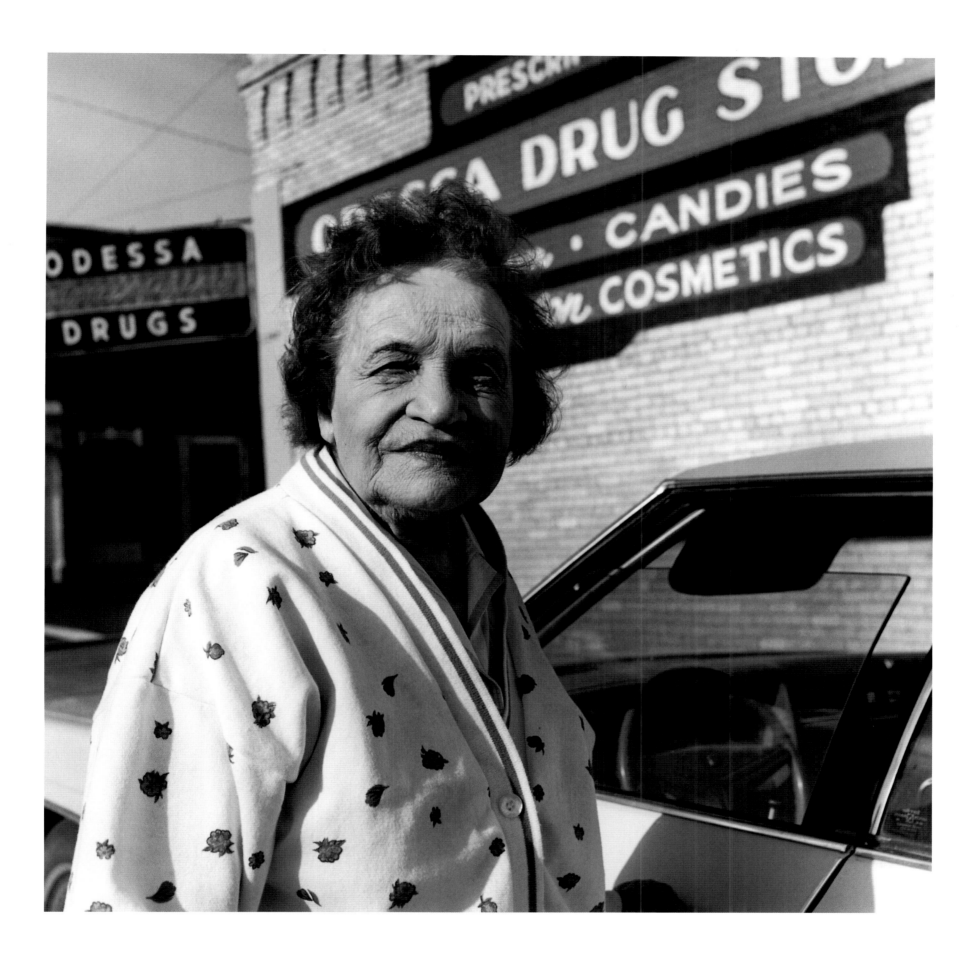

Woman outside Drug Store, Odessa, Washington, 1994

Bowery Storefront, New York, 1997

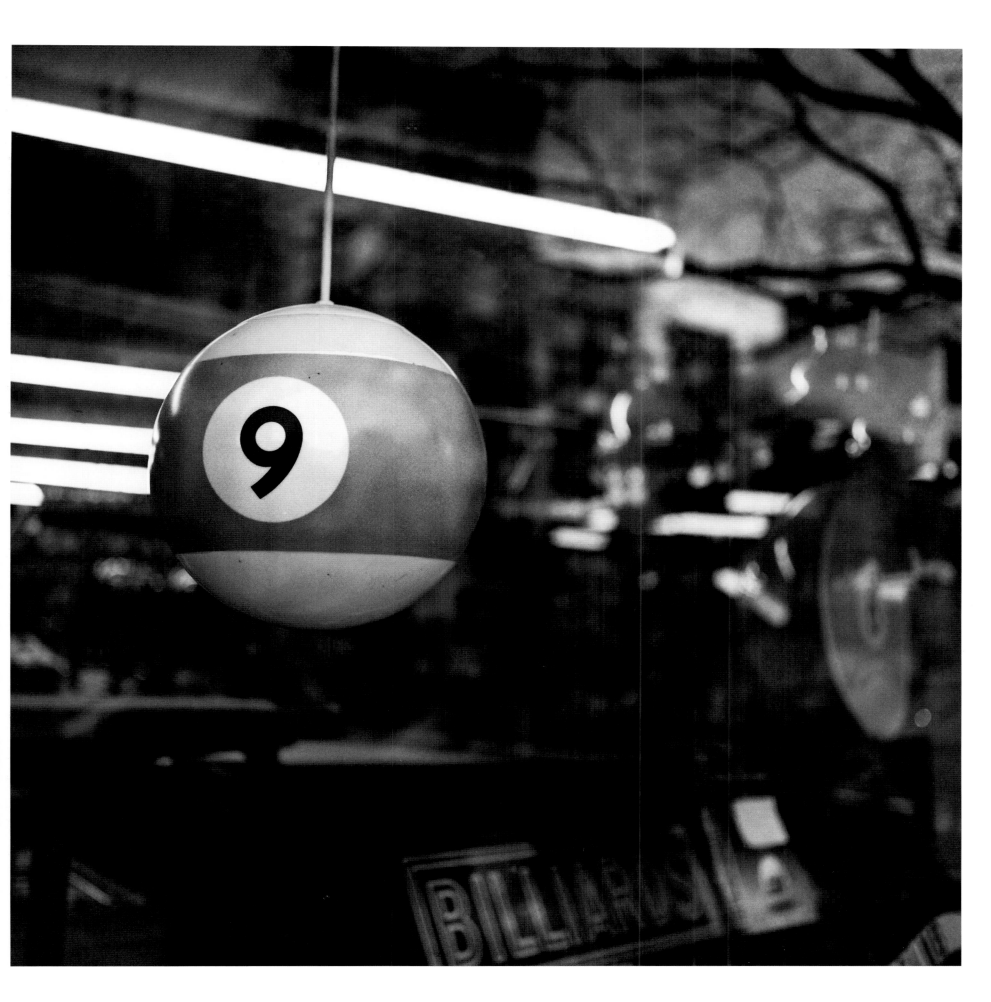

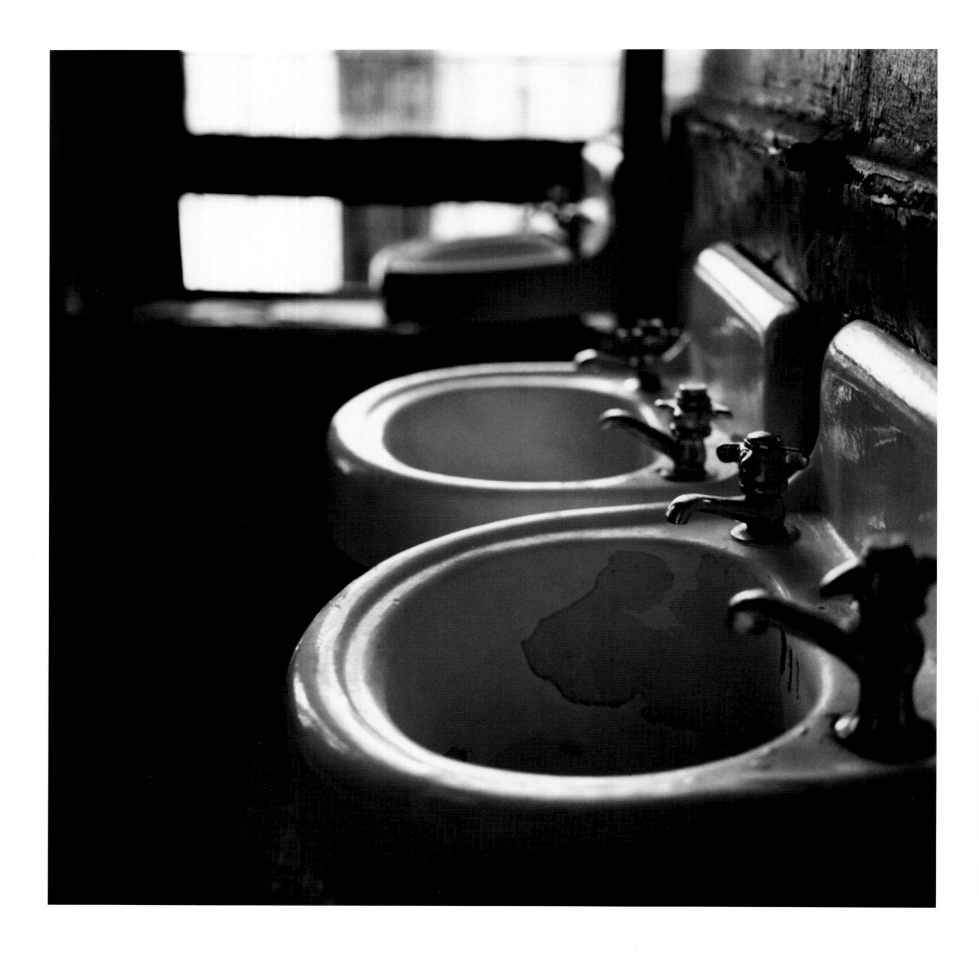

Transient Hotel Bathroom, New York, 1997

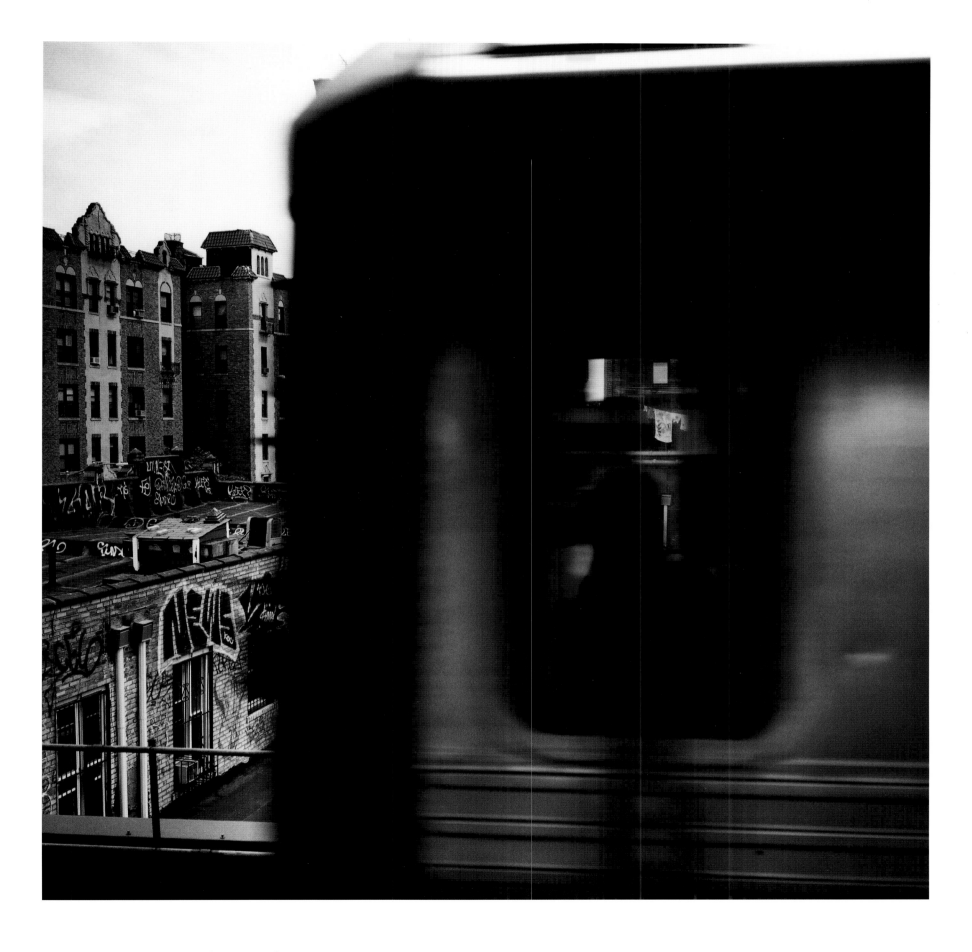

Subway Train, Brighton Beach, New York, 1998

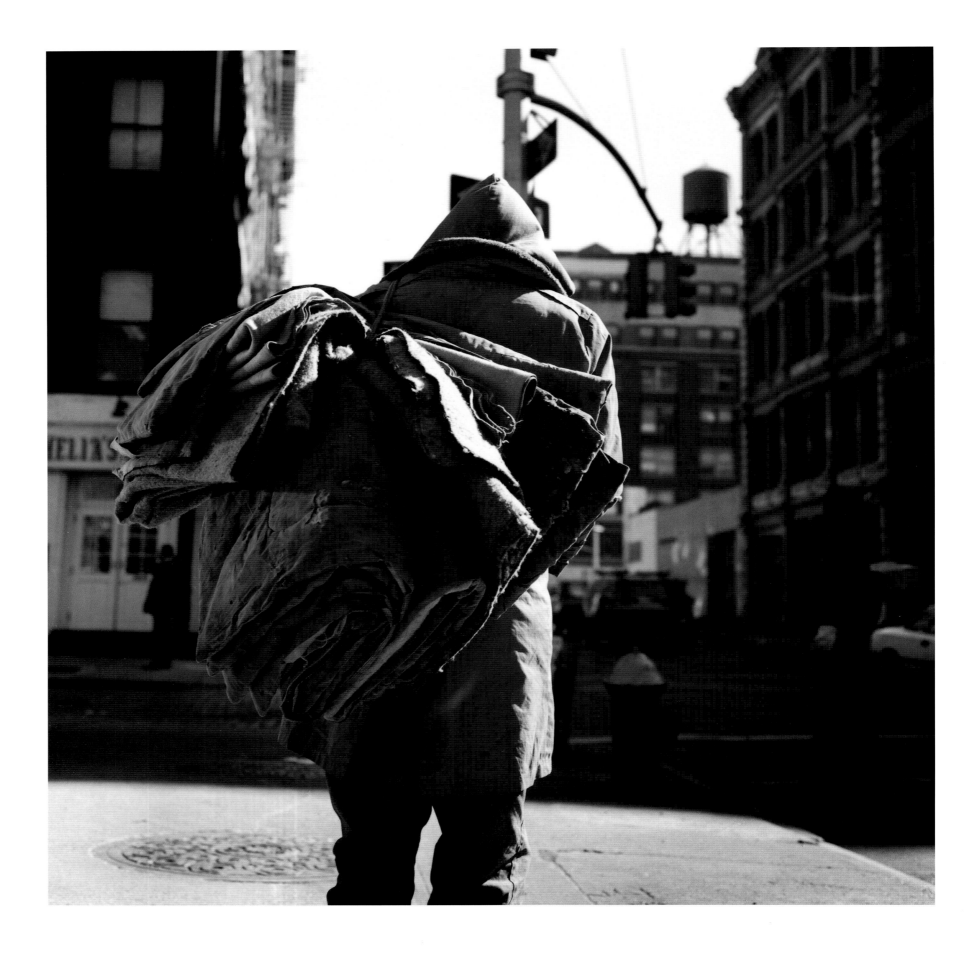

Homeless Man, Lower Manhattan, New York, 1997

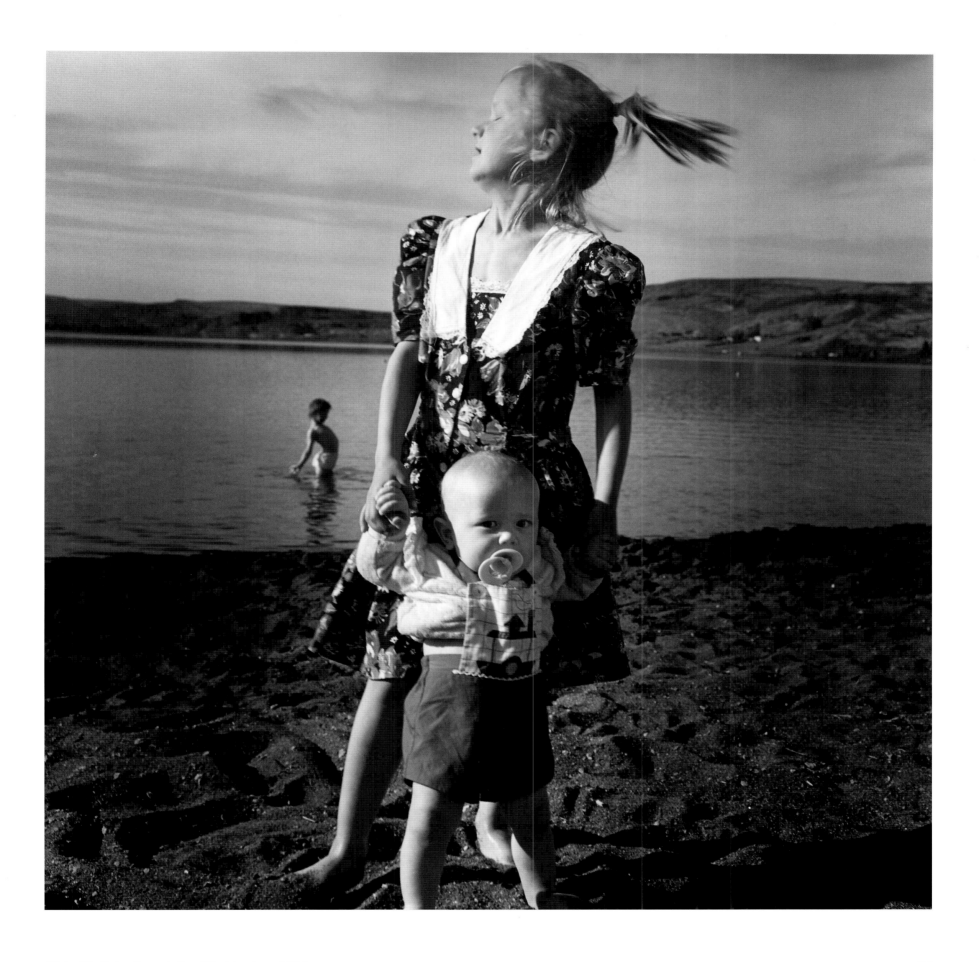

Girl with Baby, Soap Lake, Washington, 1994

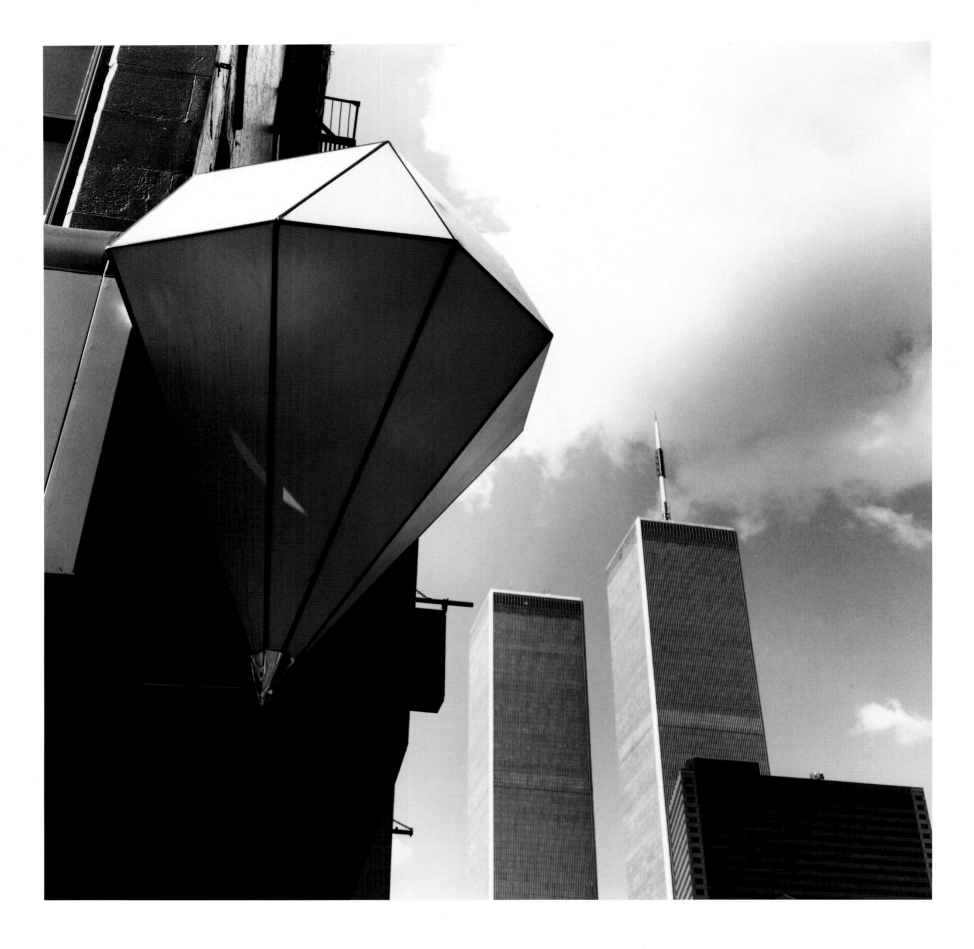

Twin Towers, New York, 1998

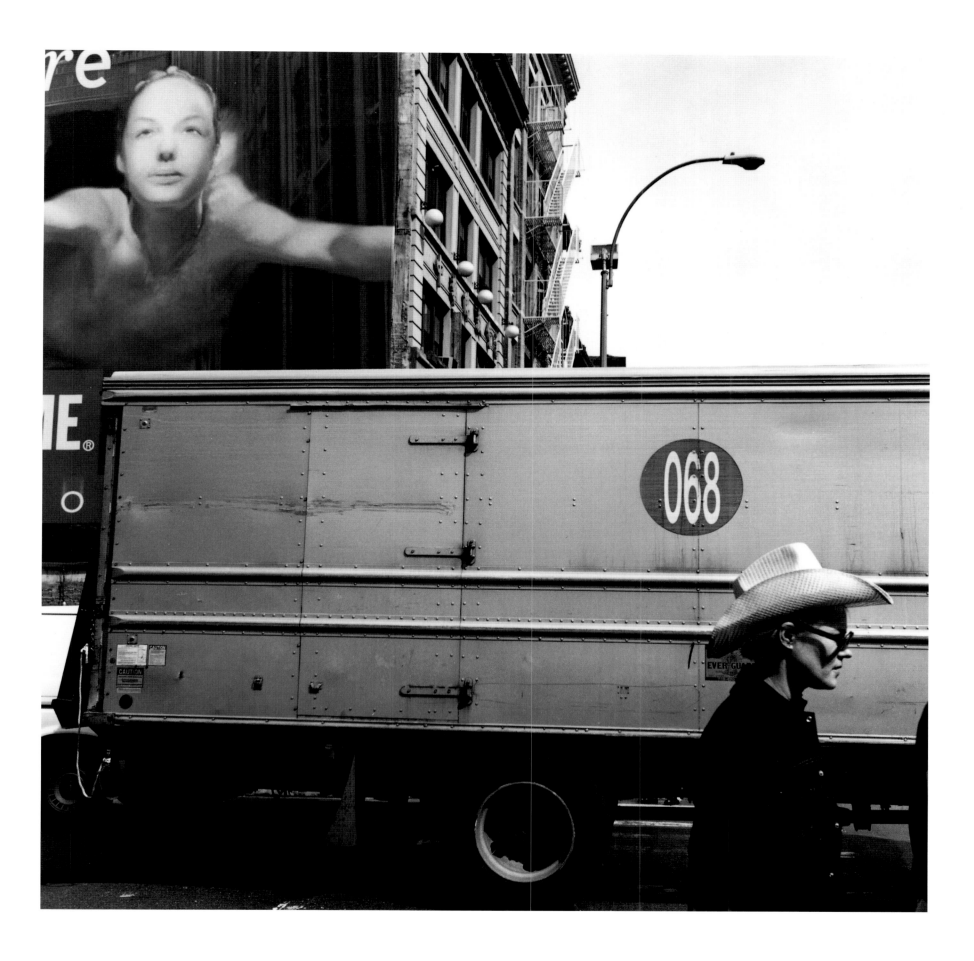

Canal Street, New York, 1998

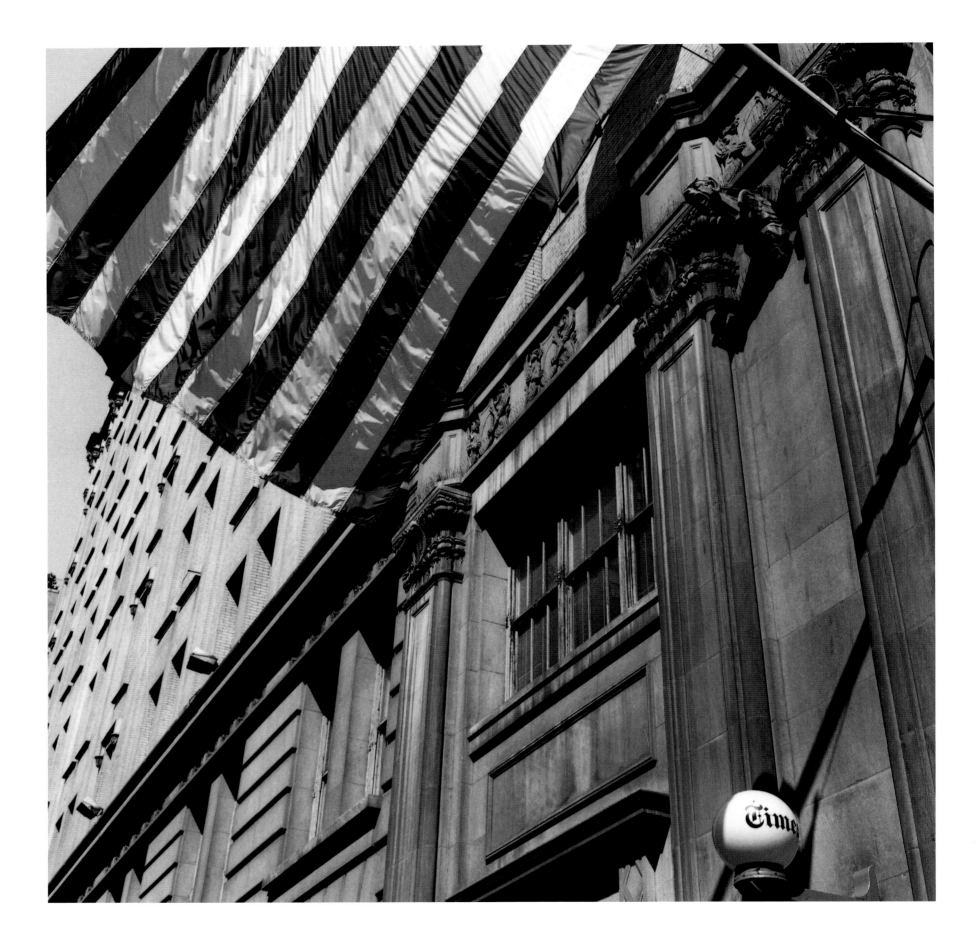

West 43rd Street, New York, 1998

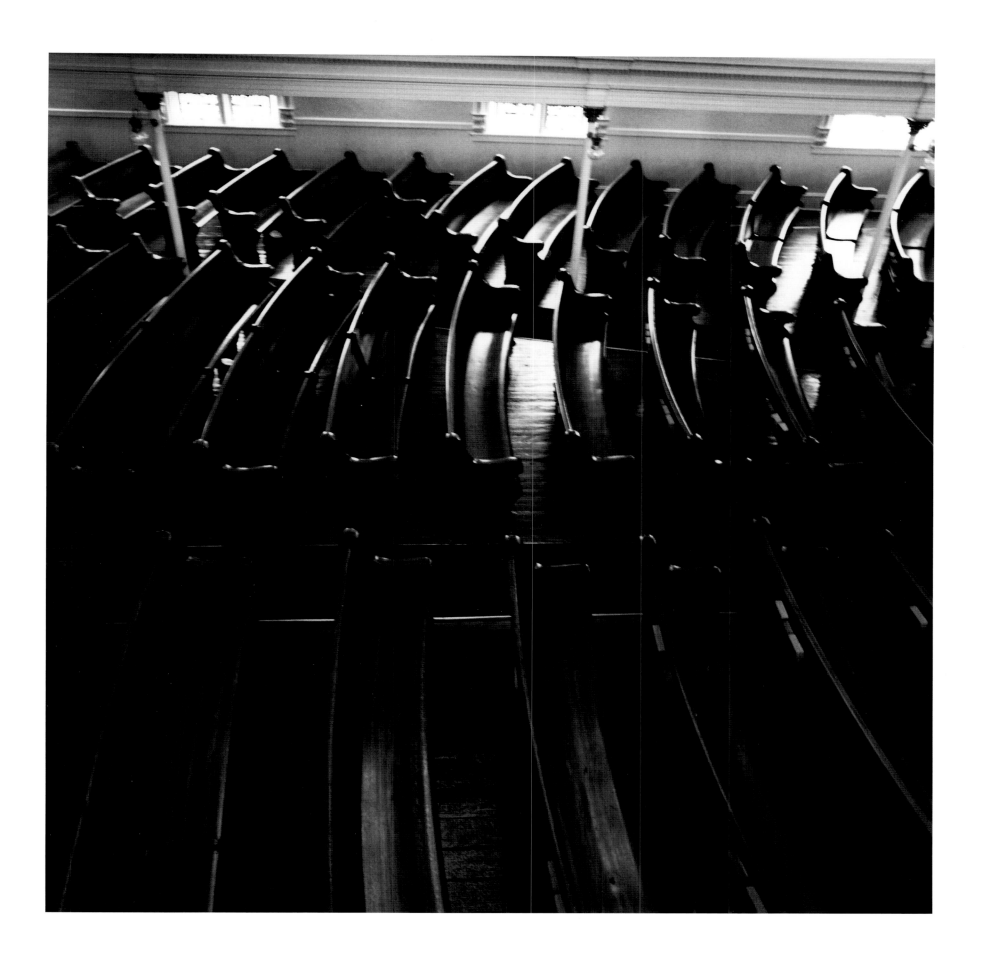

Baptist Church, Savannah, Georgia, 1998

Pow-Wow, Omak, Washington, 1995

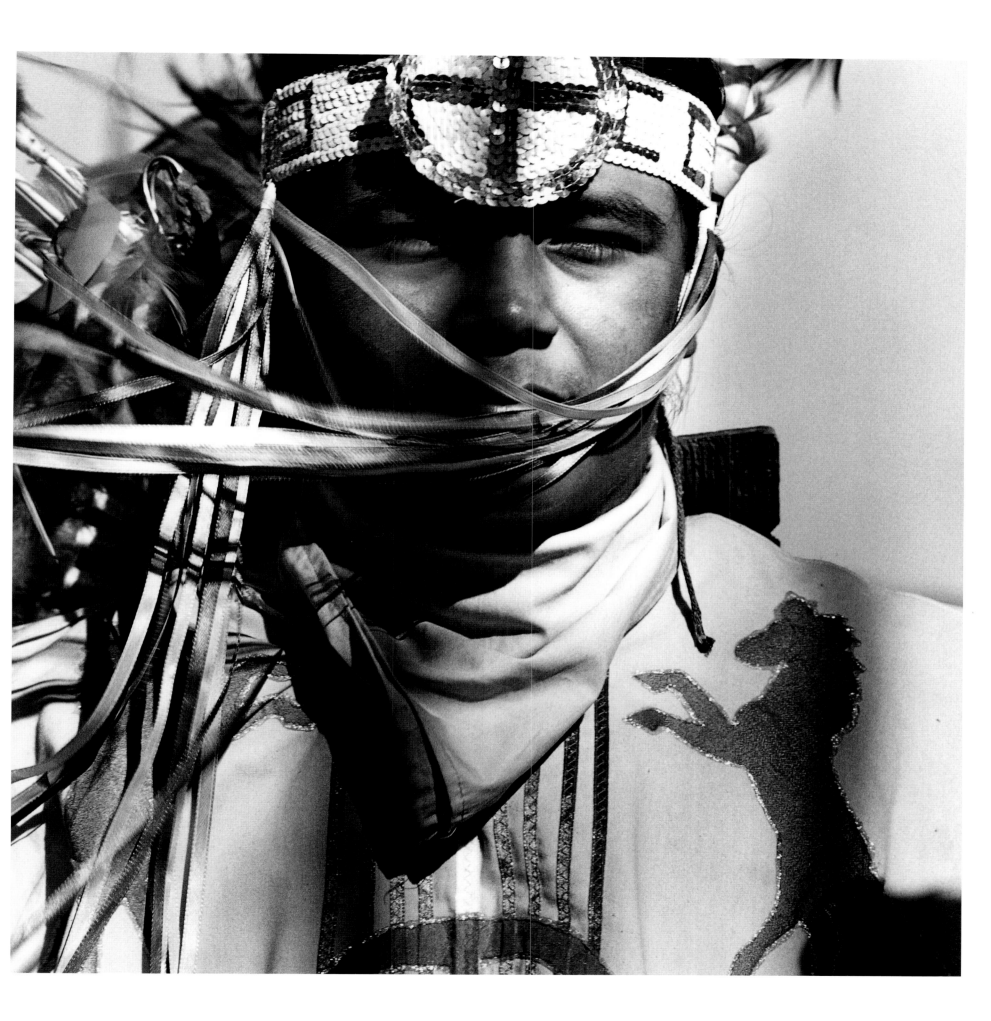

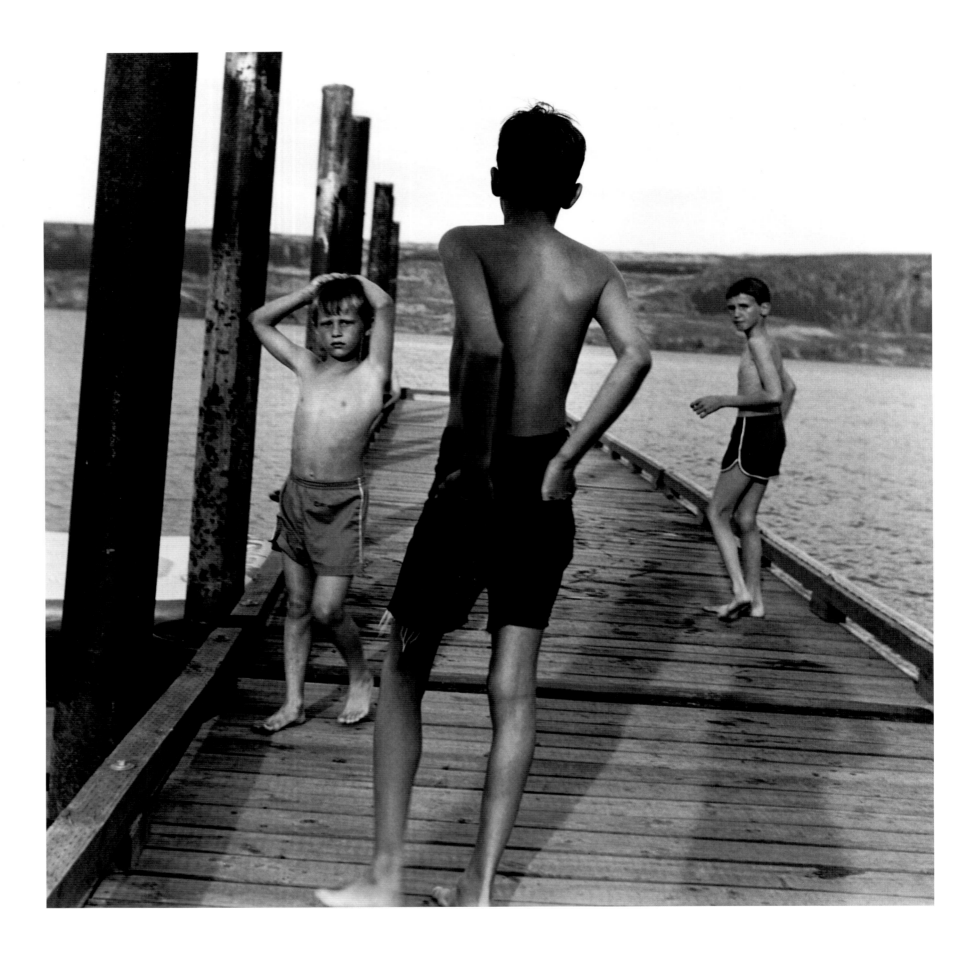

Boys on Dock, Long Lake, Washington, 1996

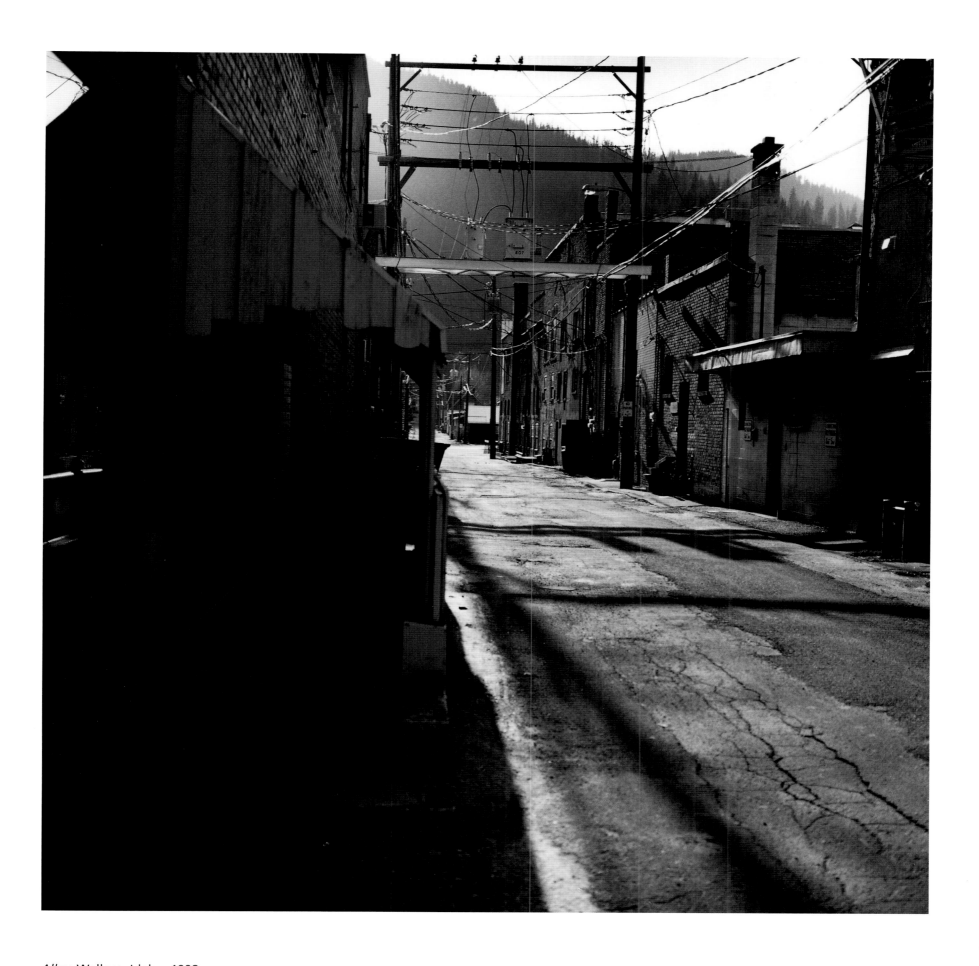

Alley, Wallace, Idaho, 1998

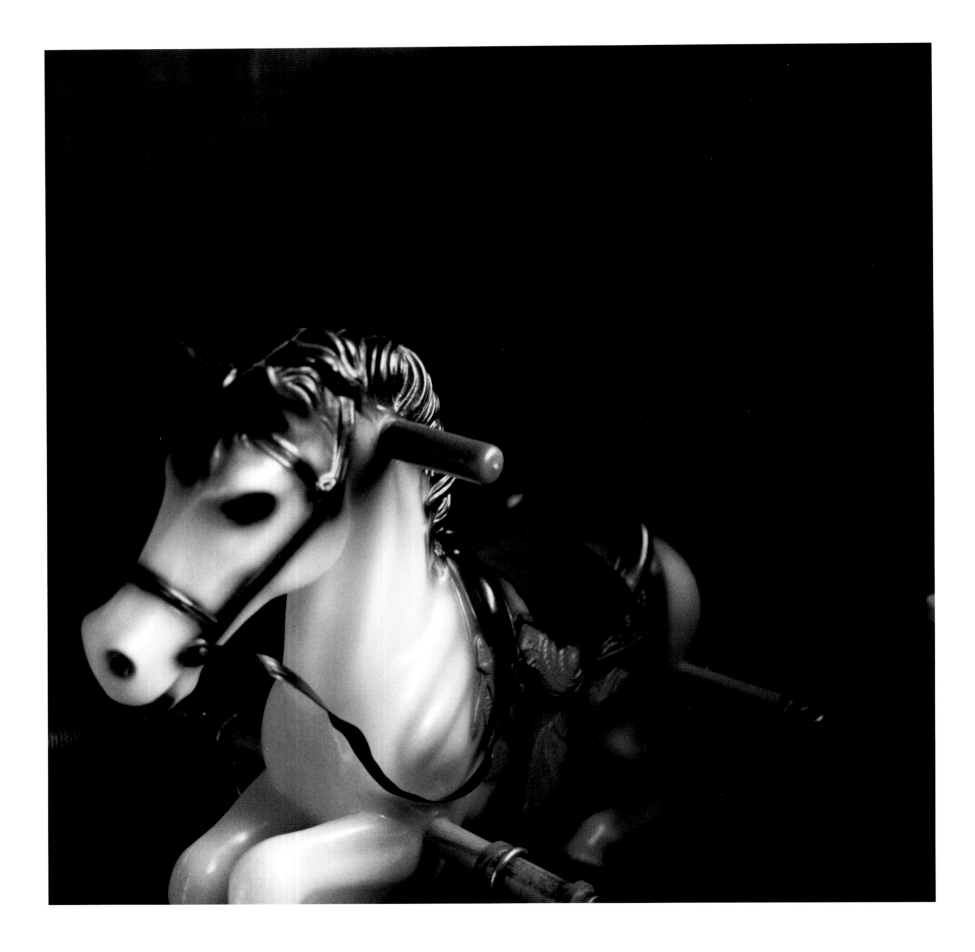

Toy Horse, Odessa, Washington, 1997

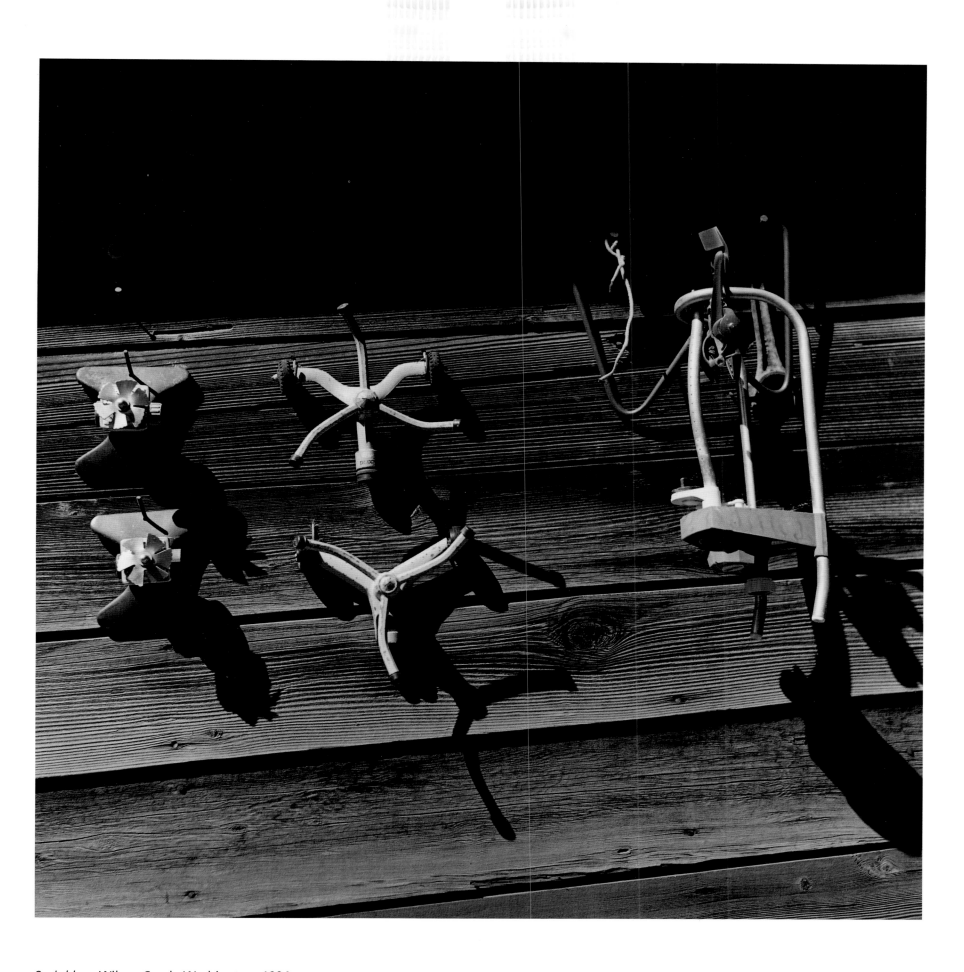

Sprinklers, Wilson Creek, Washington, 1994

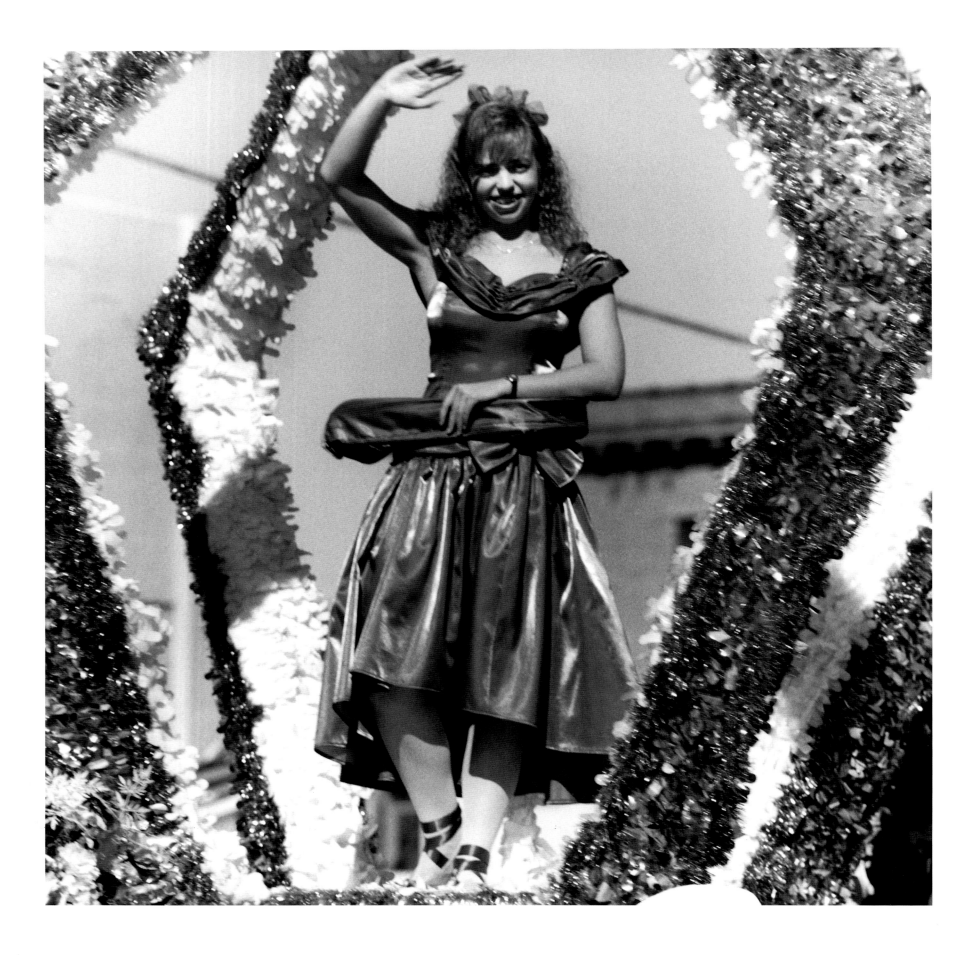

Parade Float, Harrington, Washington, 1996

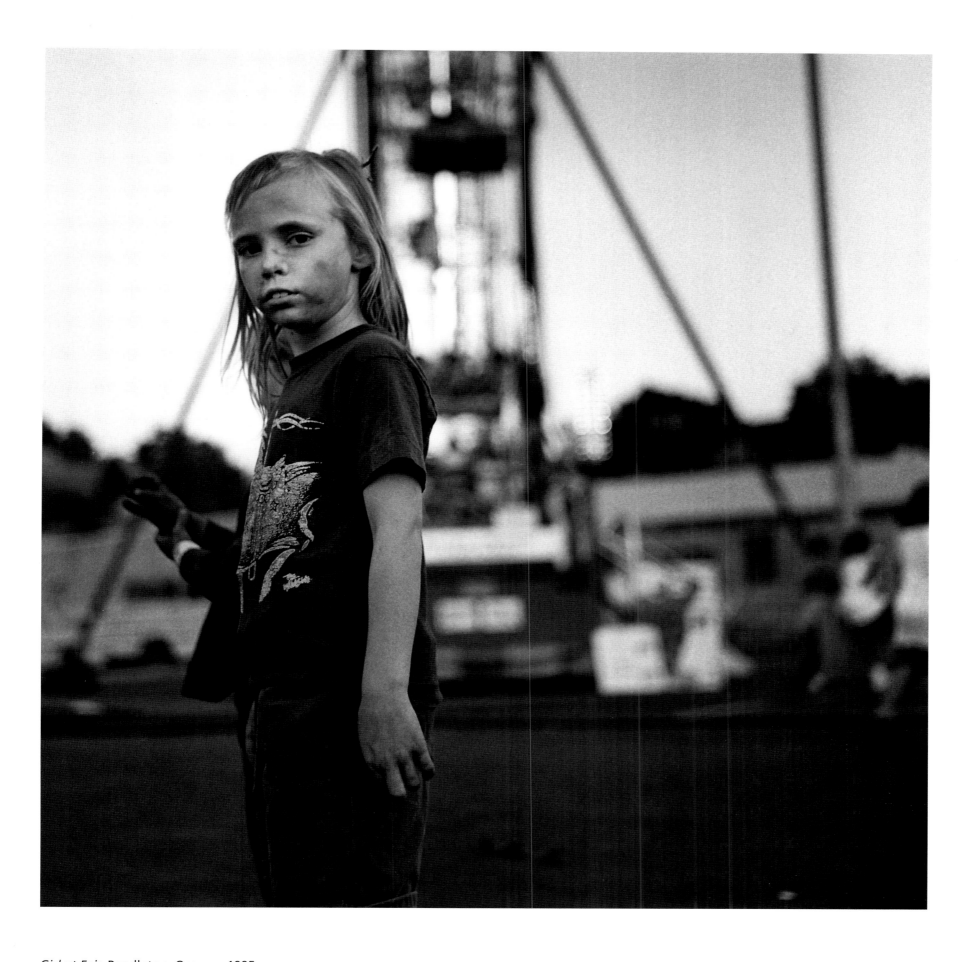

Girl at Fair, Pendleton, Oregon, 1995

Rodeo Contestant, Moses Lake, Washington, 1995

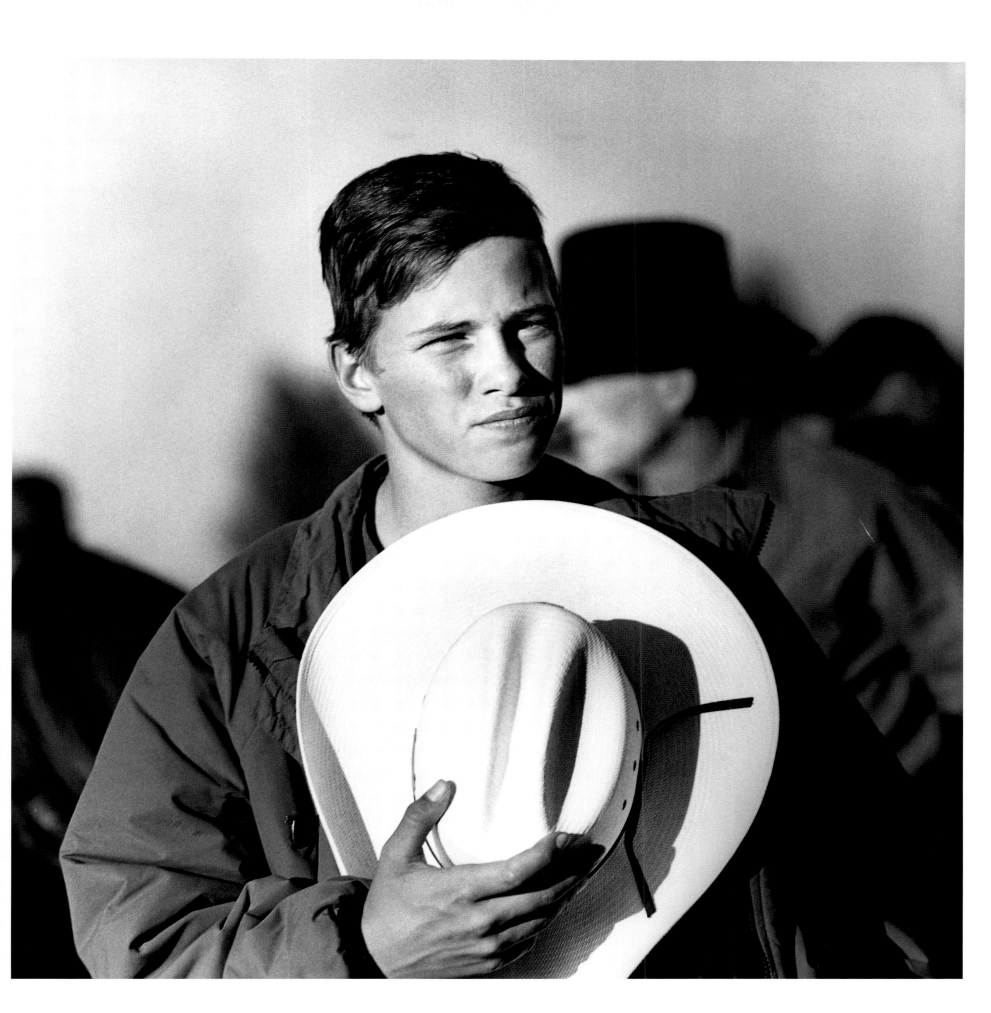

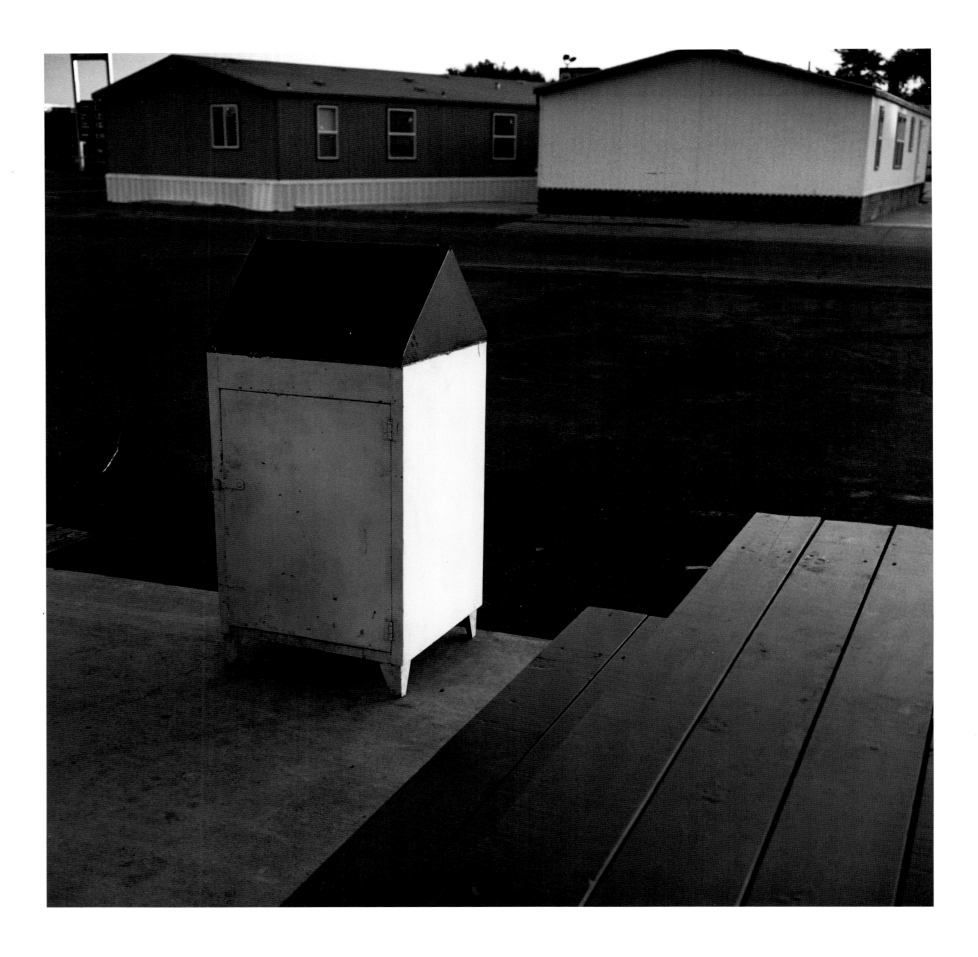

Garbage Container, Ephrata, Washington, 1998

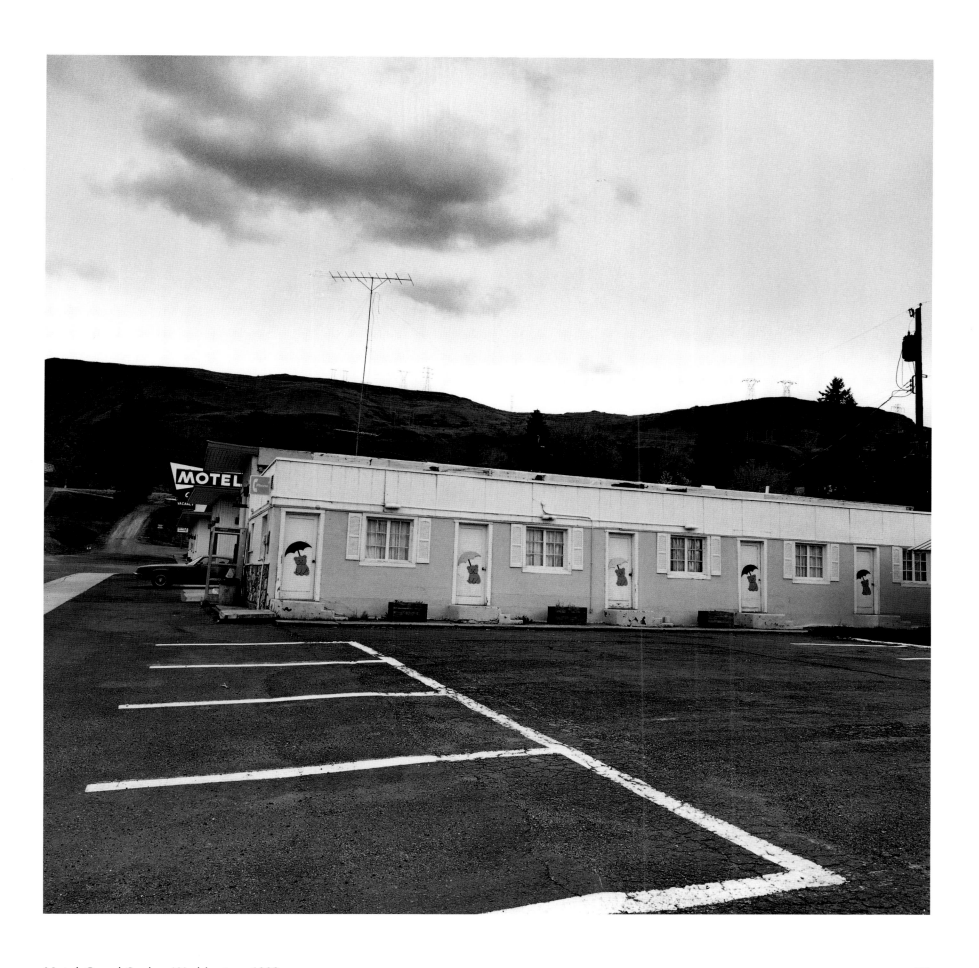

Motel, Grand Coulee, Washington, 1998

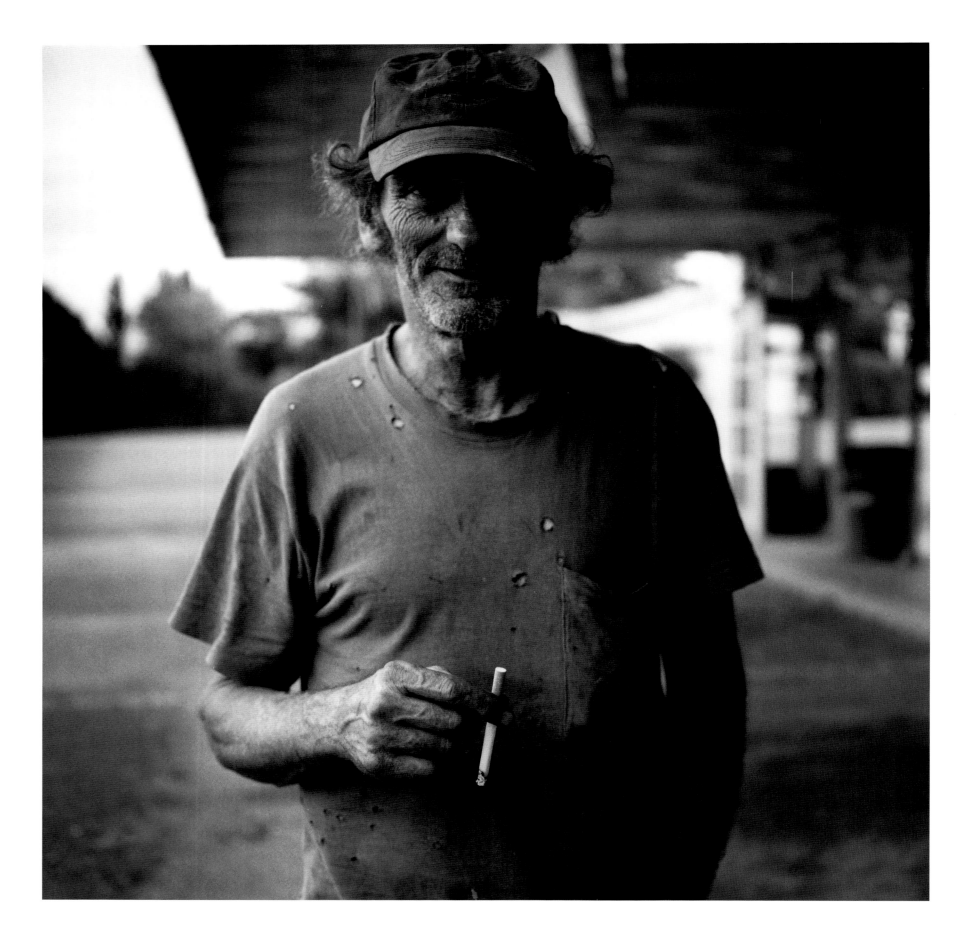

Man in Parking Lot, Soap Lake, Washington, 1997

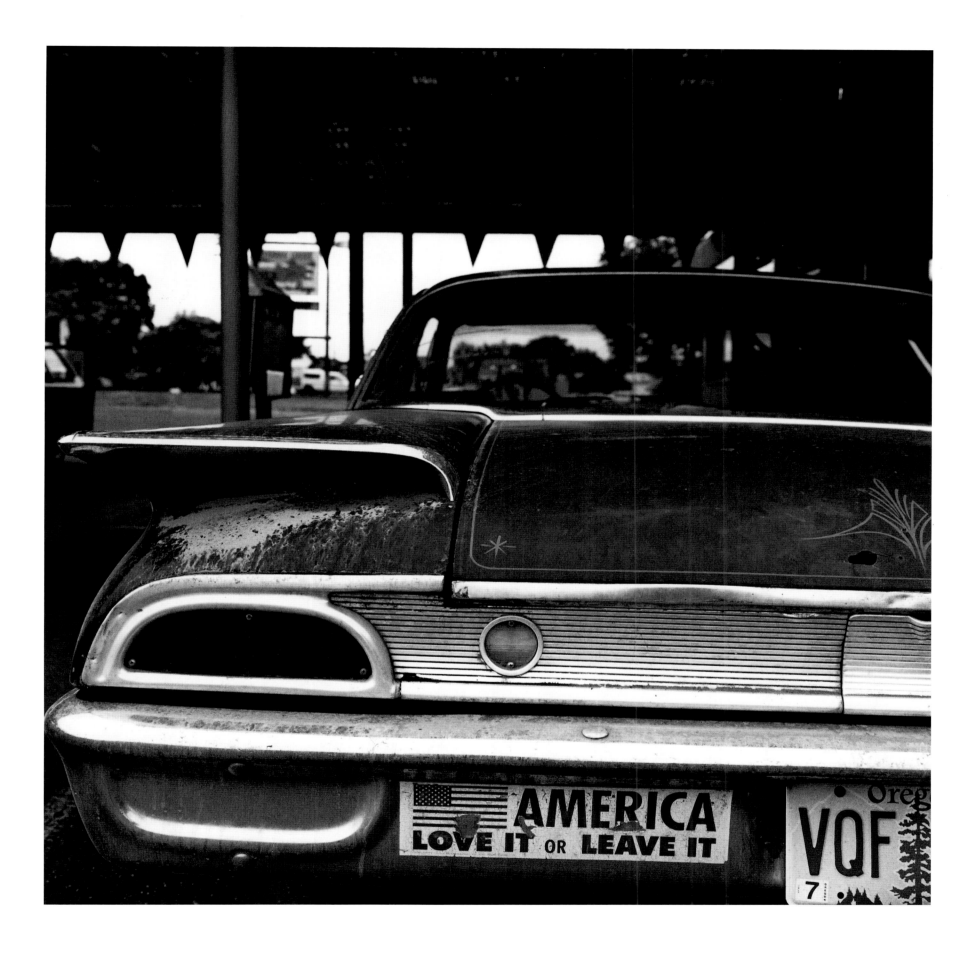

Rear Bumper, Soap Lake, Washington, 1997

Dinner Table, Whidbey Island, Washington, 1997

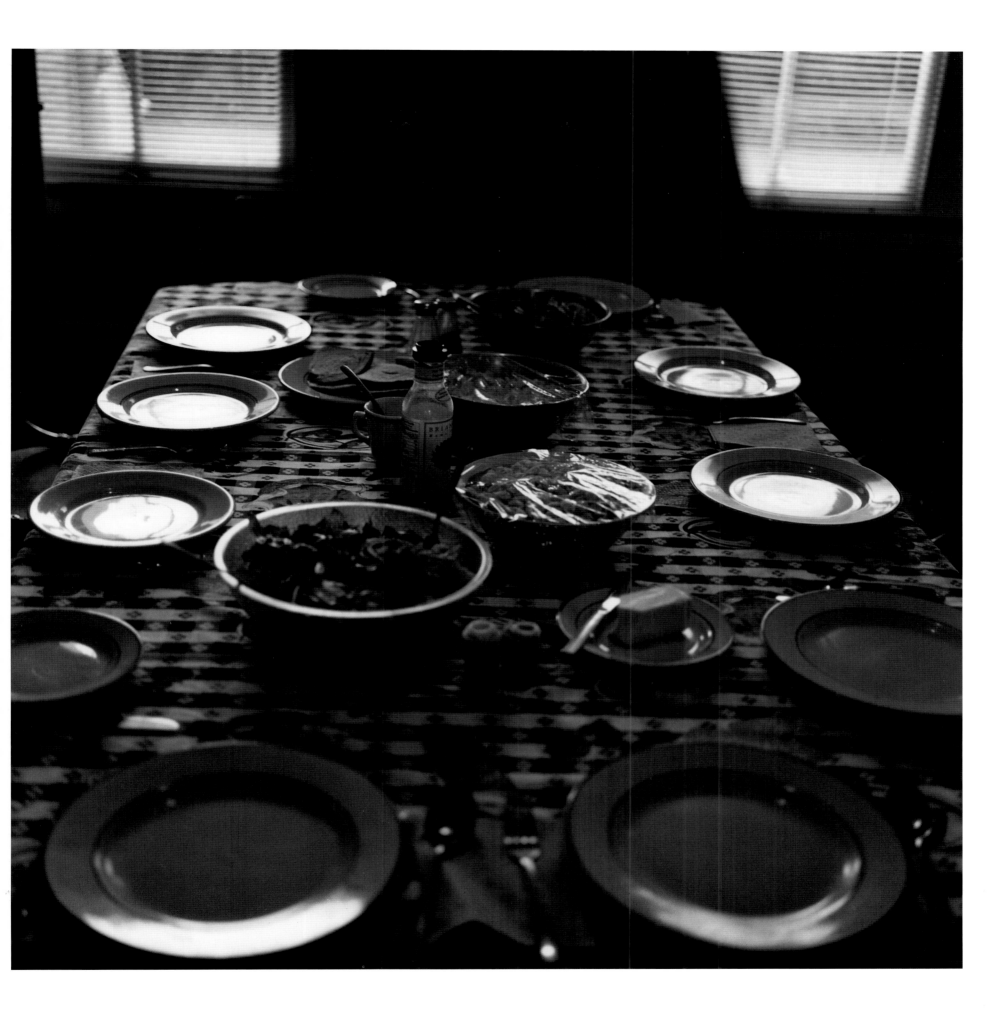

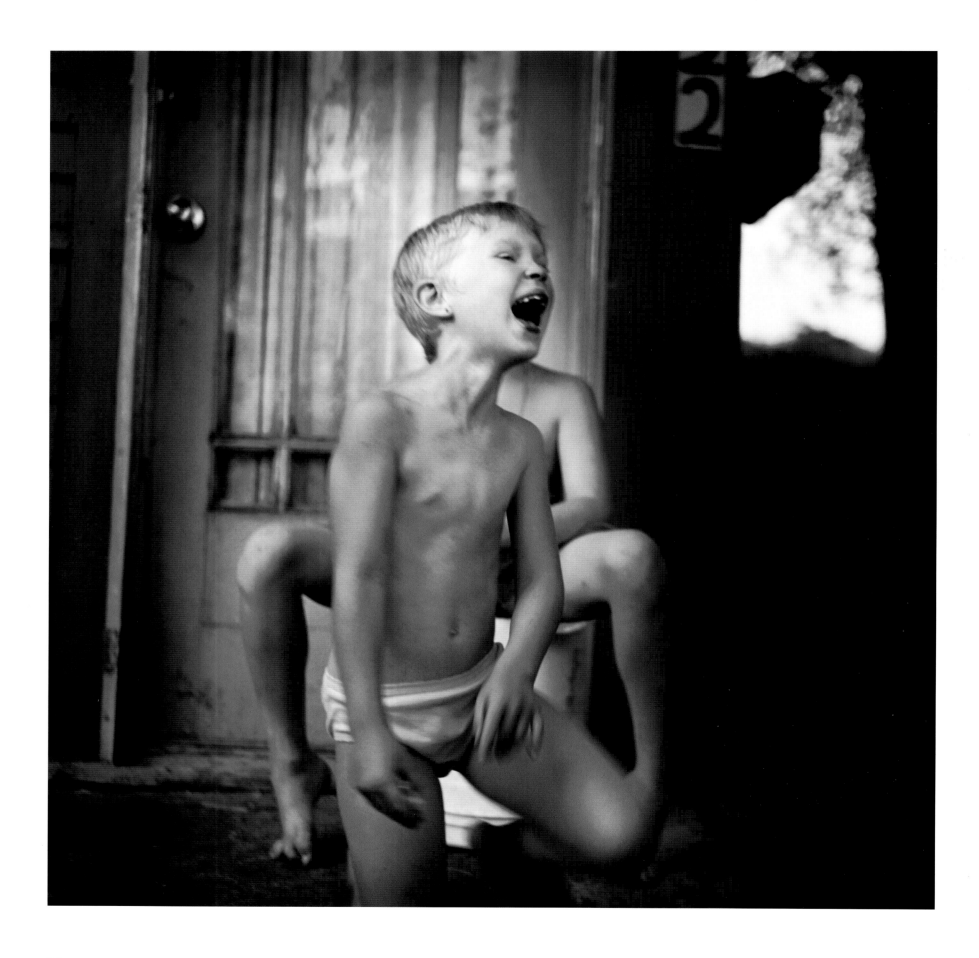

Girl Laughing, Soap Lake, Washington, 1994

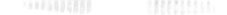

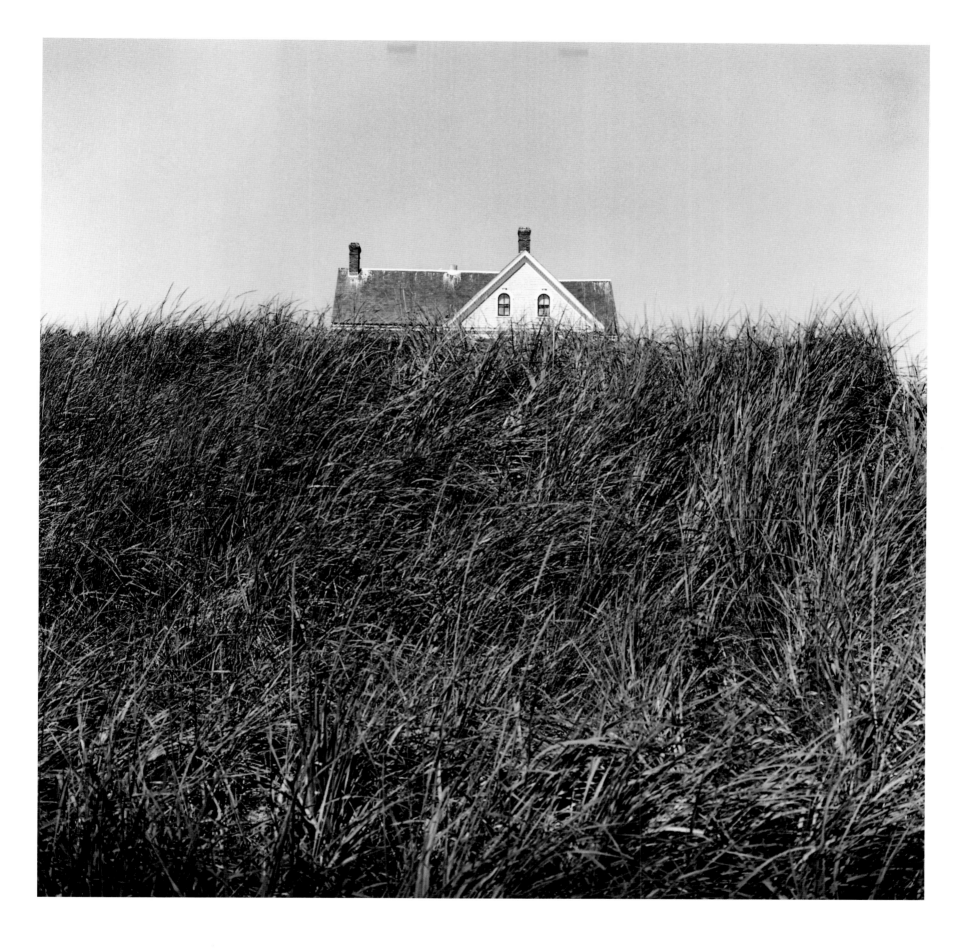

Bluff, Whidbey Island, Washington, 1997

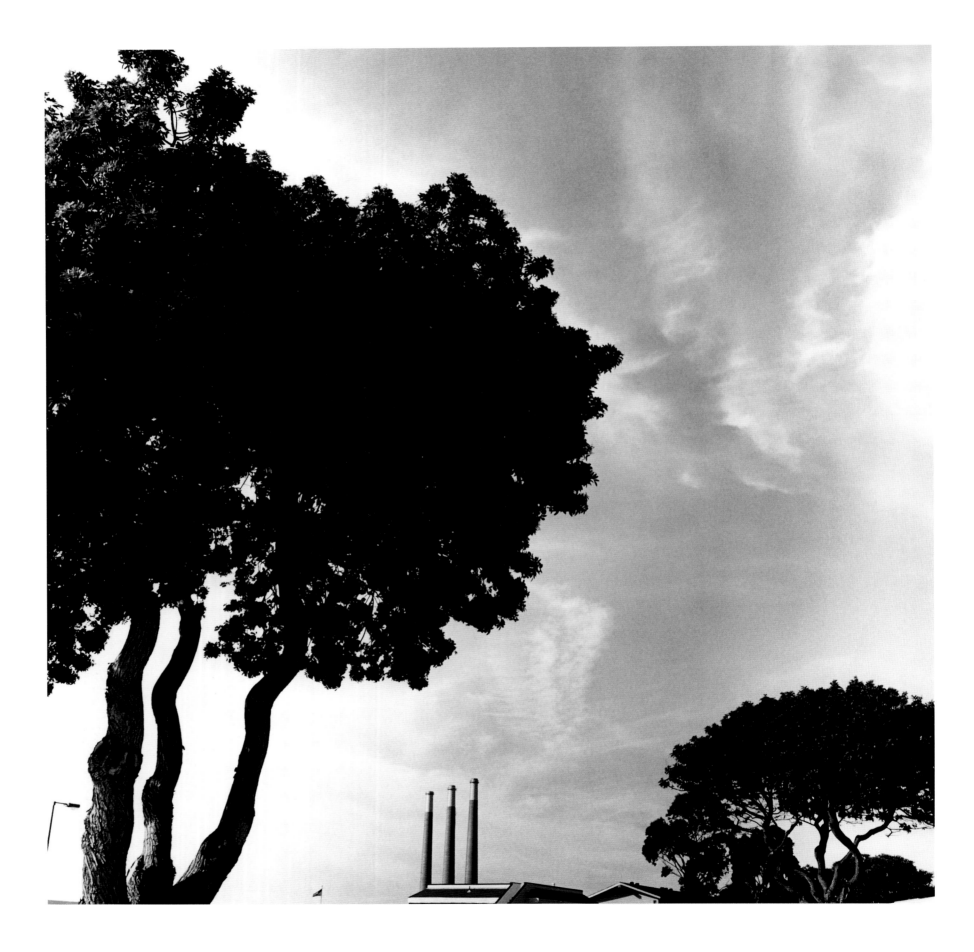

Trees and Towers, Morro Bay, California, 1996

Puzzle, Palacios Hotel, Texas, 1996

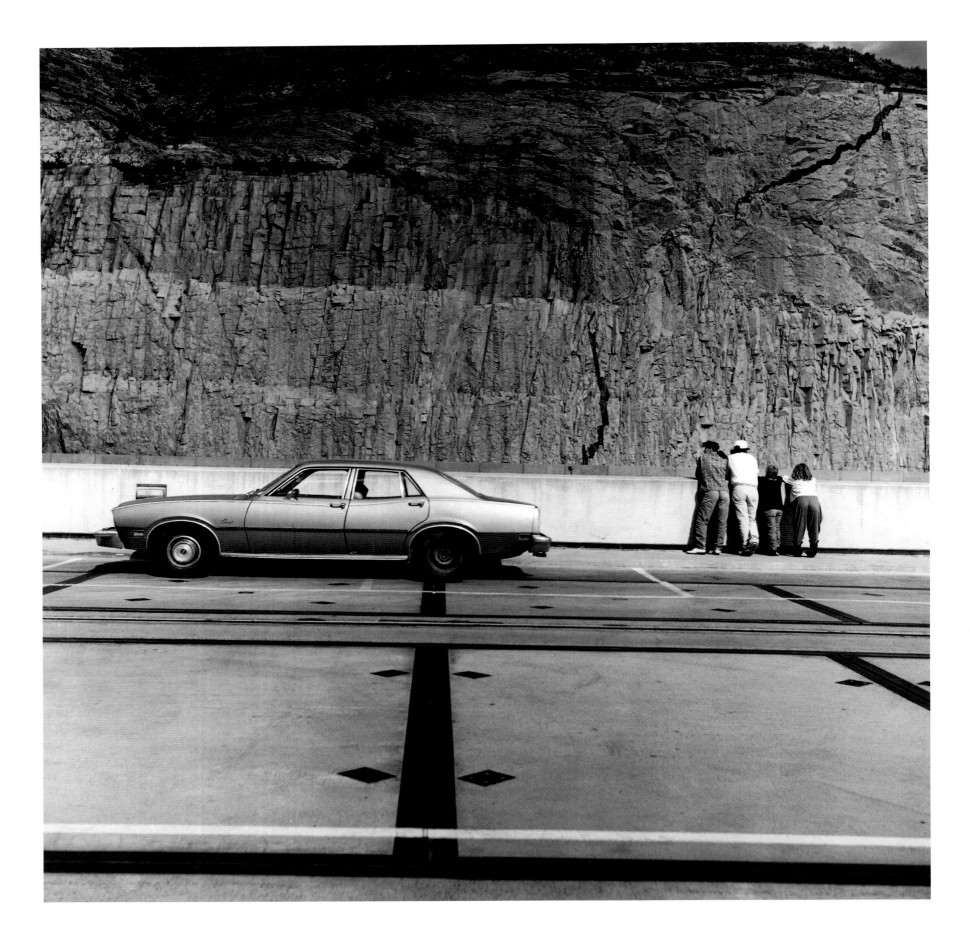

Family, Grand Coulee Dam, Washington, 1994

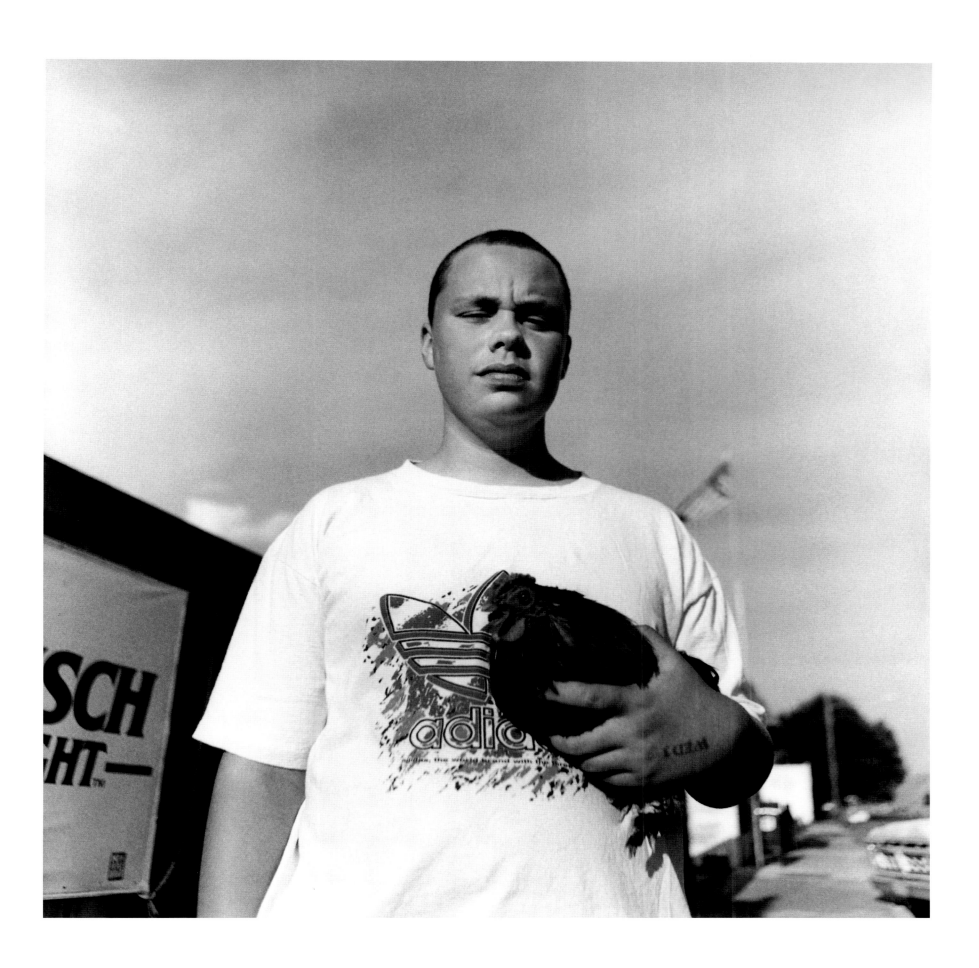

Boy with Chicken, Wilson Creek, Washington, 1995

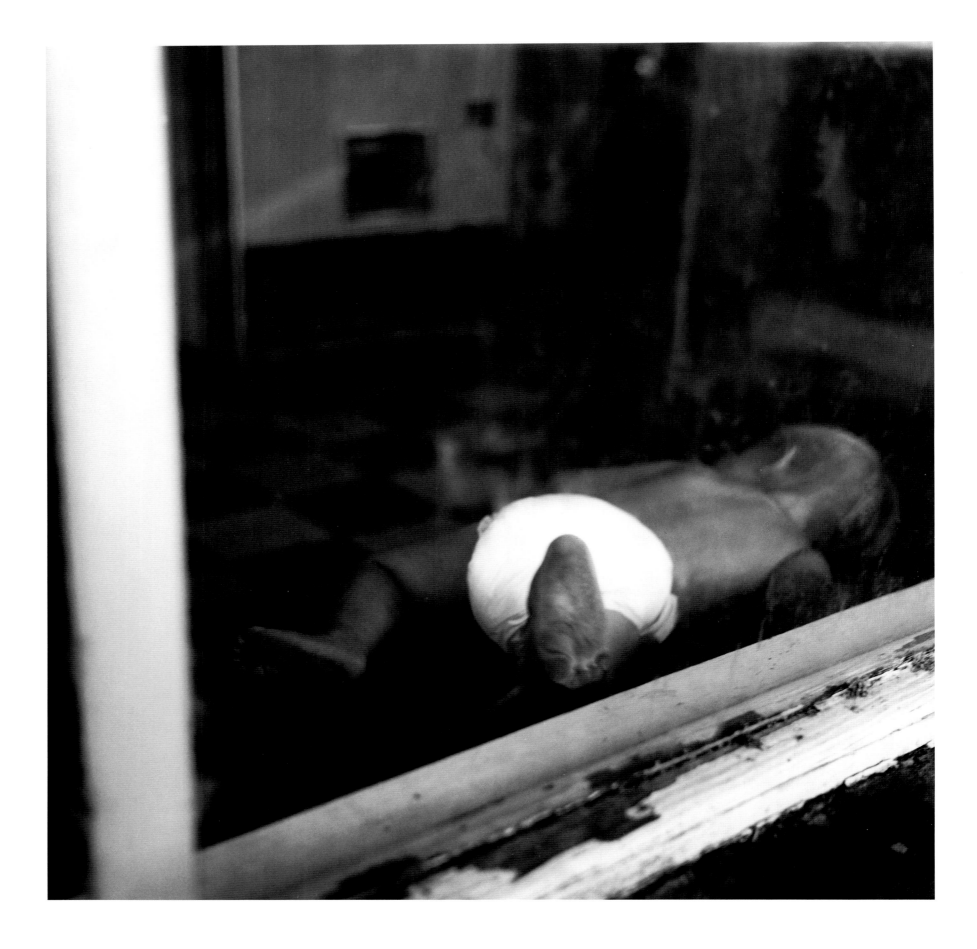

Baby in Window, Soap Lake, Washington, 1994

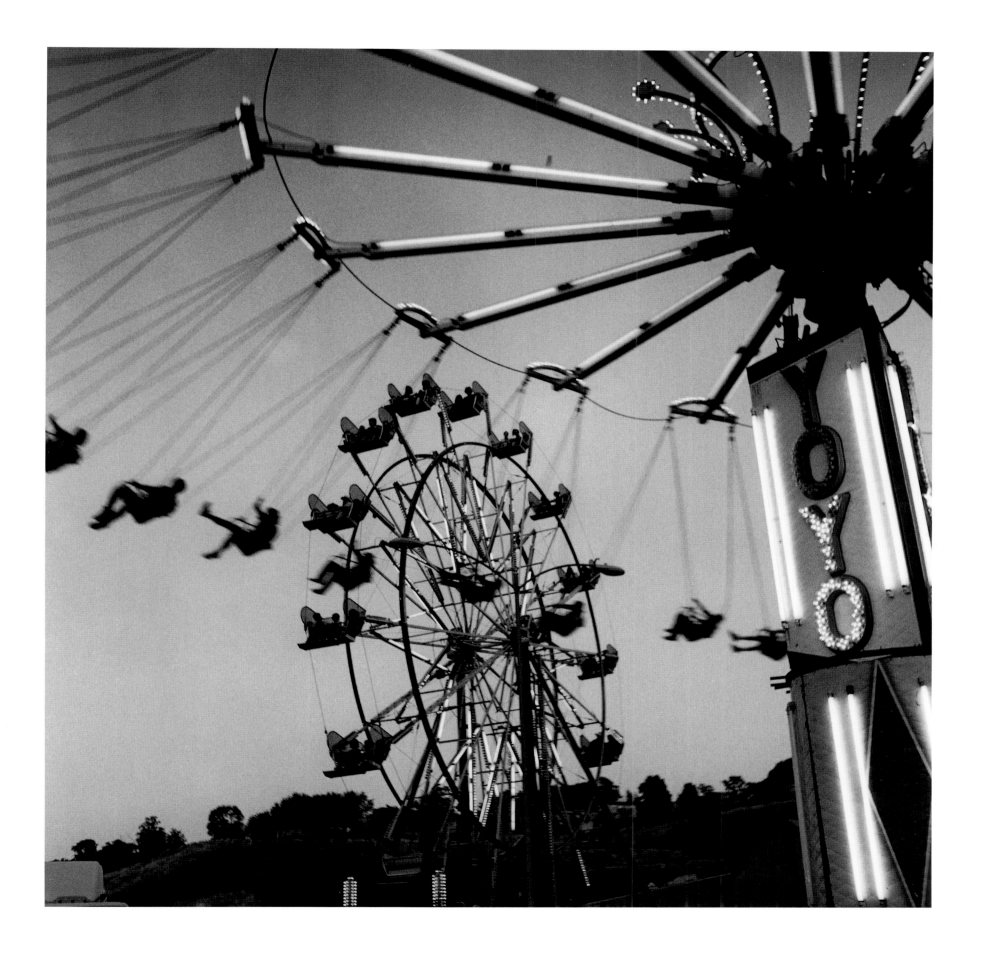

Yo-Yo Ride, Pendleton, Oregon, 1995

Cheerleaders, Soap Lake, Washington, 1995

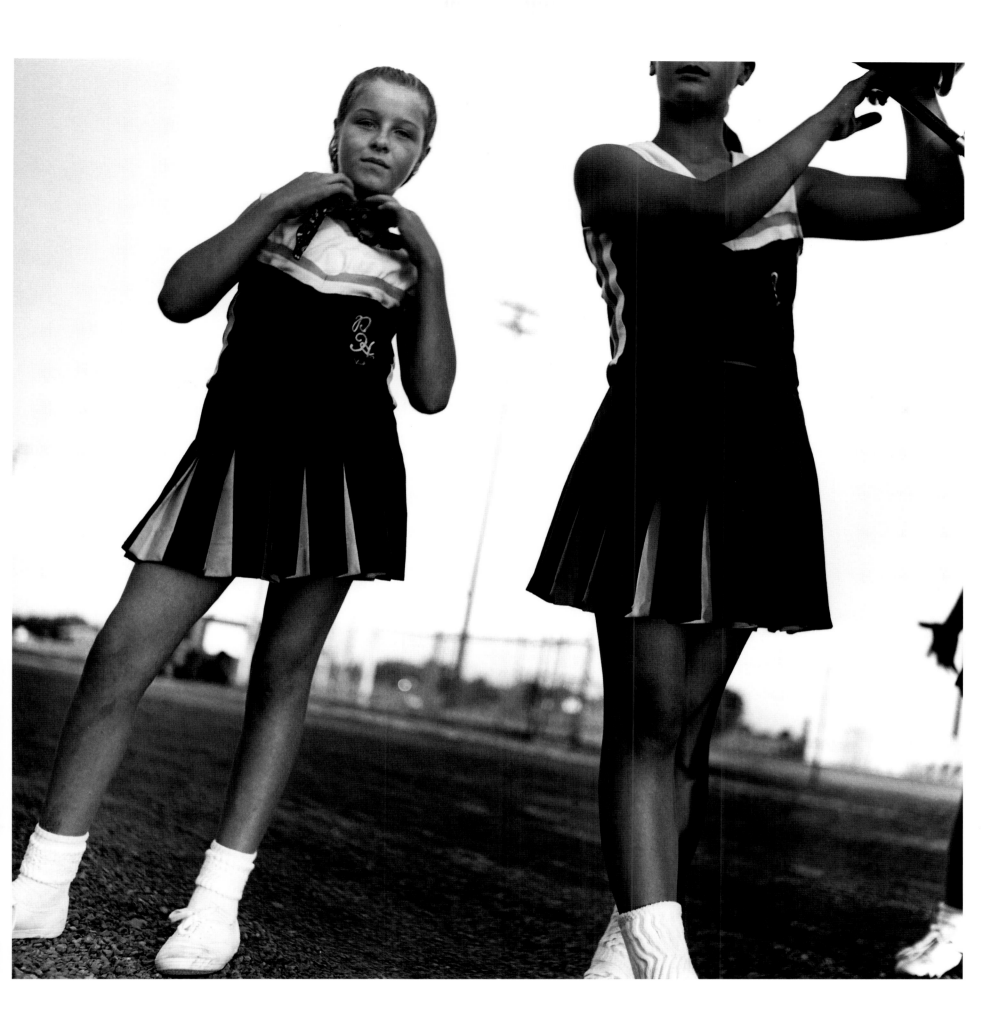

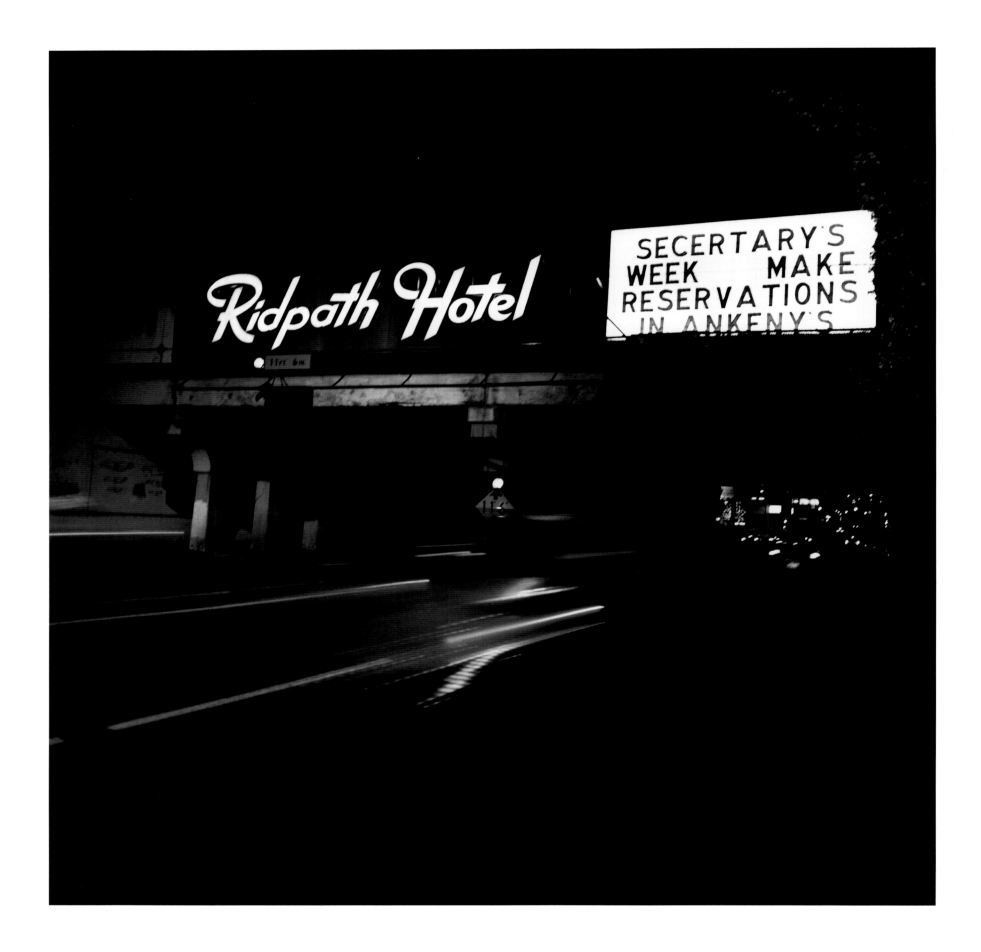

Ridpath Hotel Sign, Spokane, Washington, 1998

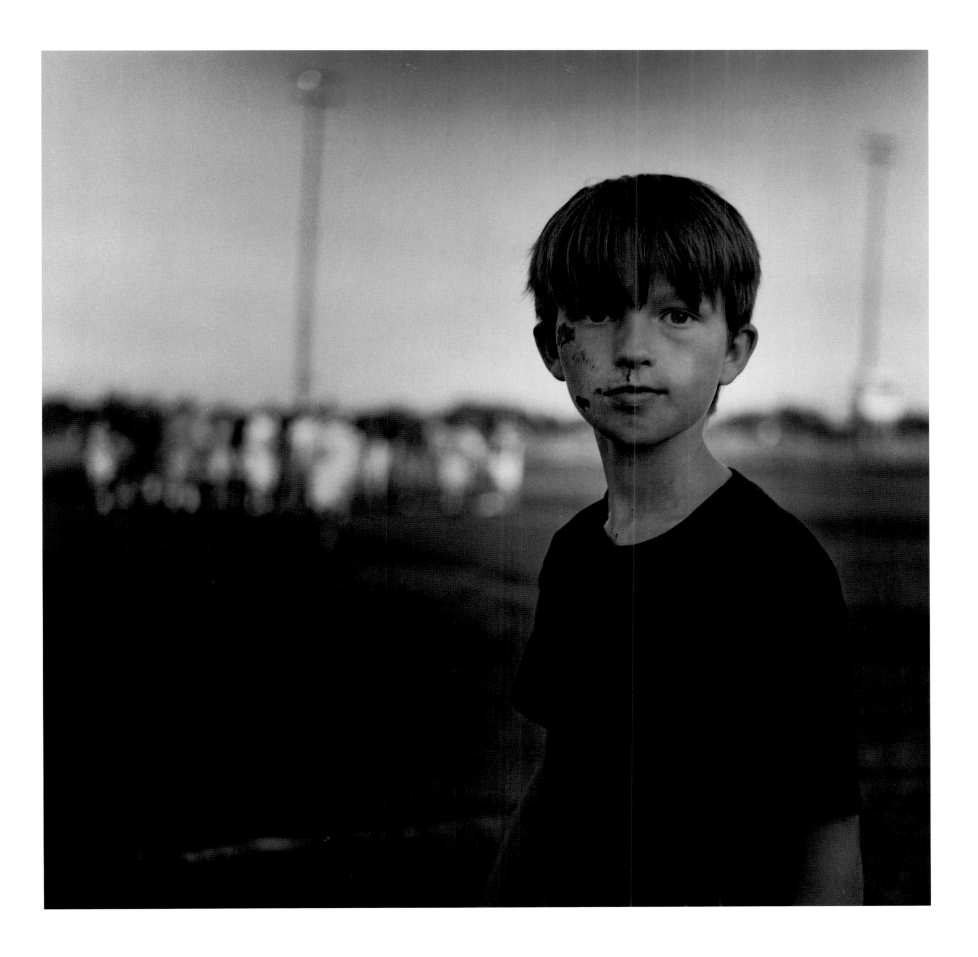

Boy at Dusk, Soap Lake, Washington, 1995

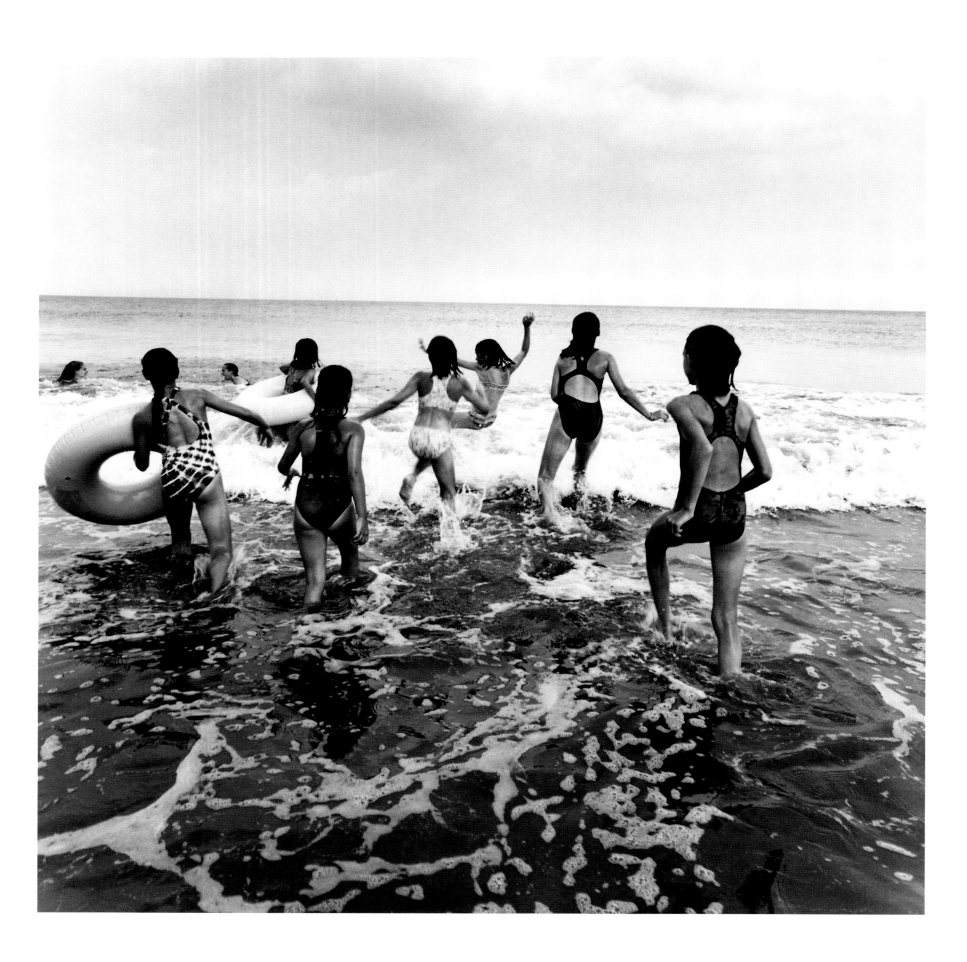

Atlantic Ocean, Tybee Island, Georgia, 1998

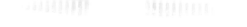
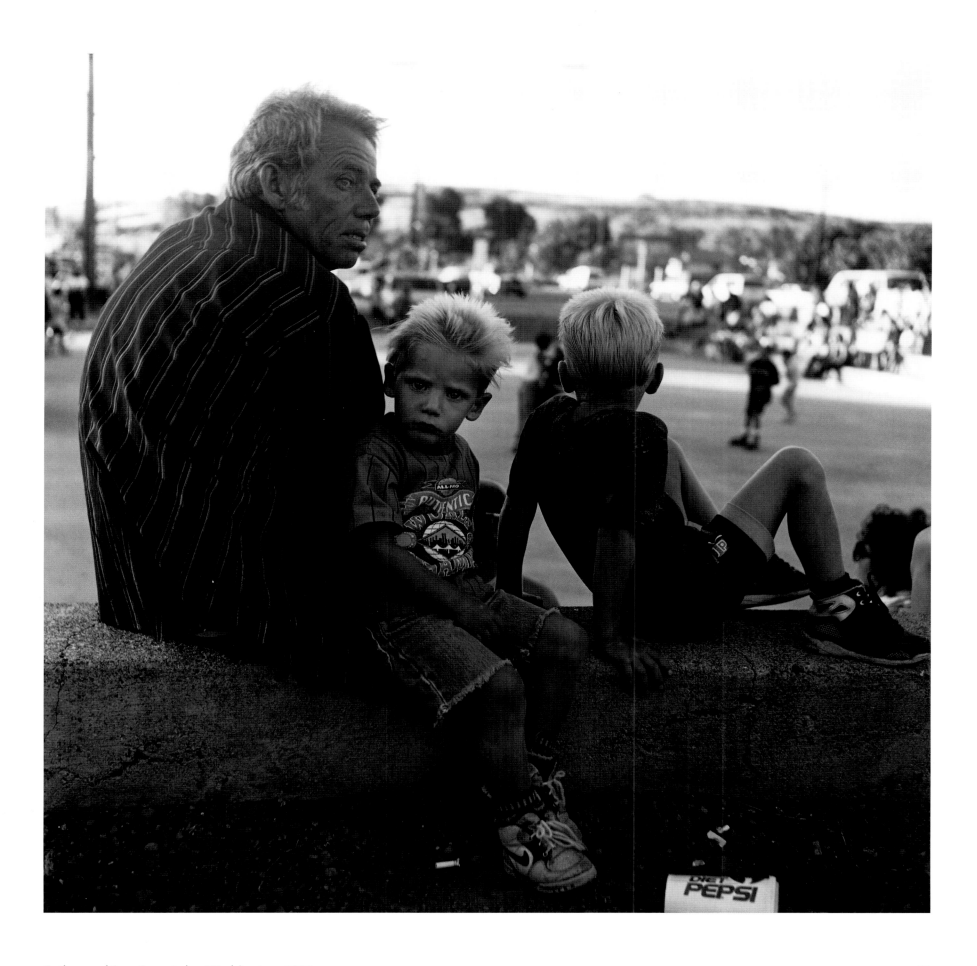

Father and Son, Soap Lake, Washington, 1994

Roller Coaster, Indio, California, 1994

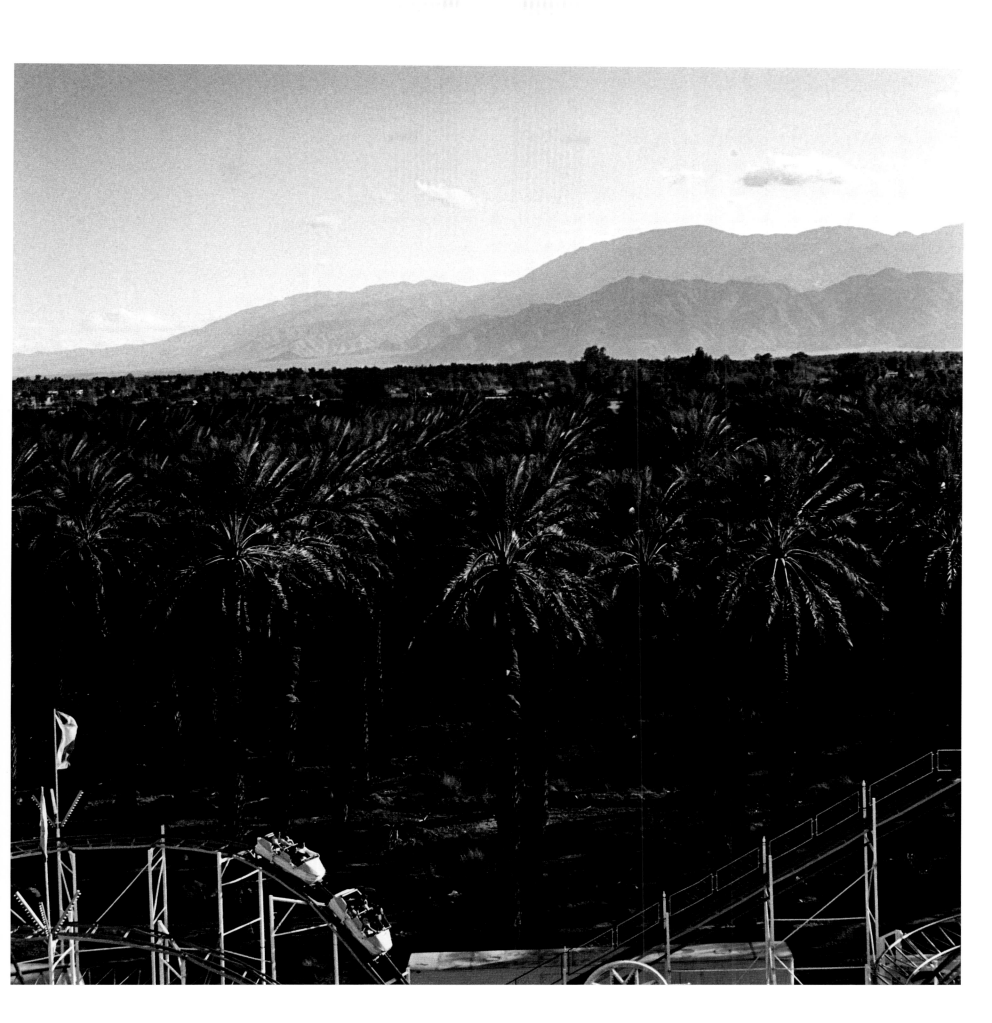

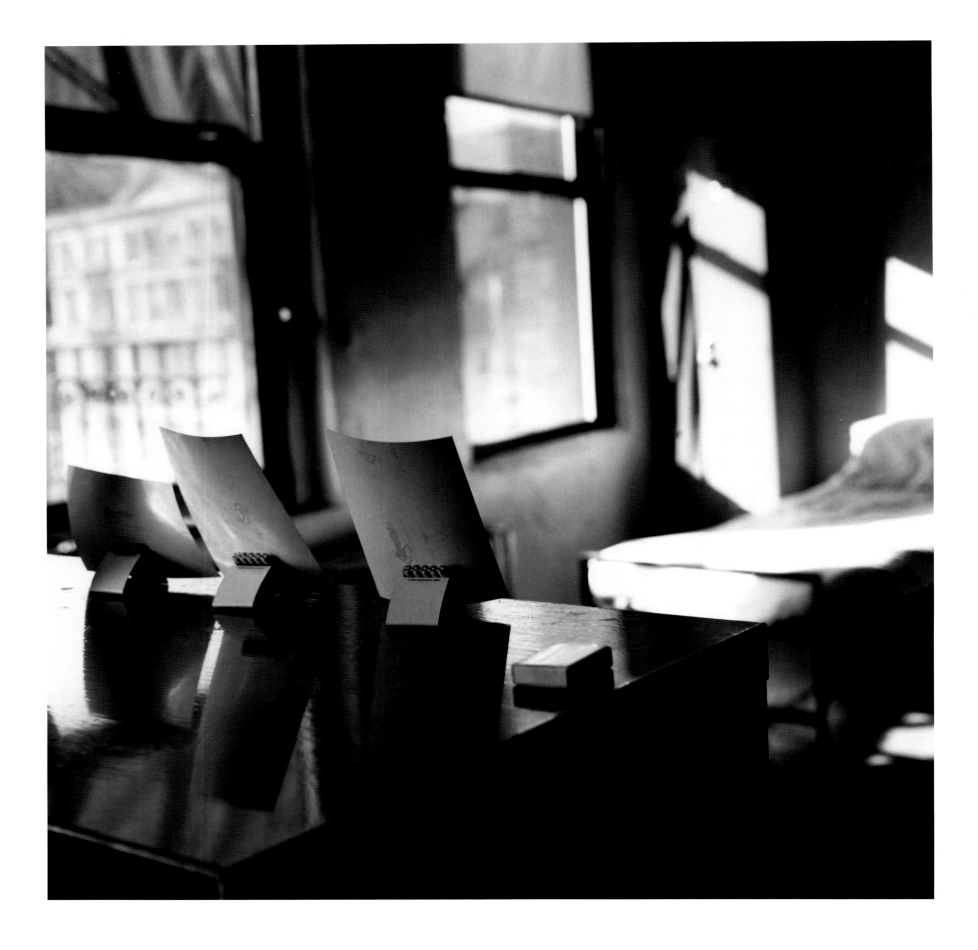

Picture Holders, Transient Hotel, New York, 1997

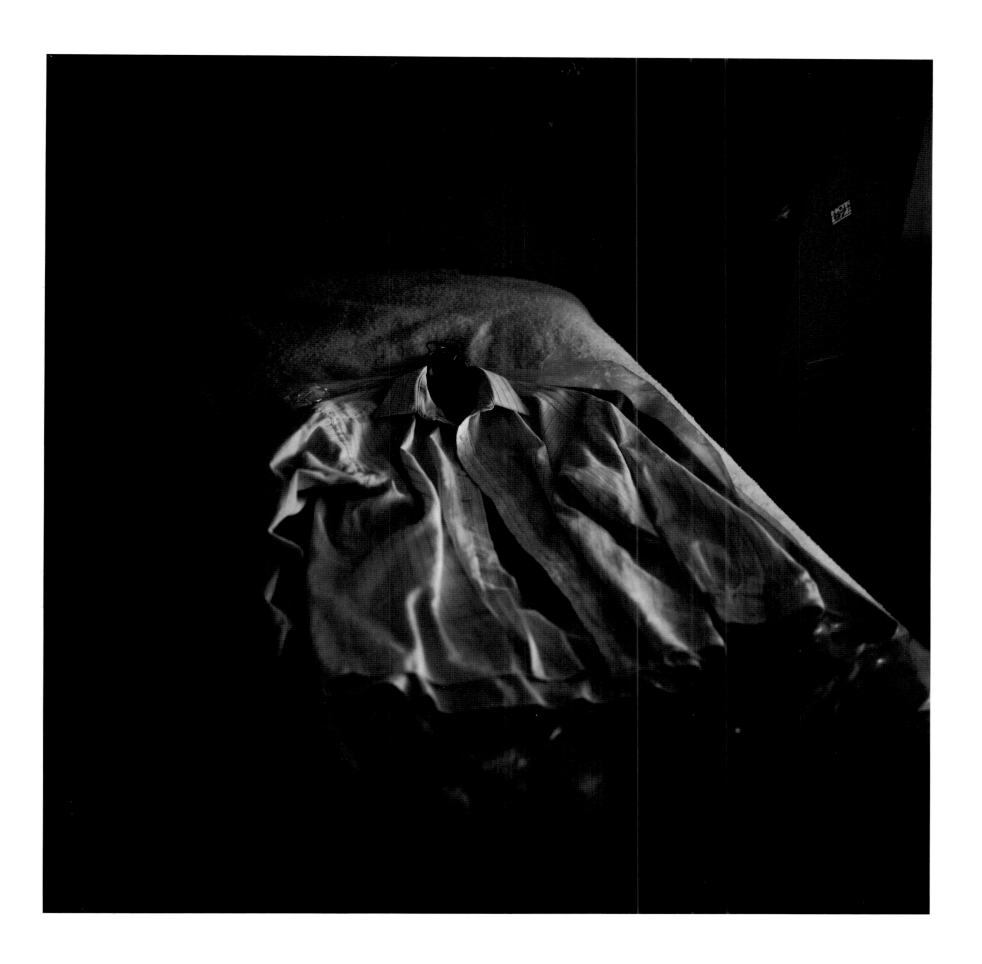

Shirts, Transient Hotel, New York, 1997

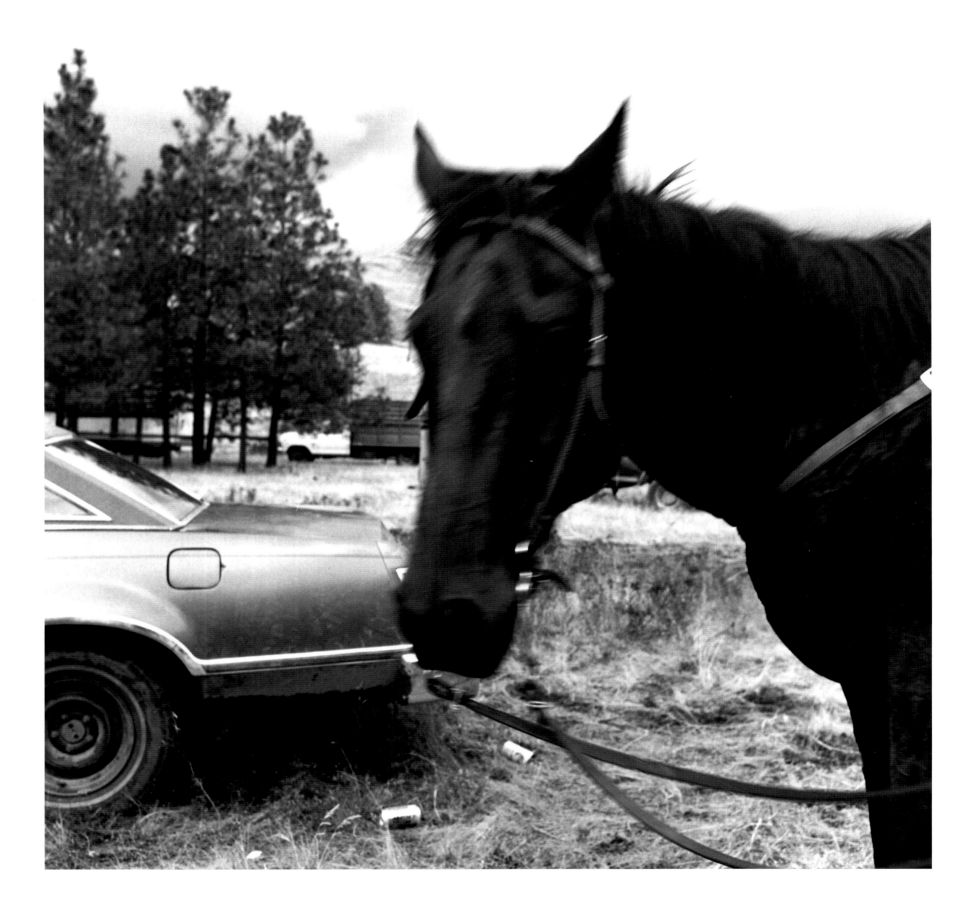

Horse Head, Colville, Washington, 1995

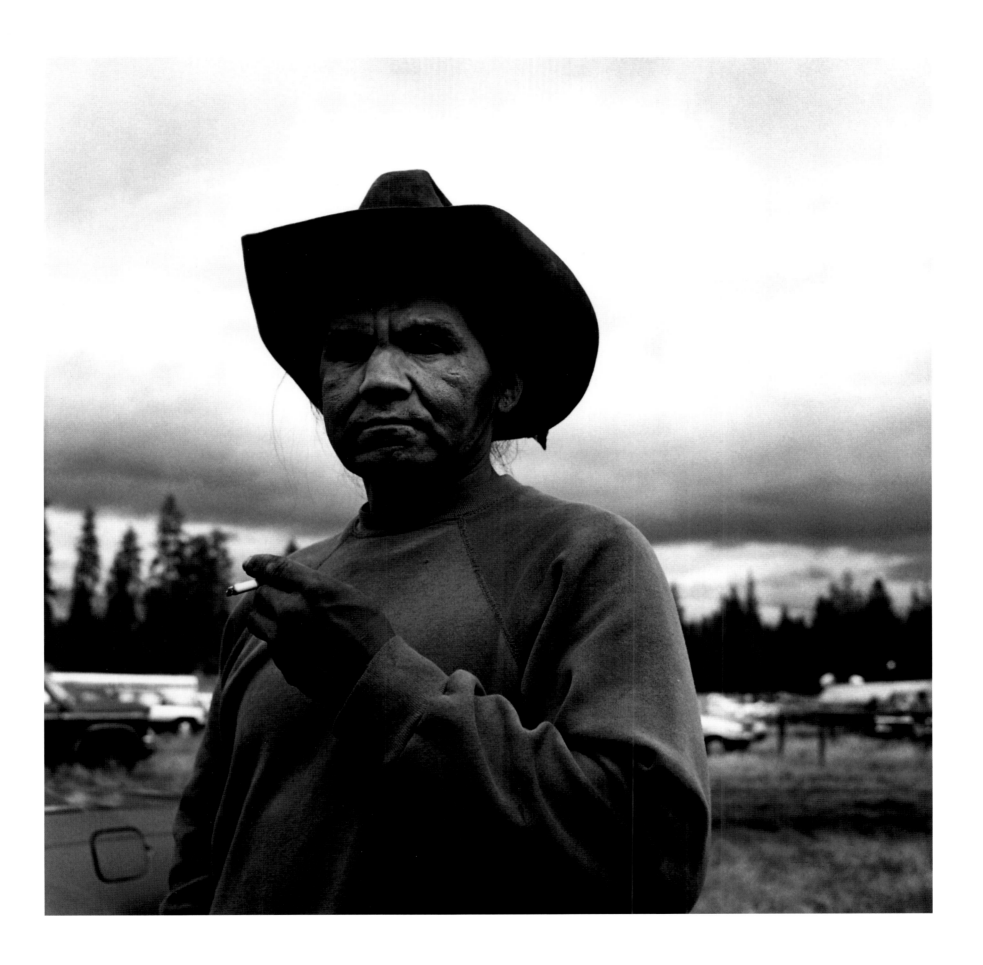

Man, Colville, Washington, 1995

Stilt Man, Waterville, Washington, 1995

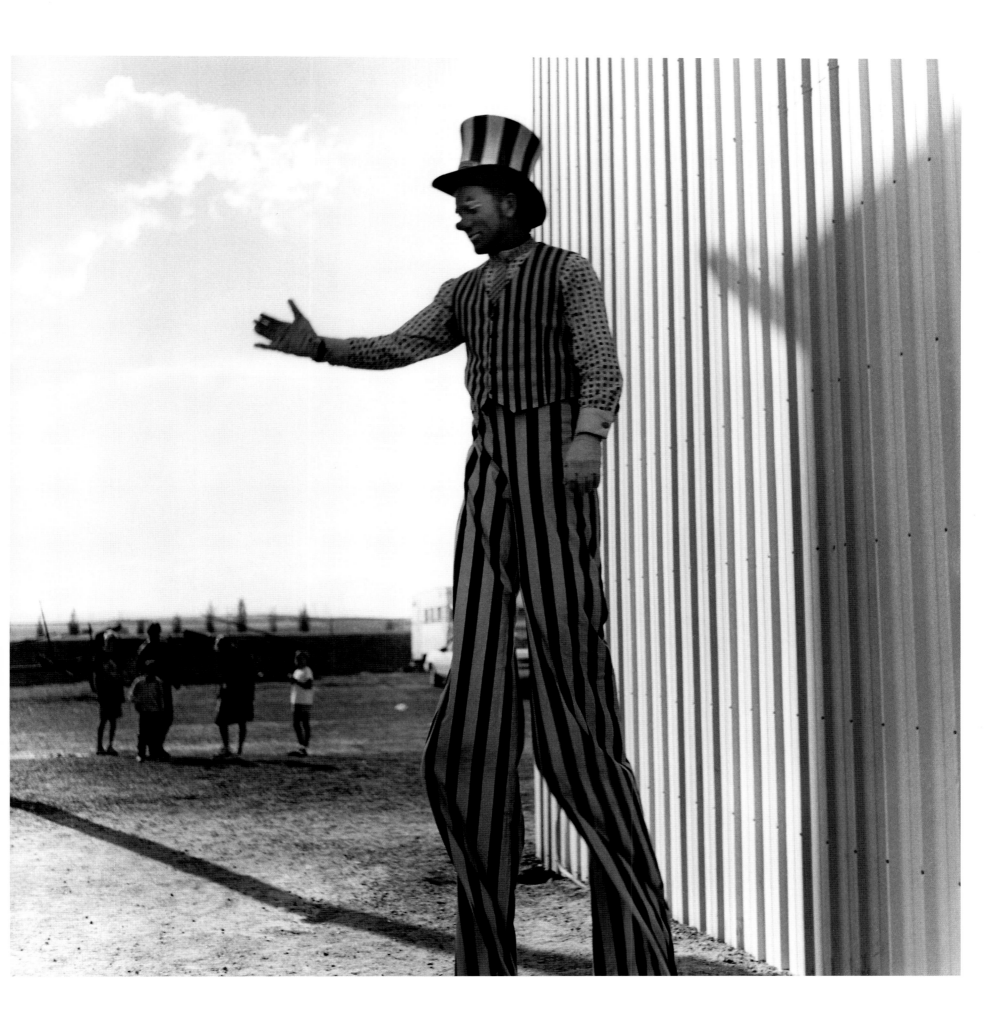

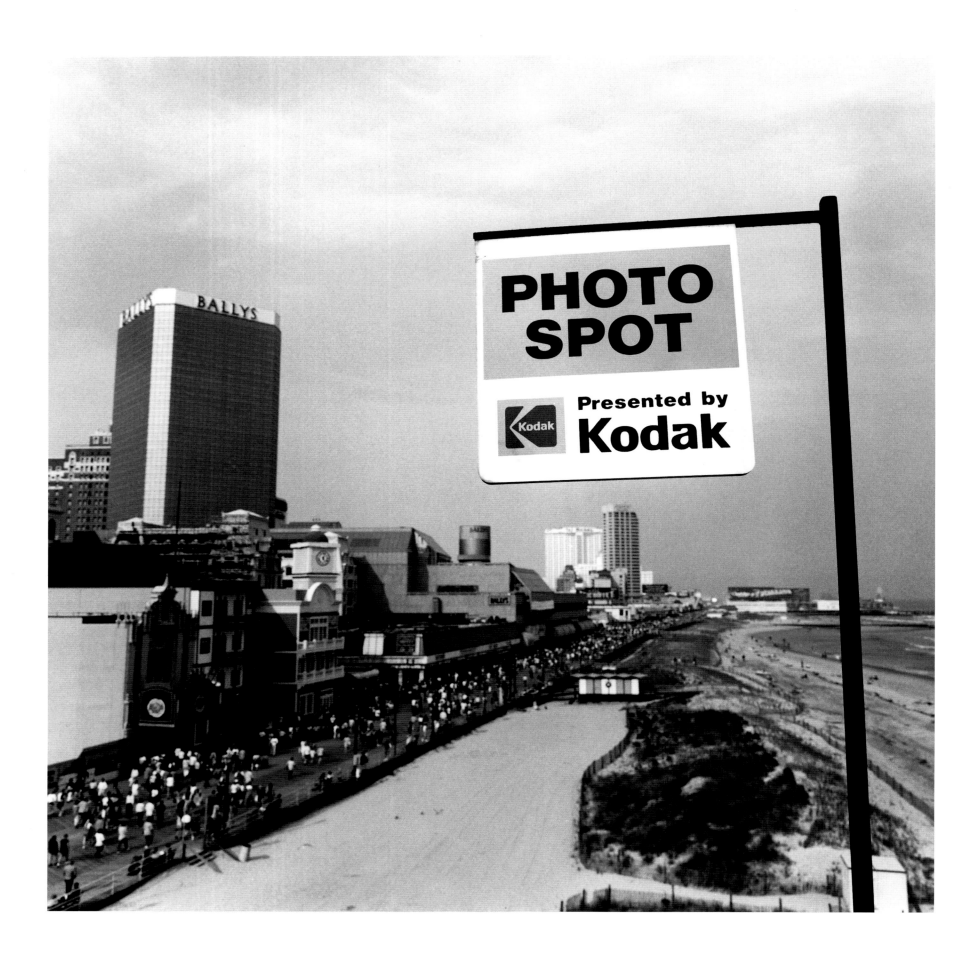

Point of Interest, Atlantic City, New Jersey, 1998

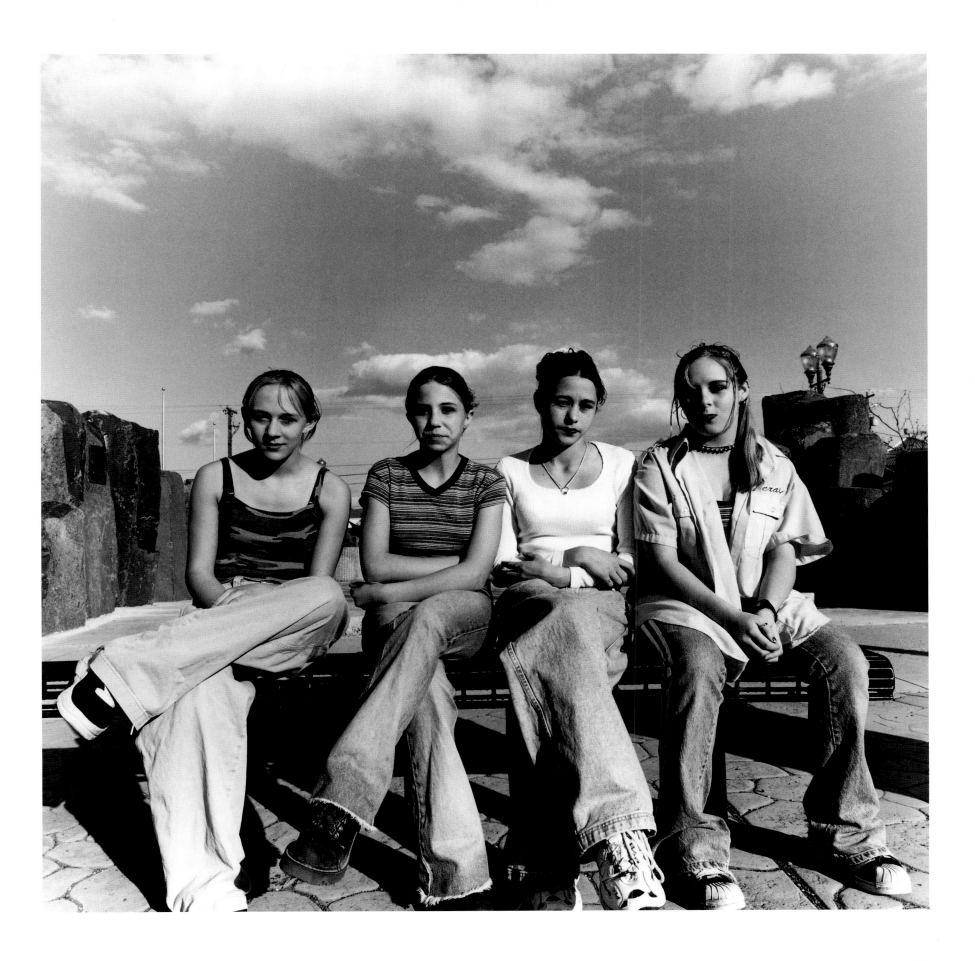

Four Girls, Ephrata, Washington, 1998

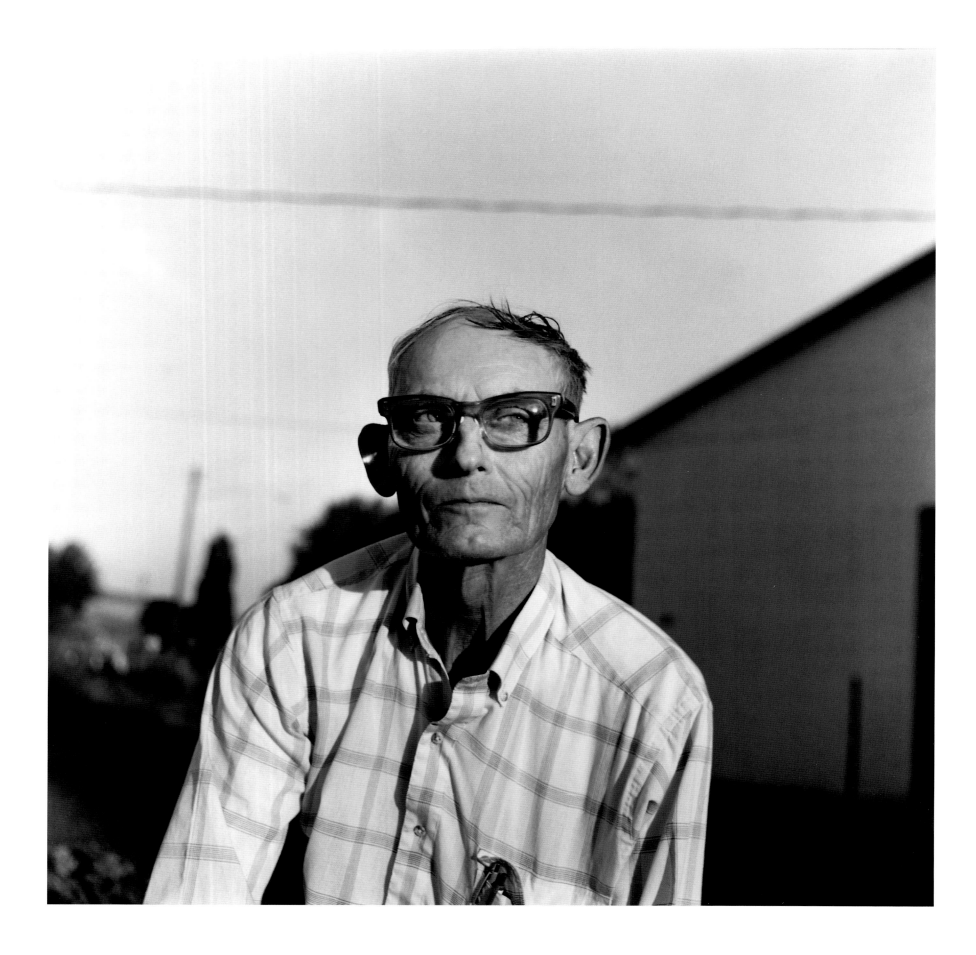

Virgil, Wilson Creek, Washington, 1994

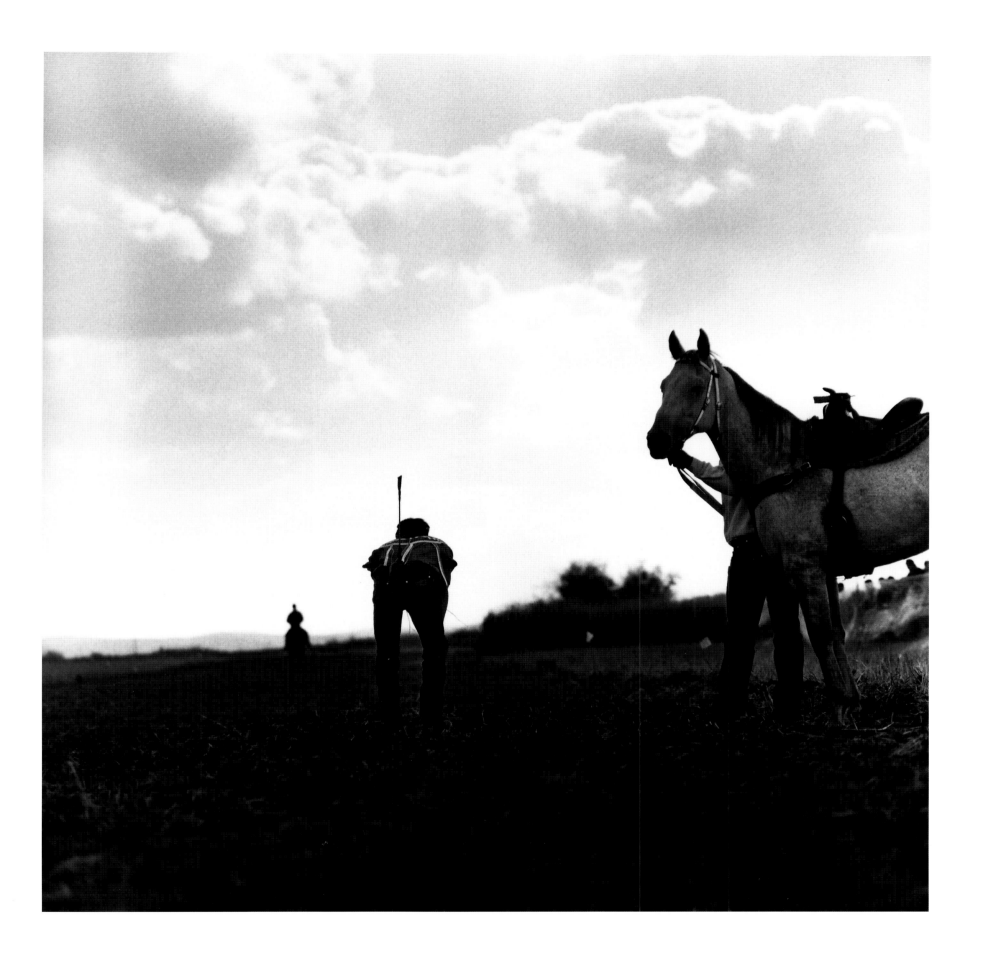

Horse Race, Coeur D'Alene, Idaho, 1995

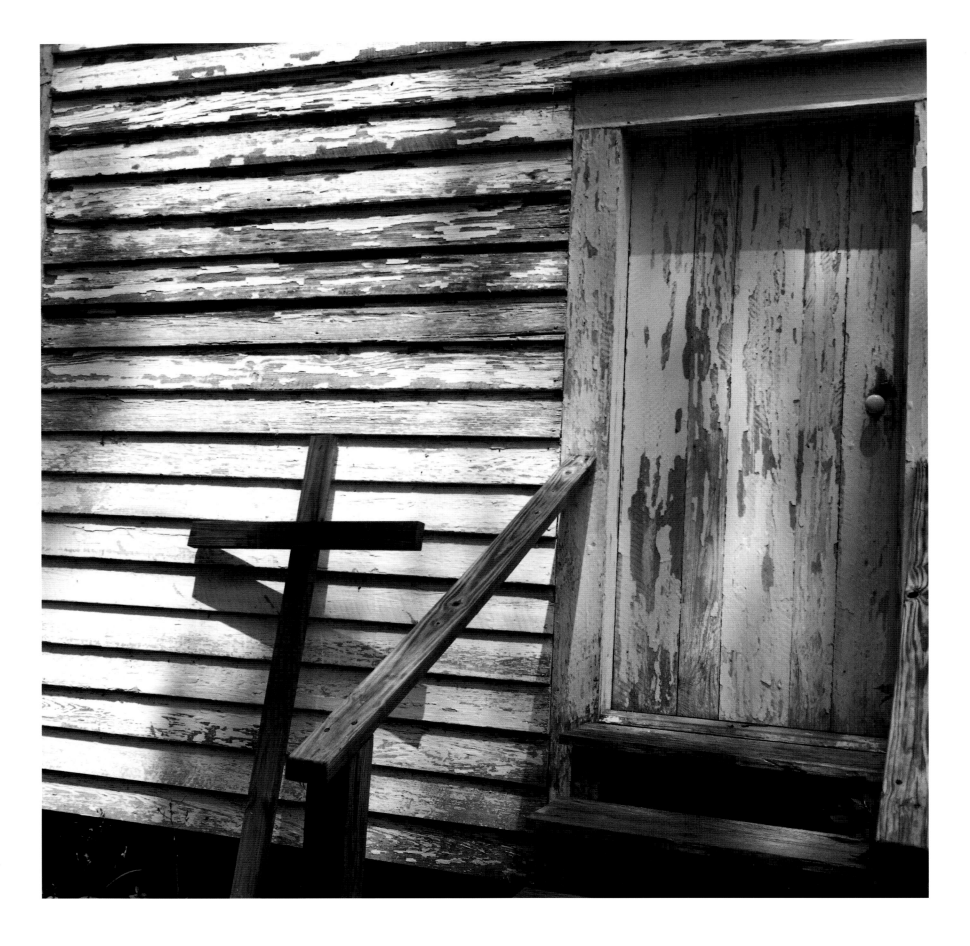

Church and Cross, Savannah, Georgia, 1998

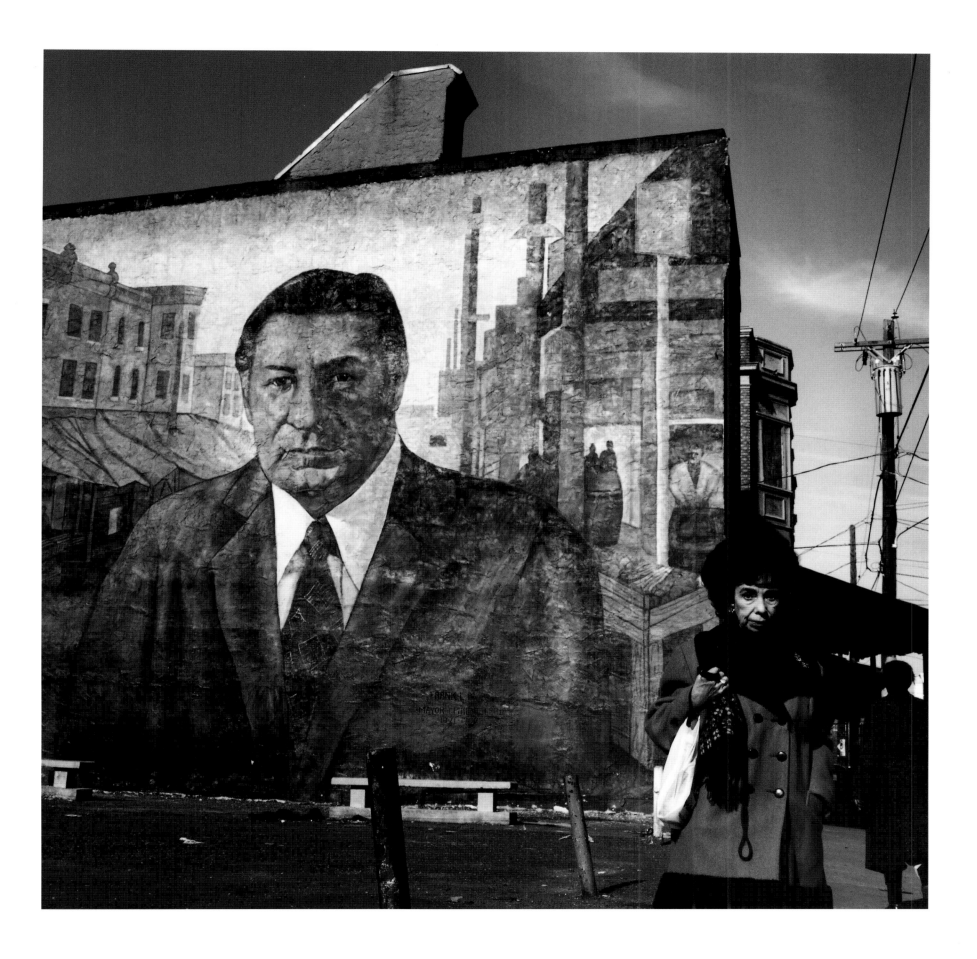

Italian Market, Philadelphia, Pennsylvania, 1997

Cowboy, Moses Lake, Washington, 1995

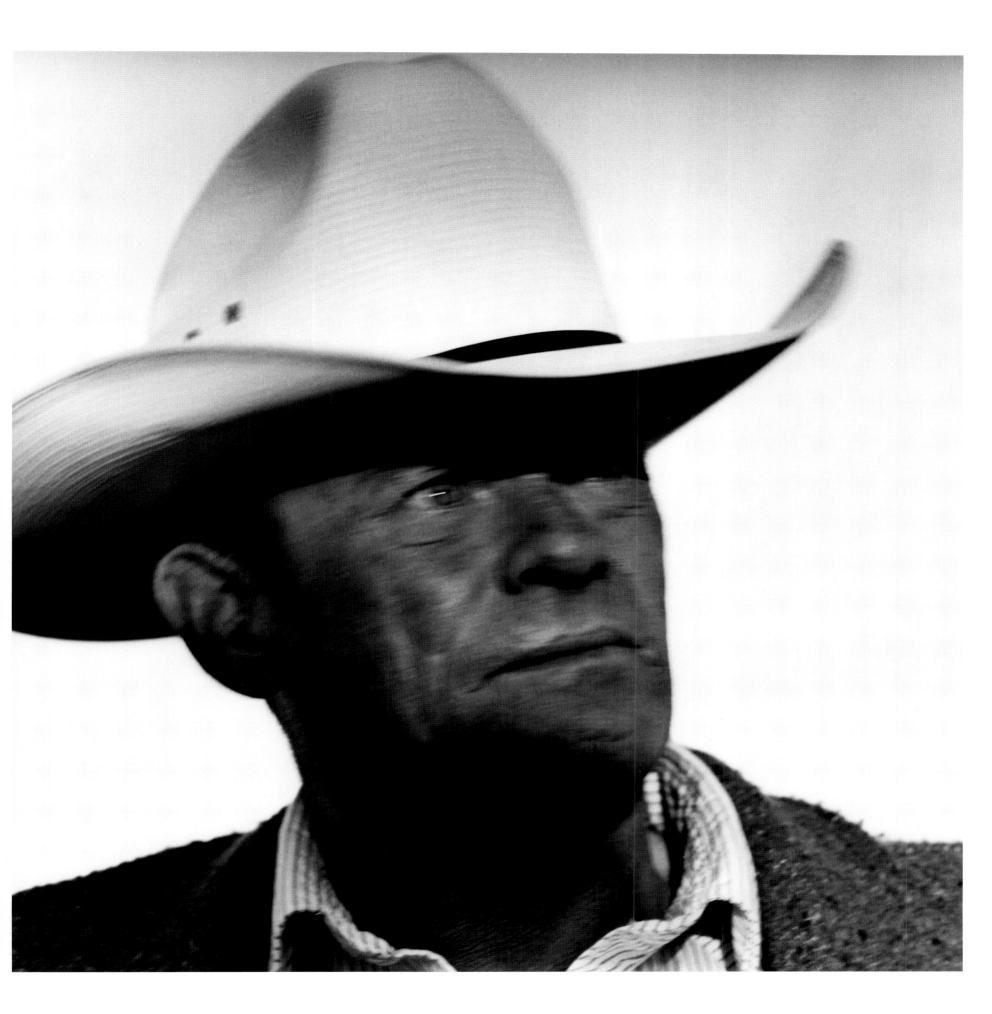

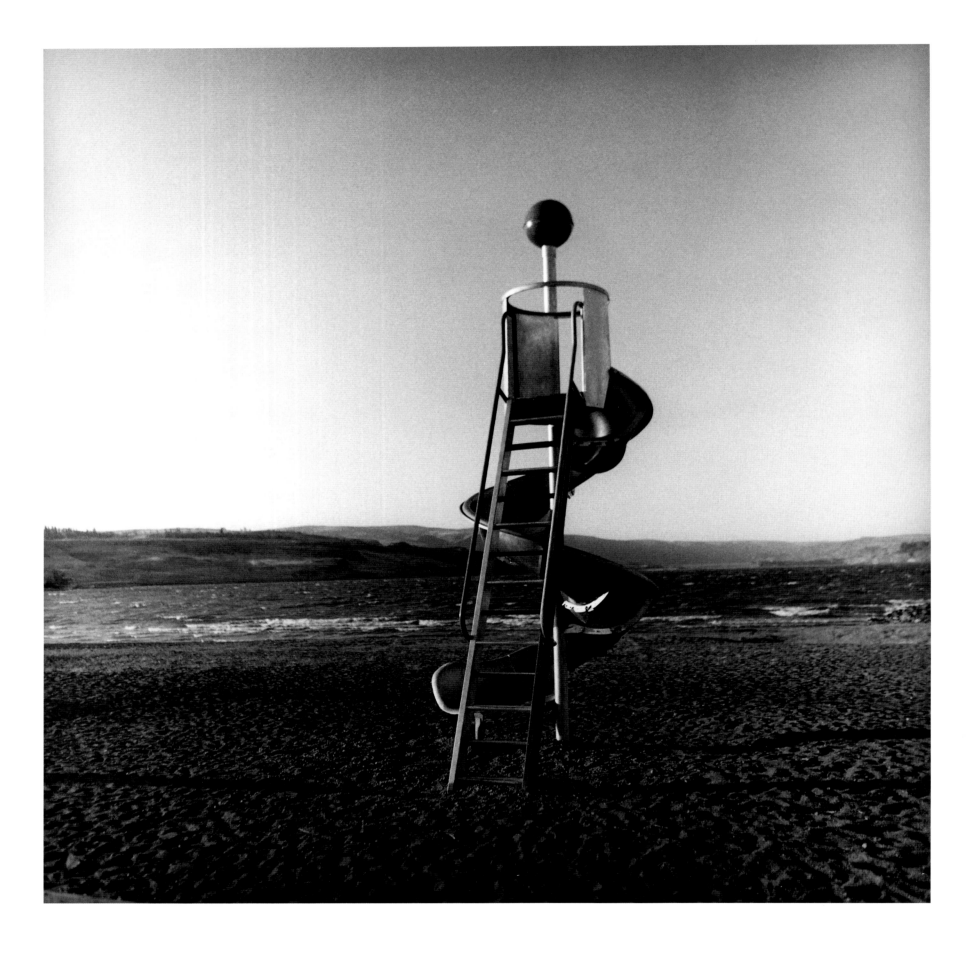

Swirl Slide, Soap Lake, Washington, 1996

IN A SILENT WAY

by Kristin Capp

My fascination with the eastern side of the state had been brewing for quite some time before I packed my car in 1994 and moved to Soap Lake, Washington. Sometimes I think one invents reasons for doing things later, after the fact, so as to give more *weight* or *meaning* to the decision. My need to move to such a remote, nondescript place at that point in my life was arbitrary then, or so it seemed, but was actually a very focused and simple life decision. It was a specific move, because the intent was to look, with hopes of finding. Or, on second thought, it was looking for something in general, with the *intent* of finding something specific.

The view from my desk on the south side of Soap Lake was a backdrop beautiful and varied, and depending on the time of day and the human element on the beach, I was always given something interesting to ponder. Often, I would wait for the silent beach to receive visitors, and would wander down when they appeared. It was a natural canvas, a window of opportunity that waited patiently for the activity to come.

I spent my days perusing the town, and wandered the streets with a thoroughness that may have appeared suspicious or strange to an onlooker. I learned that continued movement was good for observing new variations of the ordinary, and attempted to sharpen my eye for the odd ballet that occurred between people on their stoops, the sidewalk, and everywhere in between. The confined nature of my existence was balanced by the feeling that life in this remote, transient community was chock full of story: *story* that seemed destined for images. I thought of Paul Strand, whose idea of being confined to a small place and having to "dig into the smallness" was his process for making photographs in a French village. I recalled Sherwood Anderson's "Winesburg, Ohio," where moments would come into relief when two people would break through the barrier of miscommunication and incomprehension, if only for a moment. The non-event became the focus of my work, and I looked for small worlds within the ordinary to photograph.

Striving to find continuity in my subject from the beginning, I used Soap Lake as a point of departure for the work that became the group of images I now think of as "Americana." The work I did in Soap Lake was a catalyst for a way of working that eventually included more than one town in one region. I traveled to many regions of America, and have included images from urban places, suburban places and my own family milieu as well. With time, the cumulative meaning of these photographs has changed, and will continue to challenge my understanding of the elusive nature of the subject, *Americana.*

Soap Lake, May 13, 1994

It is ten thirty at night and I sit barefoot in unit "C" in the green building on the beach. I arrived in Soap Lake after sunset, but this time of year it stays so light even after sundown that the day scarcely feels over. I passed through Ephrata and stopped for soft tacos from the taco truck; picked up groceries at *John's Thrift* for the morning, and arrived at my new abode with little excitement and a little more trepidation. It is a beginning of some kind ... but the meaning of this experiment in a new place and landscape seems unclear ... vague but necessary.
The air is fragrant. It is sweet with honeysuckle, sage, burning grass and salty whiffs off the lake. My apartment is one of four units in what was at one time a small motel built in the 1950's. The walls are a knotty, light pine paneling and the studio is small, but the deck facing Soap Lake makes up for the size. My view of the lake is filled with a foreground of the swirl slide and the merry-go-round.

Soap Lake, May 14, 1994

Before I began working at the antique store today, I noticed a Russian mother with her three children emerging from the side street that borders the post office on the west side of the building. They crossed in front of the building, then entered to check their post office box. Visually, they appeared to be from another era. The young mother wore a light yellow cotton skirt, a simple white blouse and a thin white scarf over her fine, light brown hair. Her children were wide-eyed and respectful of her attempt to keep them together. They obediently held hands, forming a sibling chain behind her that kept them together and "safe" as they crossed the main highway. In the evening I drove into Ephrata to attend a cowboy poetry event at the Lee Theater. Six cowboys read their work, and I sat in the front row for a close-up view.

Soap Lake, May 18, 1994

Later in the day, I drove east on Highway 28 towards Odessa, but only as far as Wilson Creek. The sky was stunning—with thunder clouds heading west and thunder rumbling in the distance upon my arrival in Wilson Creek. I came across a Baptist church on a hill that looked out over the town. It had a white metal roof and a white, sheet metal steeple—a striking contrast to the dark gray and silver colored thunderhead in the background. On the way back to the car I picked flowers I had not seen in the area surrounding Soap Lake; they were a type of flowering sage with a dusty orange color, but with a blossom configuration that reminded me of larkspur. The sounds and the colors in this landscape are subtle, but this subtlety only seems to accentuate the originality and intensity of natural and human events when they do happen. As I stood on that knoll above the Baptist church in Wilson Creek, waiting hopefully for the sun to break through the puffball clouds and light up the white metal roof and steeple like a black light on white, I wondered if the frenetic chirping of the crickets and birds wasn't a forewarning of the weather on the way. After each rumble of thunder on the horizon,

the dogs in town barked together for a moment, then the crickets resumed until the next rumble. The sun finally broke through a sliver of space and I took my picture. I am still becoming familiar with, and very much liking the feel of this rolleiflex.

Soap Lake, May 19, 1994

I continued further east than I had previously on Highway 28, in the hope of finding the Hutterite colony that a local had told me about. I made it down a small gully to the town of Marlin and proceeded to get lost, ending up in what seemed to be one of the smallest towns in Washington, the town of Irby. In Marlin I continued down a side street and stopped at a house where a young girl was tending a rust-colored burning barrel in the yard. I inquired about the whereabouts of the colony, and she said "I don't know but Elaine might," then proceeded into the house to find Elaine. A woman came out with a trail of three children following her, and her appearance defied any small town stereotype. She was slender and urban looking, with blue eyes and auburn hair done in a soft pony tail. Taken by her elegance, I lost track of her directions and my mind wandered. I mentioned that I thought this town felt more remote than any I had been to in Washington—an oasis of some kind from the rest of America—and wondered how one makes a living here. "I just moved here from Dallas, Texas only three years ago because I decided I didn't want to have anything to do with that anymore," she said. I was still imagining her in line at a coffee shop, waiting for a double latte with four kids waiting in the car. Was this woman a pioneer, or just running from a strange life story that begged to be undiscussed? With her four cherubic children hanging on her she added: "Yeah, you just have to drive places here. You drive everywhere, this town being the smallest town in Washington ... population of 61 ... that's the life." Driving off, I figured I had found something, at least—if not the Hutterites, the smallest town of Marlin, with only 61 people.

My film order from Seattle arrived on my doorstep today. A luxury, now, to have several bricks of 120 film to get me through the next few weeks.

Soap Lake, May 22, 1994

It is evening now, and I just made it back from the Safeway in Ephrata before sunset. I love this time of day in Soap Lake, when the shadows up the canyon are rendered flat. The subtle range of desert colors: the varying hues of yellow, straw, sage and green shift in a moment to a monochromatic scheme, like color film turning to black and white instantaneously. From colors, the view changes to just a contrast between the dark outline of the canyon and the lighter sky in the background. I usually stay out and continue working (shooting) as long as the light allows. Tonight I have started in on the evening ritual a little earlier than usual—maybe just to see the light change from here, and abstain from shooting for something different.

Soap Lake, June 23, 1994

It is almost dark now. I see silhouettes of kids and a few adults down on the beach from my window. The sound of children playing near water travels far, conjuring up memories for me. They seem to play and create worlds of adventure out of nothing.

Soap Lake, June 29, 1994

I walk the tree-named streets every afternoon and evening. I cover the same sidewalks over and over, day after day. One day I will turn down a particular street to break the monotony, hoping for a discovery, and today I encountered one. Two children in front of their house caught my attention and I stopped to chat—they were friendly and took me into their yard, and I made several pictures of them on their front stoop, where they seemed perfectly framed by the structure and texture of their home. The soft light of the early evening created a filter that added to the languid feeling of the moment—I look forward to seeing the film. (Page 11)

Soap Lake, July 4, 1994

The Soap Lake firework display was held yesterday, July 3rd, because July 4th is a Monday, and the town voted to celebrate on Sunday instead of breaking up the working week. There was an all day celebration in town on the basketball court near the beach; in the late afternoon a band started playing rock, country and traditional dance-step music. People from around town sat around the sides of the platform, watching the few couples brave enough to dance in the daylight on an empty dance floor. At dusk the place filled up and the dancing continued on into the night, when the fireworks went off. This poster was hanging on the antique store for a week before the festivities. (Page 97)

"On July 3rd, 1994 a birthday party to celebrate Soap Lake's 75th birthday will be held in the East Beach Park. There will be entertainment, birthday cake, fireworks, speakers and a live band in the Camas Bowl. The Fire Dept. are planning the biggest fireworks display ever. You will see donation cans around town. Please donate what you can to the Fire Dept. to help fund the display."

Soap Lake, July 9, 1994

Fighting the silent, relentless
inertia and boredom is ominous,
but not too dear
a price to pay for
the crickets, sage, space
and images

Soap Lake, July 10, 1994

Headlights glide along the edge of the lake road like moving rhinestones on a big black stone. Mineral lake, black, glimmering stone by night, and blue-green healing waters by day. The view from my room in this green building is like a window onto the simple poetry of the hills and brush in the background landscape. Skies fade like the sound of a siren in the city, from light teal green, to black, turning to pink again in the early morning hours. At 10.30 pm the sound of people on the beach, still playing on the old merry-go-round, pierces the still, balmy air.

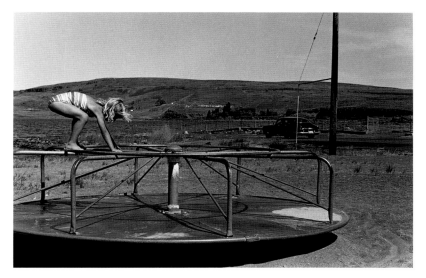

Merry-Go-Round, Soap Lake, Washington, 1990

Soap Lake, July 16, 1994

I feel now, after two months out here in Soap Lake,
that I have been here for several years, or only a few days.
I am restless, but not anxious to leave.

Soap Lake, July 24, 1994

I must eat dinner now. It is nearing 9.00 pm as a wind begins to blow up through the canyon. I only hope it rains, to calm down the dust and bring out a few more lavender stalks in the front garden. Things I intend to shoot in the coming month:

1. Bingo hall in Grand Coulee with Grandma Nycz
2. Early mornings in Soap Lake
3. Colony near Ritzville (Hutterite)
4. The Omak stampede
5. Horse races in Nespelem (Colville Reservation)
6. Rocky Boy Pow Wow in Montana

Soap Lake, August 11, 1994

I left Soap Lake today in the early afternoon, heading for Wenatchee and Leavenworth in search of the fire zone of the Tyee, Rat Creek and numerous fires. My first destination was the Entiat River Road, where I saw the first signs of charred hillsides and charcoal black trees, now turned to rods that are monuments to something recent and devastating. It was akin to seeing the wreckage of an accident, but there were no people visible and the appearance in parts was like a lunar landscape.
It is a strange contrast to be back in Soap Lake now, at a significant distance from the catastrophic situation near Leavenworth. Now back to the personal challenge of dredging out the intrigue in everyday life. Looking for the telegram of information in a face, or in a moment between people that strikes me, and suggests something more than just face value.

Soap Lake, August 13, 1994

Tomorrow, I drive up to the Colville Indian Reservation to attend the annual stampede and pow-wow in Omak, where the suicide race generates so much attention. I look forward to the landscape of the Okanogan, with the hills and ponderosa pines—a nice contrast to the low desert scrub of the Columbia Basin where I live now.
(Page 69)

Soap Lake, August 14, 1994

In people it is the shadows of their personality
that render them interesting
the shadowy places they may express
with or without knowing
are what I try to photograph
(Page 51)

Soap Lake, August 13, 1995

I walk by this placard almost every day, but only today stopped to read it:

HISTORY OF SOAP LAKE
Indians camped here each summer for many centuries. They gathered food, raced horses, gambled and used the healing waters of Soap Lake. The Indian camp was across the lake at the poplar trees. Their race track was near the hospital. The famous caribou cattle trail, used from 1859–1860 passed just east of here. Pioneers settled here about 1900. The first store was built in 1904 by Carl Jensen. Soap Lake planned 1900, incorporated 1919. Soap Lake has been called Cottage Lake, Salome Lake, Siloam, and Sanitarium Lake. Soap Lake is noted for its annual July Fourth celebration.

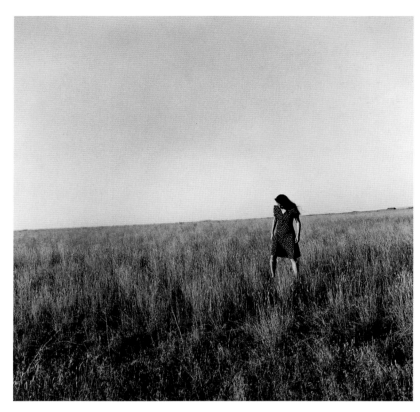

Self-Portrait, Marlin, Washington, 1998

KRISTIN CAPP

1964	Born April 23 in Portland, Oregon, USA.
1970–82	Attends school in Seattle, Washington.
1982–83	Lives in Paris, France and begins studying French.
1983–84	Attends Whitman College in Walla Walla, Washington; studies French, Political Science and classical violin.
1984	Moves to Montreal, Canada to study French and Russian Language and Literature at McGill University.
1989	Receives Bachelor of Arts; joint honors in French and Russian Language and Literature; begins studies in photography.
1990	Moves to Moscow, Russia, to begin a photographic project on Eastern Europe.
1991	Returns to the Northwest; moves to Suquamish, Washington and begins work in film as a location scout.
1994	Moves to Soap Lake in eastern Washington to begin working on the series: *Hutterite* and *Americana;* moves to New York City; later works as an apprentice to Ralph Gibson.
1995–99	Continues working on *Hutterite* and *Americana* series; travels between New York City and other regions of the United States; contributes to—among others—*The New Yorker,* the *Neue Zürcher Zeitung.*
1998	Publishes the monograph, *Hutterite. A World of Grace.*
1999–00	Travels to Africa; begins photographic project in Zimbabwe.

SOLO EXHIBITIONS

1999 Frye Art Museum, Seattle, Washington
Charles Hartman Gallery, San Francisco, California
Galerie Photo Forum, Bolzano, Italy
1998 *Hutterite. A World of Grace,* Kunsthaus Zürich, Zurich,
Switzerland
1997 *Hutterite. A World of Grace,* Musée de la Photographie,
Charleroi, Belgium

GROUP EXHIBITIONS

2000 *Recent Acquisitions,* High Museum of Art, Atlanta, Georgia
Hereabouts: Northwest Pictures by Seven Photographers,
Seattle Art Museum, Washington
Multiple Constructions, Albin O. Kuhn Gallery, University of
Maryland, Baltimore
Utopia, Candace Perich Gallery, Katonah, New York
1999 *Contemporary Documents,* Albin O. Kuhn Gallery, University
of Maryland, Baltimore
1997 *Mediterranean Symposium Exhibition,* City Hall of Polizzi
Generosa, Palermo, Italy
Photographic Resource Center, Boston University,
Massachusetts
Picturing Communities, Houston Center of Photography,
Houston, Texas
1996 Backdrop Gallery, Atlanta, Georgia
America at the Turn of the Century: Portraits, National
Museum, Prague, Czech Republic
Primary Subject, Center of Photography at Woodstock,
New York
Primary Subject, The Print Center, Philadelphia, Pennsylvania
1995 *Professional Women Photographers,* Columbia University,
New York City
1994 *Photography Council of the Seattle Art Museum,*
Photographic Center Northwest, Seattle, Washington
1993 *Double Exposure,* White Space Gallery, Seattle, Washington
1992 *Moscow and Eastern Europe,* Photographic Center North-
west, Seattle, Washington
An Historical Preview: Forty Women Photographers,
Silver Image Gallery, Seattle, Washington
Women in Photography Celebrate Freedom, Los Angeles
Photographic Center, Los Angeles, California

COLLECTIONS

Seattle Art Museum
Brooklyn Museum, New York
International Center of Photography, New York
Museum of Fine Arts, Houston, Texas
Center for Creative Photography, Tucson, Arizona
Kunsthaus Zürich, Zurich, Switzerland
New York Public Library
Museum Ludwig, Cologne, Germany
High Museum of Art, Atlanta, Georgia
Bibliothèque Nationale de France, Paris
University of Texas at Austin
Carlton College, Minnesota
Ohio Wesleyan University, Delaware, Ohio
University of Maryland, Baltimore
Musée de la Photographie, Charleroi, Belgium

BOOK PUBLICATIONS

1998 *Hutterite. A World of Grace,* Edition Stemmle, Thalwil/Zurich,
Switzerland
Our Grandmothers, an anthology of 74 women photogra-
phers, Stewart, Tabori & Chang, New York

PUBLICATIONS IN MAGAZINES/NEWSPAPERS

1999 *Utne Reader,* Minneapolis, Minnesota, November/December.
The New Yorker, New York, October.
Spot Magazine, Houston, Texas, fall.
Photo District News, New York, March.
Boston College Magazine, Boston, Massachusetts, spring.
Library Journal, New York, January.
1998 *New York Times Book Review,* New York, December.
Neue Zürcher Zeitung, Zurich, Switzerland, August.
Doubletake, Durham, North Carolina, summer.
1997 *Neue Zürcher Zeitung,* Zurich, Switzerland, July, November.
Camera Notes, New York, vol. 98, no. 3, summer.
Photographie, Dusseldorf, Germany, March.
1996 *Neue Zürcher Zeitung,* Zurich, Switzerland, December.
Blind Spot Magazine, New York, issue no. 8, November.
The PhotoReview, Philadelphia, Pennsylvania, vol. 19, no. 3,
summer.
1995 *New York Times Magazine,* New York, October.

AWARDS

1999 Kodak Book Award of Excellence, for *Hutterite. A World of
Grace*

ACKNOWLEDGMENTS

I am grateful to many people, near and far, who have contributed to the making of this book. I thank Duane Nycz for his humor and expertise on the town of Soap Lake, and for opening the door to its magic. Heartfelt thanks go to Mirjam Ghisleni-Stemmle for her editorial insights, and special thanks to Thomas N. Stemmle for his vision from the outset. I thank Andy Grundberg and Robert Creeley for their contribution, and extend my gratitude to Barbara Millstein for her insight and advice. Thanks are also due to Elizabeth Biondi and Liane Radel at the *New Yorker* for their interest, and to the following individuals who have offered invaluable support: Trevor Fairbrother and Tara Reddy at the Seattle Art Museum, Jean Caslin, Kathy Ryan, Rod Slemmons, Charles A. Hartman, Christian Güntlisberger at the *Neue Zürcher Zeitung,* and I would also like to thank Brian Wallace at the Bellevue Art Museum for his interest. Special thanks go to Ralph Gibson for his input and inspiration, and much gratitude to Ray Mortenson for his ongoing support.

I wish to thank the friends who have lent their support, including Rod and Kiff, the Walter family in Lamona, Sieglinde Geisel, Jennifer Burch, China, Laura and Leon Arksey, John Max, Janet and Del Miller, Sara and John, Kathi and Doug Newton, Ryan, Daniela, Steve, Andrew, Sacha, Bryan, Alex, Richard, Waqas, Terry and Loni, Meg and Tom Gearty.

I am deeply grateful to my family—Grayson, Myrna, Teri, John, Brian and Cindy for their faith and support, and I thank Christopher for his love and help throughout this journey.

Editorial direction by Sara Schindler and Mirjam Ghisleni-Stemmle
Layout and Typography by Giorgio Chiappa
Lithography by pp.digitech AG, Adliswil/Zurich, Switzerland
Printed by VVA Vorarlberger Verlagsanstalt, Dornbirn, Austria

Page 2: *Football Practice,* Soap Lake, Washington, 1995

ISBN 3-908163-25-0